THE THYSSEN-BORNEMISZA COLLECTION

Medieval sculpture and works of art

THE THYSSEN-BORNEMISZA COLLECTION

Medieval sculpture and works of art

Paul Williamson

GENERAL EDITOR SIMON DE PURY

Sotheby's Publications

© The Thyssen-Bornemisza Collection 1987
First published 1987 for Sotheby's Publications by
Philip Wilson Publishers Ltd
26 Litchfield Street, London WC2H 9NJ

ISBN 0 85667 335 8
LC 85–060456

 Distribuzione esclusiva in Italia: Arnoldo Mondadori Editore

Designed by Gillian Greenwood
Typeset in England by Jolly & Barber Ltd, Rugby, Warwickshire
Printed and bound by Snoeck, Ducaju & Zoon, NV, Ghent, Belgium

Contents

Acknowledgements

Many people have been most helpful with suggestions and advice on objects in the Collection, answering my queries on both specific and general points. I should especially like to thank my friends Dr Charles Little of the Metropolitan Museum of Art in New York and Dr Hanspeter Lanz of the Schweizerisches Landesmuseum in Zurich, both of whom visited the Collection with me and discussed the problem pieces at length; my colleagues in London, Miss Marian Campbell at the Victoria and Albert Museum and Mr David Buckton at the British Museum, for help with the enamels; and Mr William Forsyth of Princeton and Professor William Clark of Queens College of the City University of New York for their assistance with sculptural matters. I am very grateful to those others who helped on particular points: they are thanked individually in the relevant catalogue entries. For supplying photographs and information I would also like to thank Mr Richard H. Randall, Jr. and Dr Gary Vikan of the Walters Art Gallery, Baltimore; Dr Christian Theuerkauff of the Staatliche Museen Preussischer Kulturbesitz in Berlin; Miss Nancy Netzer, Museum of Fine Arts, Boston; Mme Ghislaine Derveaux-van Ussel, Musées royaux d'Art et d'Histoire, Brussels; Mr Robin Crighton, Fitzwilliam Museum, Cambridge; Professor Dr Anton Legner of the Schnütgen Museum, Cologne; Dr Alan P. Darr, Detroit Institute of Arts; Dr Richard Marks, formerly Keeper of the Burrell Collection, Glasgow; Miss Josephine Darrah, Department of Conservation, Victoria and Albert Museum, London; Mr William D. Wixom, Metropolitan Museum of Art, New York; Mme Danielle Gaborit-Chopin and M Jean-René Gaborit, Musée du Louvre, Paris.

At the Villa Favorita I received great hospitality and assistance from all the staff in the office and I am most grateful to the gallery attendants for making the inspection of the works of art, and especially the large sculptures, so much easier than it might have been. In London I have to thank Miss Deborah Sinfield for typing much of the text quickly and accurately.

My colleagues in the Department of Sculpture at the Victoria and Albert Museum, Mr Anthony Radcliffe and Mr Malcolm Baker, have also contributed to the catalogue. Anthony Radcliffe, who is cataloguing the later Italian sculptures in the Collection, wrote the entries 10, 11, and 18, which are initialled accordingly. Catalogue no. 19 was written jointly by the present writer and Malcolm Baker.

Lastly, I owe special thanks to my wife, Emma, who nobly put up with often-sacrificed weekends and evenings while this catalogue was in preparation.

Paul Williamson

Foreword

The Thyssen-Bornemisza Collection is best known for its paintings and is now considered the finest private collection in the world, second only to the Royal Collection of England. Its formation is the achievement of two generations of passionate collectors: Baron Heinrich Thyssen-Bornemisza (1875–1947) and his son, Baron Hans Heinrich Thyssen-Bornemisza (b. 1921), present owner of the collection.

The former began to collect during the 1920s and at the outset his goal was to illustrate a panorama of European painting from the fourteenth to the eighteenth centuries. He was then living in the castle of Rohoncz in Hungary, and it is as 'Sammlung Schloss Rohoncz' that the collection first became known. Due to the revolution of Bela Kun, the Baron was forced to leave Hungary for Holland. In 1930 the general public became aware of the collection when a large part of it received its first exhibiton at the Neue Pinakothek in Munich.

In 1932 Baron Heinrich Thyssen-Bornemisza bought the Villa Favorita, a late seventeenth-century house on the shores of the Lake of Lugano, where he decided to spend the rest of his life. Next to the villa he built a gallery to hold his collection and, after his death, his son, Hans Heinrich, opened the gallery to the public during the summer season. He inherited an important part of his father's collection and in an effort to re-assemble the whole began to buy back from his elder brother and his two sisters paintings which they had inherited. As a result, he acquired a passion for collecting which has not left him to the present day. He gradually ventured into areas that had not been covered by his father, such as European and American paintings of the nineteenth and twentieth centuries. These acquisitions now outnumber the collection of Old Master paintings. With the collection expanding on a near daily basis, the Villa Favorita soon became too small to contain it all. Since 1977, therefore, part of the collection has been in Daylesford House, Gloucestershire, the country house built between 1788 and 1796 for Warren Hastings (1723–1818) by Samuel Pepys Cockerell (1753–1823).

Baron Thyssen-Bornemisza feels that all of these works were created not only for his own exclusive pleasure; he believes in sharing them with a wider public. Over the last few years parts of the collection of paintings have been exhibited in Europe, the United States of America, the Soviet Union, Japan, Australia and New Zealand.

A part of the Thyssen-Bornemisza Collection that has so far remained virtually unknown is the sculpture and works of art. The first Baron acquired the majority of these works but when the present Baron inherited his share of the Collection in 1947 he continued to purchase sculptures and works of art, especially medieval ivories and Renaissance bronzes. Most of this part of the Collection has never been exhibited outside the Villa Favorita or Daylesford House, nor has it been fully researched or catalogued until now.

This volume on the medieval sculpture and works of art by Paul Williamson is the first of a two-part study in our series of catalogues of the entire Thyssen-Bornemisza Collection. The second volume, on the Renaissance and later sculptures, by Anthony Radcliffe, Malcolm Baker and Michael Maek-Gérard, will be published in the near future.

Simon de Pury

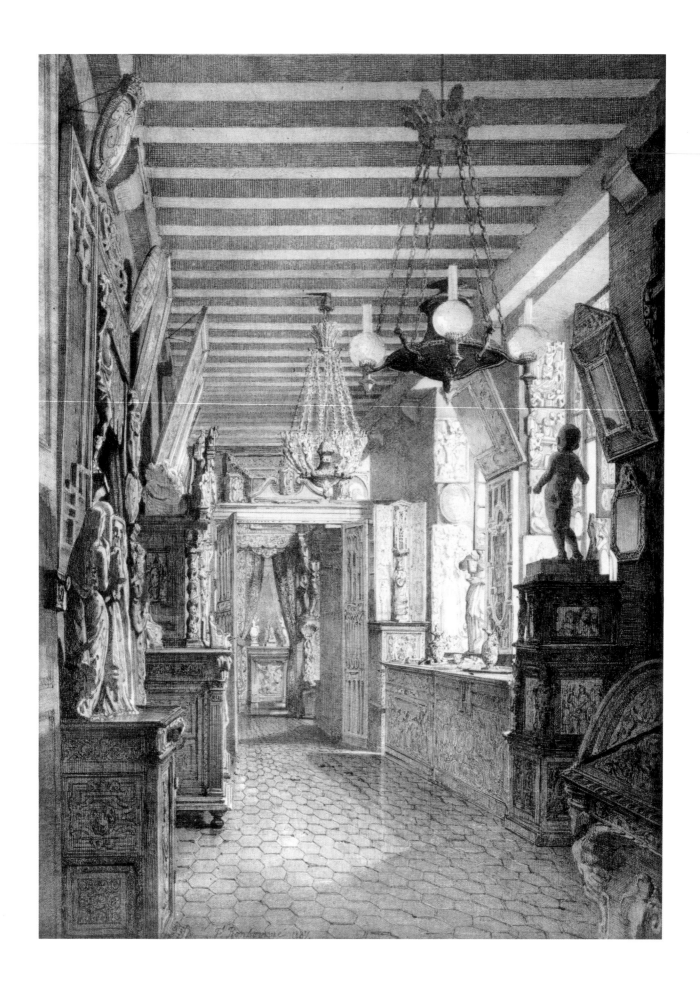

1 The collecting of medieval works of art

The phenomenon of collecting is a fascinating and complex subject which has generated a large literature, much of it written in the last decade. It has been recognised that a history of collecting is a history of taste and that the collections of yesterday tell us much more than simply reflecting the individual tastes of a particular collector: they also gauge contemporary perception of earlier times. But does the lack of availability of certain types of object exclude them from becoming fashionable, or does a fashion encourage the appearance of a particular class of work of art on the market? In the field of medieval art it has generally been understood that the upsurge of interest in the subject was directly related to the supply, so that, for instance, after the French Revolution in 1789, when there was wholesale destruction of medieval buildings, treasuries and shrines, there was a concurrent increase in collections concerned with the type of object related to those settings.

However, long before the French Revolution and the establishment of the great nineteenth-century collections of medieval art in both museums and private houses, there was a deep and informed interest in England in the art of the Middle Ages, from the 1720s onwards. In England, as a result of the Reformation and the Dissolution of the monasteries in the sixteenth century and the Civil War in the seventeenth, there must have been in the early eighteenth century large amounts of material divorced from their original contexts and consequently easily available to the interested collector. This is borne out in contemporary accounts of the collecting of such men as Horace Walpole and William Stukeley, both pioneers in the appreciation of the arts of the Middle Ages. Clive Wainwright has described how easy it was for Stukeley to acquire medieval wood sculptures: 'Stukeley purchased in 1746 for his garden grotto "A waggon load of curious antique wooden figures from Croyland (Abbey). They are of the cherubims of oak as big as life, which supported the principal of the roof . . . to support the four corners of the arch of the grot".'[1] These figures were acquired to act as striking interior decorations, to create a Romantic interior, but Stukeley and Walpole also owned smaller medieval works of art, including significant examples of Limoges enamelling: both possessed fine thirteenth-century *châsses* showing the martyrdom of St Thomas Becket.[2] Stained glass was also easily bought at this time and was very popular, presumably because it could be incorporated into new settings; Stukeley and Walpole were able to acquire much of this material often at very reasonable prices and the popularity of stained glass remained constant right through the nineteenth century.[3] Stukeley was a learned man, a Fellow of the Royal Society and a founder member and first Secretary of the Society of Antiquaries of London: consequently he had the opportunity to publish and discuss his acquisitions with an intellectual circle of associates and his interest in the Middle Ages spread to his colleagues, which in turn encouraged further collecting and study of medieval works of art. Indeed, around the middle of the eighteenth century there appears to have been a thriving community of antiquaries and dealers communicating regularly over medieval works of art. In 1762 a certain Dr Ducarel wrote to Horace Walpole that a dealer in antiquities, Angel Carmey of Chelsea, had in his possession two curiosities: '1. an antient [sic] beautiful candlestick (from some church in Kent), inlaid with gold and silver with several inscriptions in characters

1 Interior view of one of the rooms in the Hôtel de Cluny, *c*.1846, from Alexander Du Sommerard's *Les Arts au Moyen Age*, VI (Paris, 1846), pl. IV

of the XII century; 2. an antient Pix box . . . finely enamelled and quite perfect'.[4] The latter was almost certainly of Limoges workmanship. Twenty-five years earlier Stukeley had managed to increase his collection of English medieval alabaster carvings: '. . . got an excellent piece of religious sculpture on alabaster being St Audry in her habit . . . Mr Samuel Gale gave me another like carving in alabaster of st John Baptists head'.[5]

Notable scholars of Stukeley's time included Richard Gough, Gustavus Brander and Thomas Astle, all significant figures in the early study of Limoges enamels.[6] The sort of contribution made by men such as these, a combination of the collector and the scholar, has always been of the utmost importance for the development of the study of medieval works of art. Unlike the student of architecture who studies the subject of his researches without close personal contact through ownership, the collector-scholar was often driven in a quest for further knowledge about the object in his possession. While these researches were sometimes less than disinterested they almost invariably added to the sum of knowledge and are now often invaluable documents for information on the earlier provenance of objects.

The interest in and love of the Middle Ages in England continued from Walpole's time onwards. In the early nineteenth century famous characters such as William Beckford and Sir Walter Scott took an interest in the period for the Romantic connotations it inspired rather than for any scholarly reasons, but they nevertheless both owned important medieval pieces, like Beckford's enamelled *châsse*, said to have come from Saint-Denis, which is now in the Metropolitan Museum of Art in New York.[7] Meanwhile in France an awareness of the country's riches of the medieval period, paradoxically precipitated by the vandalism and dispersal of large amounts of this material at the Revolution, began to stir. Alexandre Lenoir's Musée des Monuments Français, set up in 1790 to house homeless pieces of sculpture and the remains of the royal tombs, was initiated perhaps not as a museum devoted to the Middle Ages but rather as a collection of antiquities relating to the history of France generally, but because of the pre-eminence of the medieval monuments contained therein it naturally encouraged an interest in the period in those who visited it.[8]

In the late 1820s Edme Durand and Pierre Révoil gathered together a group of 31 Limoges enamels for the Musée des Souverains, all of which are now in the Louvre,[9] and Seroux d'Agincourt published his monumental *Histoire de l'art par les monuments* in six volumes between 1811 and 1823.[10] But the person who did more than any other to promote an interest in the arts of the Middle Ages in the first half of the nineteenth century was Alexander Du Sommerard. Du Sommerard had purchased the Hôtel de Cluny in Paris in 1832 to contain his ever-expanding collection of medieval and Renaissance antiquities, which by the time of his death in 1842 was of considerable size: it now forms the nucleus of the present Musée de Cluny. Du Sommerard's Hôtel de Cluny was not just a museum, as he lived there, and it is clear that he based the interiors of his rooms on the Romantic principles established by Walpole and his followers in eighteenth- and nineteenth-century England (fig. 1). Apart from his collection and the building itself, Du Sommerard's greatest legacy was his six-volume *Les Arts au Moyen Age*, which was published from 1838 to 1846 and played an important part in the dissemination of interest in the Middle Ages throughout Northern Europe.[11]

It was the publication of volumes such as Du Sommerard's and the establishment of major international museums around the middle of the nineteenth century which encouraged a widespread interest in the arts, of the Middle Ages and every other period. There can be no doubt that with the improvement of colour lithography and the increase in both general and

scholarly texts, the medieval period became more accessible and encouraged those with even quite modest means to collect in some form.

Typical of a more public interest in the arts at this time was the formation of the Arundel Society in London in 1848. One of the Society's avowed intentions was to 'preserve the record and diffuse a knowledge of the most important remains of painting and sculpture . . .'.[12] This it did by printing good quality reproductions of famous paintings, which were offered to subscribing members at regular intervals. There was special emphasis placed on the Italian schools, and the 'medieval' frescoes of Giotto in Padua and those of other painters before 1500 were especially popular.[13] By 1855 the Society's interest had spread to sculpture: 'In the Spring of 1855 the Society became possessed of a valuable collection of moulds and other materials for the manufacture of casts, representing, nearly in facsimile, some of the most interesting specimens of ancient Ivory-carvings now in existence.'[14] The formation of the collection was due to Alexander Nesbitt, J. O. Westwood, and Augustus Franks of the British Museum: what started as a modest group of mostly Early Christian casts quickly expanded to a comprehensive collection from the Late Antique to the eighteenth century so that by 1876 the total number of casts, known as 'fictile ivories', taken by the Arundel Society was close to a thousand (not all of these were available to members of the Society).[15] Nor was the Society limited to a few *cognoscenti*: by 1863 the membership had risen to more than 1600.[16] There can be no doubt that the 1850s saw a significant upsurge in interest in medieval art, stimulated both by publications and by exhibitions such as that at Crystal Palace, outside London, where there were prominent 'Medieval' and 'Byzantine and Romanesque' courts in 1854.[17] All of this further encouraged collectors in these fields, adding to the already considerable number of substantial private collections formed by 1855. Ivories were avidly collected, the most notable collections being those of Prince Soltykoff, Sauvageot, Carrand and Micheli in France, and those of Colonel Meyrick, Maskell, Fountaine, the Rev. Walter Sneyd and Mayer in Britain; indeed, two other noted collectors of medieval art in England, Thomas Gambier Parry and Alexander James Beresford Hope, were influential members of the Council of the Arundel Society.[18]

These great collections have since largely been broken up, although a number of them remained intact and passed into major museums, such as Jean Baptiste Carrand's which was bequeathed by his son, Louis, to the Bargello in Florence in 1888 (although the Carrands were Frenchmen and had kept the collection in Lyon and Paris for many years). Maskell's collection ended up in the British Museum, and Mayer's marvellous collection (consisting largely of the collection formed by Baron Fejérváry, which was bought *en bloc* by Count Pulszky) is now in the Liverpool Museum.[19] The Meyrick collection, consisting of over 70 medieval ivories, was lent to the South Kensington Museum (now the Victoria and Albert Museum) in the 1870s, but was later split up, and much of the Soltykoff Collection was bought by Frederic Spitzer.[20]

During the late 1850s and the 1860s substantial amounts of medieval and Renaissance sculpture and painting, of a large and small scale, became available from Italy as a result of the war of independence, and the subsequent suppression of religious orders and secularisation of convents. The Victoria and Albert Museum, with the indefatigable John Charles Robinson buying for it until 1867, succeeded in building up an incomparable collection of Italian Gothic and Renaissance sculpture in the space of 15 years, and there are indications that John Webb, a dealer-collector in London at this time, who supplied the Victoria and Albert Museum with the vast majority of its medieval ivories, also took advantage of the situation in Italy.[21] Although the Victoria and Albert Museum is perhaps an extreme case, being extraordinarily successful

with acquisitions between 1854 and 1870, the market was full of great works of art and many of the most important collections were formed at this time.

Not surprisingly, concurrent with this growth of interest in the art of the Middle Ages and the dramatic increase in collections of medieval objects was the development of a market in clever fakes and forgeries supplying the unwary with spurious products when the supply of genuine objects did not meet demand. Ironically, one of the reasons why fakers could produce such good copies was that they now had good illustrative source material and many of the earlier nineteenth-century fakes were clearly derived from engravings and other illustrations.[22] It is also highly likely that the casts supplied by the Arundel Society were used to produce copies in ivory: the casts were often taken from little-known ivories and copies of them could be circulated on the art market before the original was sufficiently well-known to alert suspicion.[23] There were also a number of highly-skilled craftsmen who had been employed as restorers in cathedral treasuries, such as Reinhold Vasters at Aachen (who perhaps worked for Spitzer in Paris), who because of their close connections with the medieval objects they worked on, often had a deep understanding of medieval style and iconography: these fakes and restorations are still often difficult to identify.[24]

The second half of the nineteenth century was a period of steady consolidation in the study and collecting of medieval works of art. The major museums gradually built up their collections by purchases and bequest and most of the national European public collections had acquired a large proportion of their present medieval holdings by 1900. Undoubtedly the largest and most impressive private collection at this time was the Spitzer Collection in Paris, which was sold in 1893, requiring two large volumes of text and plates to describe and illustrate all 3369 works of art.[25] Frederic Spitzer was a dealer-collector, a *marchand-amateur*, who is now perhaps unfairly remembered almost as much for his 'improvement' of objects by restoration as for his stupendous collection.[26] Another very important private collection in Europe at this time was the Basilewsky Collection, also formed in Paris by its owner: the entire collection was bought by the Hermitage in 1884 and passed into the Russian collection in the following year.[27] Not all of it is still in Leningrad, as in the early 1930s the Soviet authorities decided to sell a number of western medieval pieces which have since passed to collections in the West: one of these, a beautiful Limoges enamel eucharistic dove of the early thirteenth century, is now in the Thyssen-Bornemisza Collection (no. 30).[28]

There can be no doubt that at the end of the nineteenth and the beginning of the twentieth century France (and Paris in particular) was the centre of the trade in medieval works of art, and that the most important private collections were to be found there. In the first ten years of the present century alone the magazine *Les Arts* contained major illustrated feature articles on no less than eleven important collections: the Martin Le Roy and Dutuit Collections in 1902,[29] the Arconati-Visconti Collection in 1903,[30] the Homberg Collection in 1904,[31] the Chalandon Collection in 1905,[32] in 1906 the Garnier, Maignan and Côte Collections,[33] the Mège and Piet-Latandrie Collections in 1909,[34] and the Cottreau Collection in 1910.[35]

But by the beginning of the twentieth century a new factor was starting to affect the market – the American collector of medieval works of art. Walter Cahn and Linda Seidel have shown how the interest in medieval architecture – and more specifically Romanesque architectural forms – had spread from contemporary American architects at the end of the nineteenth century to those with sufficient means to collect original specimens of the medieval mason's craft.[36] The first collector in America to collect medieval sculpture in a serious manner was

2 The Court, Isabella Stewart
Gardner Museum, Boston

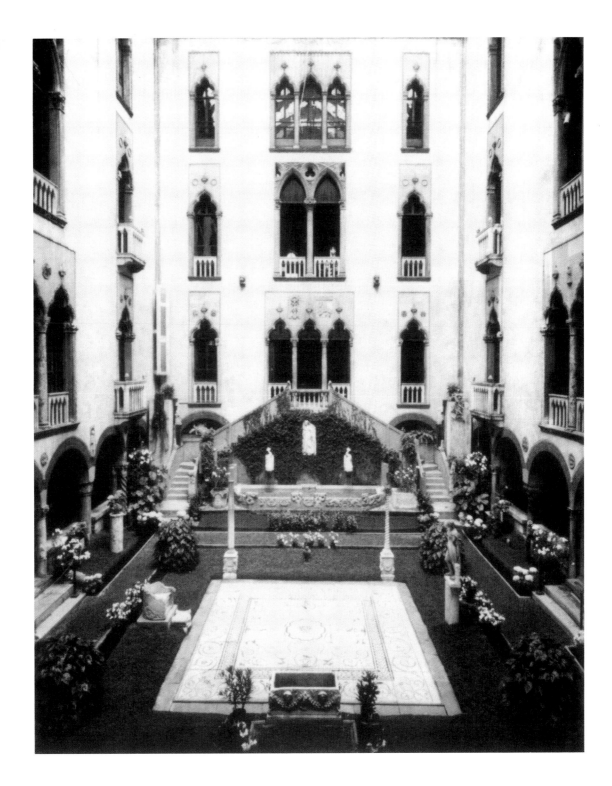

Isabella Stewart Gardner, who in the late 1890s made a number of trips to Venice and Northern
Italy to purchase architectural sculpture; this was set into the walls of Fenway Court, her
residence in Boston (fig. 2), rather as the sculpted reliefs and roundels were applied to the walls
of Venetian *palazzi*.[37] In this way her collecting has more to do with the taste of Stukeley and
Walpole than with those collectors who studiously concentrated on the Middle Ages. This
purchasing of large-scale, often architectural, pieces of sculpture became something particularly
associated with American collectors in the early years of the present century. This was un-

doubtedly due to the distance between America and the cloisters and cathedrals of Europe, which prompted the reconstruction of a number of derelict cloisters from Europe in American settings in an attempt to fill the *lacuna*. The most famous of these is the Metropolitan Museum of Art's branch museum of medieval art at Fort Tryon Park in New York, simply known as 'The Cloisters', the nucleus of which was acquired by the sculptor George Gray Barnard between 1903 and 1925.[38] Other notable ensembles are at Toledo and Philadelphia, and the hugely successful business magnate William Randolph Hearst energetically bought large amounts of this kind of material to furnish his castle-like residences at San Simeon and elsewhere.[39] John Pitcairn and, after his death in 1916, his son Raymond likewise purchased medieval sculpture and stained glass in Europe for their church and scholastic institution at Bryn Athyn, Pennsylvania.[40] This was done not solely to form a collection but to encourage the workmen engaged on the building to emulate the working methods of the medieval mason and craftsman; nevertheless, Raymond Pitcairn did build up a substantial collection of smaller-scale works of art, including ivory carvings, enamels, bronzes and manuscripts, which are still housed at Bryn Athyn.[41] However, the two collectors who stood head and shoulders above all others in the early years of the twentieth century in America (and indeed anywhere else) were J. Pierpont Morgan and Henry Walters, whose collections now form such important parts of the Pierpont Morgan Library, the Metropolitan Museum of Art and the Walters Art Gallery in Baltimore.

J. Pierpont Morgan (1837–1913), born into an already immensely wealthy family, became interested in art collecting while still a youth; it is recorded that when he was at school in Europe, at Vevey in Switzerland, and later at university in Göttingen, between 1854 and 1857, he had founded his art collection with bits of stained glass from the shattered windows of old churches.[42] By the time of his death in 1913 he enjoyed an awesome reputation as a voracious collector of medieval works of art and manuscripts, and on a number of occasions he bought important European collections *en bloc* at enormous prices. This inevitably led to a certain number of inferior pieces creeping into his collection with the good, but with his vast financial resources such small sacrifices were not a real hardship. Henry Walters (1848–1931) also had the benefit of a considerable fortune behind him, based on a shipping and railway empire, and like Pierpont Morgan was in a position to challenge even the wealthiest museums for works of major importance. Although he occasionally bought collections *en bloc* in the same way as Morgan, Walters preferred to build up his collection with carefully considered individual purchases.[43] His father William T. Walters had already established the Walters Collection as a prominent gallery of paintings and nineteenth-century art, but Henry concentrated on Early Christian, Byzantine and medieval works of art and manuscripts perhaps above all else and built his collection into one of the greatest holdings of this material in a remarkably short period of time. Both Morgan and Walters had the good fortune to have their enormous resources available at the same time as great European collections became available for purchase; by being in the right place at the right time they ensured that medieval art was well-represented in America. Their perceptiveness and generosity in making these collections freely available to the public has since encouraged in-depth research into the art of the Middle Ages and has produced a continuous stream of scholar-curators capable of carrying on their energetic collecting, albeit within a somewhat different framework.

In Europe after World War I the in-depth scholarship of German experts, especially in Berlin, opened up previously obscure areas to a wider public and refined the groupings of earlier scholars in the better known areas such as ivory carvings and metalwork. Adolph Goldschmidt's

magisterial *corpus* of early medieval ivory carvings, presented in four volumes between 1914 and 1926, gave a new precision to the dating of these works of art and supplied the collector with a firm foundation upon which to judge potential acquisitions; two further volumes, on Byzantine ivories, were written with Kurt Weitzmann in 1930–34.[44] Raymond Koechlin's three-volume study of French Gothic ivory carvings, published in 1924, and Margaret Longhurst's book on English ivories (1926) likewise allowed the collector to build up a comprehensive knowledge of the subject.[45] In the field of medieval metalwork there was the immensely authoritative *corpus* of Romanesque candlesticks and Gothic vessels by Otto von Falke and Erich Meyer, published in Berlin in 1935.[46] It should also be noted that the inclusion of privately-owned pieces in these catalogues invariably increased the value of the objects and brought them to the attention of other collectors and museum curators. Side by side with these *corpora*, and in many cases inspired by them, there were produced numerous museum catalogues of medieval objects, sculpture especially: the Berlin catalogues of sculpture between the wars were revised at regular intervals and continue to be particularly useful.

With this plethora of scholarly apparatus at his disposal the collector could now stand on the same footing as the museum or university specialist, who had previously had the advantage of photographic archives and international contacts. A new breed of collector was born – very well informed and in constant communication with specialists in the subject. Such a figure was Walter Leo Hildburgh, the major donor of medieval works of art to the Victoria and Albert Museum from the 1920s until his death in 1955.[47] Hildburgh was especially interested in English medieval alabaster carvings, of which he built up the largest collection in the world: these he donated to the Victoria and Albert Museum in 1946.[48] Hildburgh used his collection as a springboard into the academic world, reading numerous papers to the Society of Antiquaries in London, most of which were published, over many years, and writing articles in a wide range of scholarly journals. He was recognised as the expert in the field – taking over from another famous collector-scholar, Dr Philip Nelson, whose collection of alabasters Hildburgh purchased *en bloc* in 1926 – and he did more than anyone else to further knowledge in this branch of art history. He will also be remembered for his important – although controversial – book on Spanish medieval enamels.[49] The other major collector of medieval art in Britain between the wars – Sir William Burrell – was not so single-minded as Hildburgh, nor did he have his scholarly frame of mind; nevertheless, he assembled a remarkably catholic collection, which is now open to the public in Glasgow.[50]

Since World War II a small number of private collections of medieval works of art have gained semi-legendary status. The first, that of Robert von Hirsch, was built up with the assistance of von Hirsch's scholar friends – men like Georg and Hanns Swarzenski – so that when von Hirsch died in Basel in 1977 his collection included a number of objects of the utmost importance for the history of medieval art:[51] outstanding amongst the works of art were the *Armilla* of Frederick I Barbarossa and the enamel roundel from the St Remaclus shrine. At the sale of the von Hirsch collection in London in 1978 the public imagination was captured and the prices realised were unprecedented, setting a new level for the art of the Middle Ages. The German government was a determined bidder and was largely successful in its attempted purchases: the *Armilla* went to the Germanisches Nationalmuseum in Nuremberg, the enamelled roundel to the Kunstgewerbemuseum in Berlin and a number of other pieces also returned to Germany. One of the most enigmatic pieces, a kneeling *Virgin Annunciate*, is now in the Thyssen-Bornemisza Collection (no. 18).

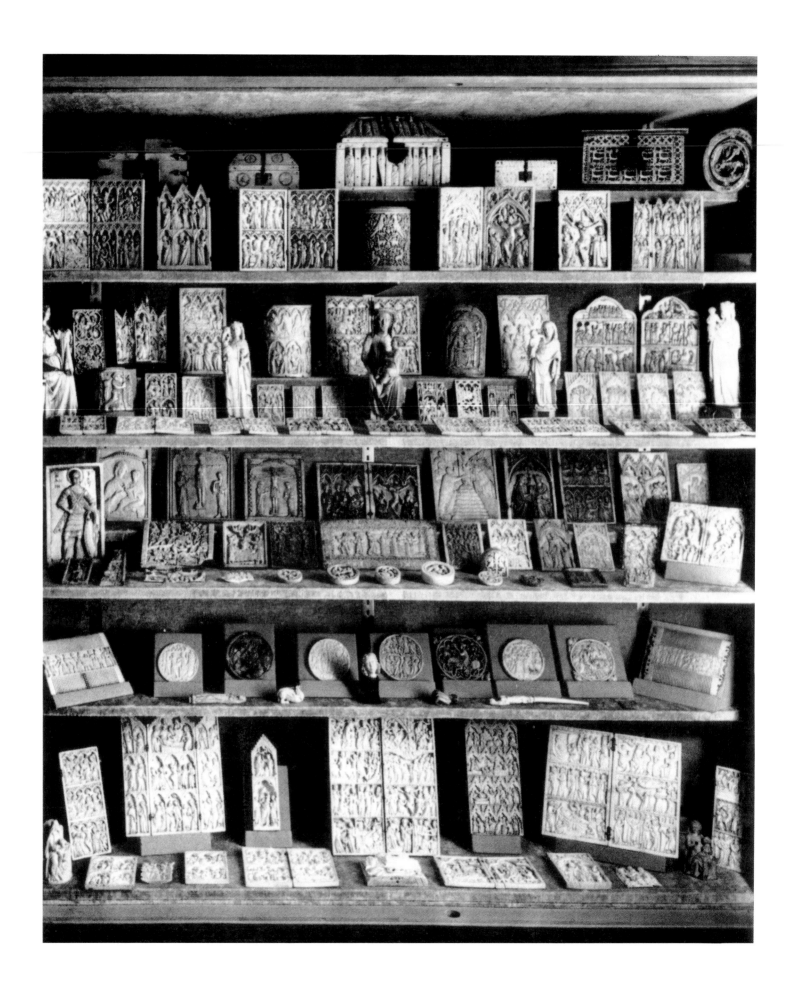

3 A case containing the majority of the medieval ivories in the Kofler-Truniger Collection in Lucerne. A number of pieces are now in the Thyssen-Bornemisza Collection: on the bottom shelf, at the left, is no. 23 (triptych); on the third shelf, at the left, is no. 20 (Virgin and Child relief), and at the centre, no. 21 (Baptism relief); on the fourth shelf, at the far left, is no. 22 (Virgin and Child)

4 An *armoire* containing some of the treasures collected by Abbot Suger at Saint-Denis, as arranged at the beginning of the eighteenth century, from Dom Michel Félibien's *Histoire de l'abbaye de Saint-Denis en France* (Paris, 1706), pl.1

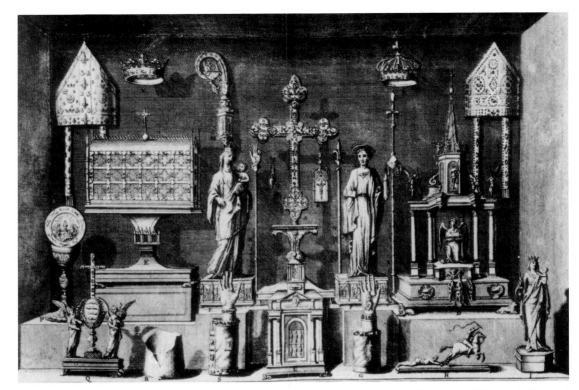

The collection of Ernst and Martha Kofler-Truniger of Lucerne was larger and better balanced than von Hirsch's, but it would be fair to say that it did not include so many undoubted masterpieces of the medieval craftsman's art.[52] It was especially strong in medieval ivories and Limoges enamels (fig. 3), and although the ivories have since been split up into many different collections – there are five pieces in the Thyssen-Bornemisza Collection – the enamels have been kept together and now form the nucleus of the so-called Keir Collection.[53]

The third collection of special note was that assembled by John and Gertrude Hunt. John Hunt built up a superb collection of medieval works of art while a dealer in London and Dublin; in this time he established a considerable reputation not only as a result of his sales to museums and private collectors but also as a connoisseur and scholar of high standing. When he died in 1975 the collection was the equal of those in many major museums; since then some of the most important pieces have been sold, but it still contains many objects of great interest and is especially rich in small bronzes and ivories. Unfortunately a catalogue of the collection was never published.

The medieval works of art owned by Baron Hans Heinrich Thyssen-Bornemisza fit naturally amongst the famous collections previously discussed. Although they may be seen as an ensemble in their own right, at the same time they form part of a larger art collection which is generally accepted as the richest private collection in existence, excluding that of H.M. The Queen. The present Baron is well known as an energetic buyer of modern paintings, but he has also transformed the earliest part of the collection: although the larger medieval sculptures were bought by his father, he has greatly increased the display of smaller-scale objects and virtually all the ivories were purchased by him. It thus stands as a remarkable private collection of medieval art at the end of a long tradition reaching back to the beginning of the eighteenth century. But ultimately the practice of accumulating medieval objects of great beauty is one that has its root in the great Church treasuries, such as that initiated by Abbot Suger at Saint-Denis in the twelfth century (fig. 4).[54] Just as these ancient repositories preserved older works of

art, which often influenced the style and even the form of later objects, so the more recent collections of medieval works of art played a vital part in the revival of interest in the arts of the Middle Ages, encouraging a connoisseurship and scholarship of the 'object-orientated' type so vital to the well-being of the art-historical discipline.

NOTES

1 C. Wainwright: 'The Romantic Interior in England', *National Art-Collections Fund Review* (1985), 82. Stukeley's account is to be found in Ms.Eng.Misc.C.538 (f. 45), Bodleian Library, Oxford. I am most grateful to Clive Wainwright for discussing eighteenth-century collecting with me and for giving me a number of references to publications

2 For Stukeley's *châsse*, see S. Caudron: 'Connoisseurs of *champlevé* Limoges enamels in eighteenth-century England', *The British Museum Yearbook*, II (1977), 9–33; for that of Walpole (now in the Burrell Collection, Glasgow), see *Horace Walpole and Strawberry Hill* (Twickenham, 1980), cat. no. 30, ill. p. 68 [exhibition catalogue: Orleans House Gallery]

3 Wainwright, *op. cit.*, 82; *Horace Walpole and Strawberry Hill*, cat. no. 30; see also J. Lafond: 'The traffic in old stained glass from abroad during the 18th and 19th centuries in England', *Journal of the British Society of Master Glass Painters*, XIV/I (1964), 58–67

4 J. Nichols: *Literary Anecdotes of the Eighteenth Century . . .* (London, 1812–15), VIII, 509

5 *The Family Memoirs of the Rev. William Stukeley and the Antiquarian and other correspondence of William Stukeley, Roger and Samuel Gale* (Durham and London, 1883), II, 43 [Publications of the Surtees Society, LXXVI]

6 Caudron, *op. cit.*, 10–19; see also M.-M. Gauthier's introduction to M.-M. Gauthier and G. François: *Medieval Enamels: Masterpieces from the Keir Collection* (London, 1981), 7–8

7 Wainwright, *op. cit.*, 83–5

8 F.H. Taylor: *The Taste of Angels: A History of Art Collecting from Rameses to Napoleon* (Boston, MA, 1948), 565–8. The important contribution made by Montfaucon in recording medieval monuments prior to the Revolution should not be underestimated – B. de Montfaucon: *L'Antiquité expliquée et représentée en figures*, 15 vols (Paris, 1719–24), and *Les monumens de la monarchie françoise qui comprennent l'histoire de France avec les figures de chaque règne que l'injure des tems a épargnées*, 5 vols (Paris, 1729–39)

9 Gauthier and François, *op. cit.*, 8

10 J. B. L. G. Seroux d'Agincourt: *Histoire de l'art par les monuments, depuis sa decadence au IVe siècle jusqu'a son renouvellement au XVIe*, 6 vols (Paris, 1811–23)

11 A. Du Sommerard: *Les Arts au Moyen Age*, 6 vols (Paris, 1838–46)

12 *Art Journal* (Jan 1869), 26

13 R. Cooper: 'The popularization of Renaissance art in Victorian England: the Arundel Society', *Art History*, I/3 (1978), 263–92, esp. 264–7

14 Foreword in M. Digby Wyatt and E. Oldfield: *Notices of Sculpture in Ivory* (London, 1856) [Arundel Society]

15 J. O. Westwood: *A Descriptive Catalogue of the Fictile Ivories in the South Kensington Museum* (London, 1876), ix

16 Cooper, *op. cit.*, 275

17 M. Digby Wyatt and J.B. Waring: *The Mediaeval Court in the Crystal Palace* (London, 1854); idem: *The Byzantine and Romanesque Court in the Crystal Palace* (London, 1854)

18 Cooper, *op. cit.*, 264. For Gambier Parry, see also *Burlington Magazine*, CIX/768 (Mar 1967). [Special number devoted entirely to his collection, which is now in the possession of the Courtauld Institute Galleries, University of London]

19 Gerspach: 'La Collection Carrand au Musée National de Florence', *Les Arts*, XXXII (Aug 1904), 18–32; O. M. Dalton: *Catalogue of the Ivory Carvings of the Christian era . . . of the British Museum* (London, 1909),

xvii–xviii; for the Mayer Collection, see W. Maskell: *A Description of the Ivories Ancient and Mediaeval in the South Kensington Museum* (London, 1872), 165–75

20 For the Meyrick Collection, see Maskell, *op. cit.*, 175–82; the majority of the Soltykoff Collection was sold at the Hôtel Drouot, Paris, in April–May 1861

21 For Robinson's collecting, see J. Pope-Hennessy: *Catalogue of Italian Sculpture in the Victoria and Albert Museum* (London, 1964), I, vii–xi

22 This is most obvious when the faker has misunderstood his model, not having seen the original: see, for instance, the copy in bone of the tenth-century Gotfredus *situla* in Milan, which has been carved as a plaque, betraying its graphic source (E. Maclagan: 'Ivoires faux fabriqués à Milan', *Arethuse*, I (Oct 1923), 1–3, pl. v/4)

23 See the numerous copies of an ivory relief in the Fürstlich Oettingen-Wallerstein'sche Kunstsammlung in Harburg über Donauwörth, casts of which were in Munich, Oxford, London and elsewhere at an early date; see M. H. Longhurst: *Catalogue of Carvings in Ivory, Victoria and Albert Museum*, II (London, 1929), 126–7, and O. Pelka: *Elfenbein* (Berlin, 1923), 378, fig. 293

24 For Vasters, see C. Truman: 'Reinhold Vasters – "the last of the goldsmiths"?', *Connoisseur*, cc (1979), 154–61

25 *Catalogue des Objets d'Art et de Haut Curiosité Antique, du Moyen Age, et de Renaissance composant l'importante et précieuse Collection Spitzer*, Paris, 17 April–16 June 1893 [sale catalogue]; of course not all the objects were medieval

26 See no. 31

27 A. Darcel and A. Basilewsky: *Catalogue raisonné de la collection Basilewsky, précédé d'un essai sur les arts industriels du Ier au XVIe siècle* (Paris, 1874); A. Bank: *Byzantine Art in the Collections of Soviet Museums* (New York and Leningrad, 1978), 7

28 The most important medieval work of art from the Basilewsky Collection to leave the Hermitage was the so-called Basilewsky *Situla*, bought by the Victoria and Albert Museum in 1933: see J. Beckwith: *The Basilewsky Situla* (London, 1963)

29 *Les Arts*, X (1902), 2–34 (Martin Le Roy); XI (1902), 2–46 (Dutuit)

30 *Ibid.*, XIX (1903), 17–32; XX (1903), 2–14

31 *Ibid.*, XXXII (1904), 33–48

32 *Ibid.*, XLII (1905), 17–29

33 *Ibid.*, LIII (1906), 13–24 (Garnier); LIX (1906), 3–16 (Maignan); LIX (1906), 28–32, and LXIII (1906), 30–32 (Côte)

34 *Ibid.*, LXXXVI (1909), 2–19 (Mège); XCII (1909), 2–32 (Piet-Latandrie)

35 *Ibid.*, C (1910), 2–31

36 W. Cahn and L. Seidel: *Romanesque Sculpture in American Collections. Volume I: New England Museums* (New York, 1979), 1–6

37 *Ibid.*, 6–7

38 *Ibid.*, 12. See also J. J. Rorimer: *The Cloisters: The Building and the Collection of Mediaeval Art* (New York, 1938)

39 Cahn and Seidel, *op. cit.*, 13

40 *Ibid.*, 13; see also Jane Hayward's introduction to *Radiance and Reflection: Medieval Art from the Raymond Pitcairn Collection* (New York, 1982), 33–45 [exhibition catalogue: Metropolitan Museum of Art]

41 P. Williamson: 'The Raymond Pitcairn Collection at the Cloisters', *Burlington Magazine*, CXXIV (1982), 472; a selection of these small-scale works of art were illustrated in *Medieval Art from Private Collections* (New York, 1968) [exhibition catalogue: The Cloisters, Metropolitan Museum of Art]

42 F. B. Adams, Jr.: *An Introduction to the Pierpont Morgan Library* (New York, 1964), 6; see also F. L. Allen: *The Great Pierpont Morgan* (New York, 1949), and F. H. Taylor: *Pierpont Morgan as Collector and Patron* (New York, 1957)

43 See 'Connoisseur's Haven', *Apollo*, LXXXIV (1966), 422–33

44 A. Goldschmidt: *Die Elfenbeinskulpturen aus der Zeit der karolingischen und sächsischen Kaiser, und der romanischen Zeit*, 4 vols (Berlin, 1914–26, repr. 1969–75); A. Goldschmidt and K. Weitzmann: *Die byzantinischen Elfenbeinskulpturen des X. – XIII. Jahrhunderts*, 2 vols (Berlin, 1930–34, repr. 1979)

45 R. Koechlin: *Les Ivoires Gothiques Français*, 3 vols (Paris, 1924, repr. 1968); M.H. Longhurst: *English Ivories* (London, 1926)

46 O. von Falke and E. Meyer: *Romanische Leuchter und Gefässe, Giessgefässe der Gotik* (Berlin, 1935, repr. 1983) [Bronzegeräte des Mittelalters, I]

47 See Hildburgh's obituaries in *The Times*, 28 November 1955, and *Burlington Magazine*, XCVIII (1956), 56

48 See F. Cheetham: *English Medieval Alabasters. With a catalogue of the collection in the Victoria and Albert Museum* (Oxford, 1984), 66

49 W. L. Hildburgh: *Medieval Spanish Enamels* (London, 1936)

50 See R. Marks *et al.*: *The Burrell Collection* (London and Glasgow, 1983). The Wernher Collection, largely formed by Sir Julius Wernher in the late nineteenth century, was also particularly strong in medieval ivories; some of the best pieces are now in the British Museum but the remainder are still displayed at Luton Hoo, Bedfordshire: *The Wernher Collection* (Luton Hoo, 1950)

51 *The Robert von Hirsch Collection*, II, *Works of Art*, London (Sotheby's), 22 June 1978 [sale catalogue]

52 Schnitzler *et al.* (1964); idem (1965)

53 Gauthier and François, *op. cit.*

54 *Abbot Suger on the Abbey Church of St. Denis and its Art Treasures*, ed., trans. and annotated by E. Panofsky (Princeton, NJ, 2/1979, ed. Gerda Panofsky-Soergel); also the introduction to P. Williamson, ed.: *The Medieval Treasury: The Art of the Middle Ages in the Victoria and Albert Museum* (London, 1986), 5–14

2 Materials and techniques of the medieval artist

There is a common fallacy, still widely adhered to, that has the medieval artist as an obscure, anonymous figure, selflessly toiling away on works of art for the greater glory of God, preferably in a monastery. But after the eleventh century the medieval artist was in truth no more anonymous than his Renaissance counterpart: we simply happen to know more about the latter because of the advent of biography and autobiography. In fact, hundreds of names of sculptors, craftsmen, painters and architects are known to us before 1400 – through inscriptions, signatures and documentary sources[1] – and there is a reasonable body of technical literature from the medieval period. The most famous is probably the treatise *De diversis artibus*, written by Theophilus (a pseudonym for a Benedictine monk, perhaps to be identified as the goldsmith Roger of Helmarshausen) in the first half of the twelfth century, which gives technical guidance on painting and the preparation for it, stained-glass working, and metalworking.[2] There are even copious contemporary illustrations of the medieval artist at work, showing him carving and painting statues, illuminating manuscripts and so on.[3] However, because the surviving works of art – especially the sculptures – are often quite different in appearance from their original form it sometimes takes a certain amount of imagination to reconstruct the artist's intentions. Consequently it is worthwhile to know something of the working practices followed by medieval artists and their approach to different materials. The following is a very brief discussion of the methods employed by the artist when working in the materials in which most of the medieval objects in the Thyssen-Bornemisza Collection are made; for ease of use the materials have been divided into the same categories employed in the catalogue section: stone and marble, wood, ivory and enamel.

Stone and marble

This is not the place to give a detailed account of the medieval sculptor, and it would not be worth attempting to do justice to the subject in anything less than a full study. Generalisations covering such a wide date bracket are doomed to be full of errors if analysed in depth, but nevertheless it is possible to touch upon the most significant points pertaining to the working of stone and marble in the Middle Ages. To start with, it is doubtful whether the 'sculptor', as we know him today – that is someone working exclusively in three dimensions – existed in the medieval period. From the twelfth century through to the sixteenth there seems to have been an interchangeability between stone cutters, stone masons and image carvers, and in contemporary documents it is not always possible to be sure exactly what a craftsmen was being paid for by the description applied to him.[4] There were clearly hierarchies and in many instances the payments made to the different types of 'stone cutters' vary considerably.[5] However, much work remains to be done on the organisation of the medieval mason's workshop and the overall picture is far from clear until about 1400.

The method of working stone also varied over the centuries. In the earliest representations of sculptors at work, such as the stained-glass images of about 1225 at Chartres, the statues of kings (perhaps jamb figures for the transept portals) are shown propped-up at an angle: the sculptor at the left is using his chisel alone, pushing it forward to work fine detail delicately,

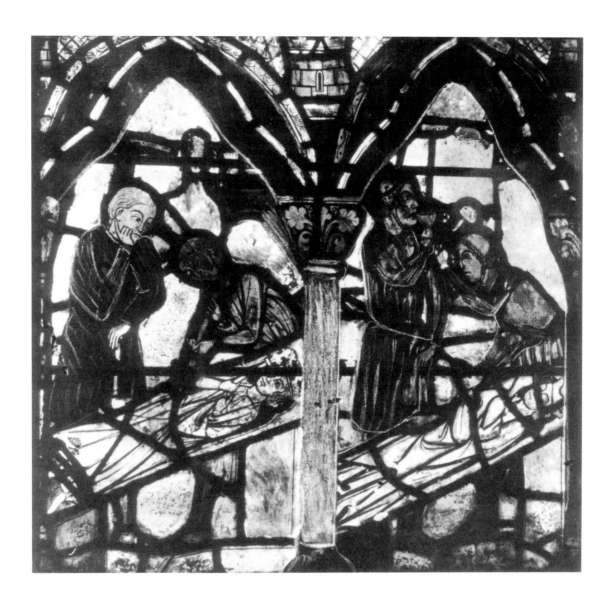

5 Sculptors carving statues for Chartres Cathedral; detail of north apse window, Cathedral of Notre-Dame, Chartres; *c.* 1225

while the sculptor at the right is using both a chisel and hammer (fig. 5). Obviously at this date and later large statues such as these were carved before being put into position on the outside of churches.[6] Unfortunately there are no medieval manuals of stone-carving to give a clear idea of how the mason was trained, but it is likely that the block of stone would have been marked with the outline of the figure to be carved from it and that the sculptor would have worked straight onto the block without the benefit of a sketch model, as became the norm at a later date. The different marks left on the surface of medieval sculptures testify to a wide range of mason's tools – many different types of chisels, files and drills.[7]

Nearly all medieval sculptures differ radically today from their original appearance as a result of the loss of their polychromy. The majority of stone sculptures have been stripped of their painted decoration and because of this the modern observer can gain only a limited impression of how they must have looked. Recent research by conservation staff in museums has allowed a deeper understanding of the types of paints used and the ground on which they were applied, but the results gleaned are often arrived at from analysis of microscopic remains of pigmentation hidden deep in the folds of drapery, and the reconstruction of original colour schemes is often hazardous. To gain an impression of how a completely painted Gothic portal

6 Main portal (detail),
S Maria, Laguardia

must have looked at its completion it is necessary to travel to northwestern Spain, to the church of S Maria in the small town of Laguardia, where there is a doorway covered by a porch, which although probably restored, retains a complete covering of paint (fig. 6): the faces are each naturalistically painted and the draperies are covered with extraordinarily delicate textile designs. In an earlier Spanish manuscript, of the second half of the thirteenth century, there is a fascinating illustration actually showing a painter at work on a statue of the seated Virgin and Child on the outside of a church; at the left a young apprentice grinds the colours on a slab (fig. 7).

Attesting to the importance attached to the painting of statues in the Middle Ages are the salaries paid to the painters and the masons: there are many contemporary documents from the medieval period in England recording that the painters of the sculpted images received almost as much as the sculptor.[8] Although the sums mentioned may have included the cost of paints and gold leaf for gilding, there can be no doubt that the painted decoration was considered to be an essential component of the finished statue.

It is also clear that the popularity of polychromy in many cases affected the choice of stone used. In England, for instance, in the thirteenth century Purbeck marble was a popular, if expensive, material for carving tomb effigies. But by the end of the century there was such a demand for extravagant surface decoration, created by laying down a gesso ground, moulding or stamping it while wet and then painting it in bright colours, that it ceased to matter which kind of stone lay underneath the decoration: consequently cheaper freestones and even wood

7 An artist painting a statue;
Las Cantigas of Alfonso X
(Escorial, Biblioteca Real, MS
T.I.I., detail of f. 192*r*); second
half of thirteenth century

were used instead of the more difficult to carve and more expensive Purbeck marble.[9] Marble and alabaster figures and reliefs were sometimes left unpainted before 1500 in the North, as the natural colour of the material appealed more than the rougher-grained stones. Many of the English alabaster panels produced predominantly in the fifteenth century had details picked out in colour, while the cream-coloured stone was left plain as a background (see no. 8). In central and southern Italy marble decorative sculpture and church furniture were highlighted with coloured glass or paste in many instances (no. 4).

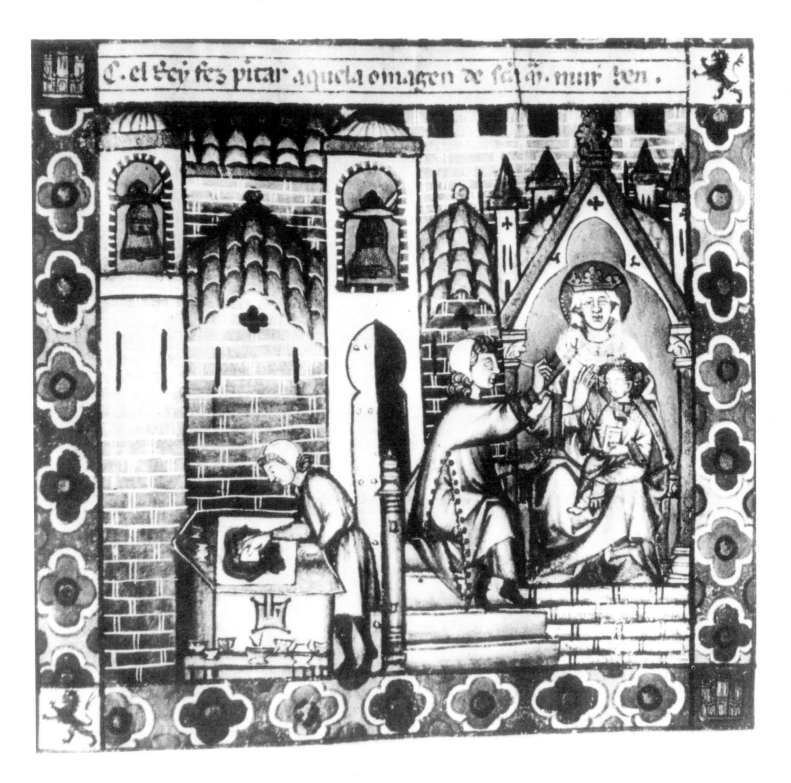

Wood

A wide range of woods was used for carving figures throughout the Middle Ages. Oak and walnut were used in France and the Netherlands (the former also in England and Scandinavia), limewood was used in South Germany, and pine and poplar were employed in Spain and Italy. All these woods had different properties, varying greatly in density and weight, so that in some areas – for instance in southern Germany in the fifteenth and sixteenth centuries – sculptors were able to gain sculptural effects beyond the capabilities of artists elsewhere working in other types of wood.[10] Although wood was easier to carve than stone, the material brought with it a different set of problems for the sculptor; the most important of these was the possibility of the wood cracking and splitting after carving, as a result of shrinking caused by water loss. This could be largely overcome by removing all superfluous uncarved wood from the figure, especially the heartwood at the centre of the log; the vast majority of larger medieval wood sculptures have been reduced in this way (fig. 8).[11]

Even more than stone sculpture of the same period, medieval wood sculpture was intended to be painted and sometimes embellished with surface encrustations, such as paste and glass gems. As opposed to stone sculptures, many statues in wood do retain their original polychrome decoration, and even more probably have their original paint concealed by later layers. The intention was clearly to make the sculptures as life-like as possible, as is evidenced by the appearance of the many figures of the Crucified Christ in the twelfth and thirteenth centuries in Italy and elsewhere (no. 13). Every effort was made to disguise the surface of the wood, covering the joints, knots and nails with linen or canvas and then laying the gesso on top so that the painted surface would be as smooth as possible.[12]

Ivory

In the Gothic period, from when most of the ivory carvings in the Thyssen-Bornemisza Collection come, elephant ivory was in good supply and the great majority of the pieces made then were crafted from that material. Other types of 'ivory' were also used at different periods in different places: walrus ivory and whalebone were in wholesale use during the Romanesque period in northern Europe and ordinary bone was employed for carving more humble objects in the Roman period, for small reliefs on Byzantine boxes, and in a mass-produced manner in the assembly of marriage caskets and other products of the Embriachi workshop in fifteenth-century Italy.[13] It was elephant ivory which was most prized and which had the most attractive, close-grained, lustrous appearance, combining well with an enamelled or jewelled setting, but there were restrictions imposed on the carver by the material, not least being the limitations of size. Very rarely does one find an ivory statuette taller than 35 cm (c. 15 in) high: once this size is exceeded it becomes very difficult to conceal the natural curve of the tusk.[14] Likewise, when preparing plaques of ivory – which were cut from the centre of the tusk – it was necessary to avoid the central nerve channel and the pulp cavity, especially at the thicker end.[15]

In common with stone and wood sculpture, many medieval ivory carvings – though not all – were originally painted or gilded (or both) and several of the carvings in the present collection retain traces of polychromy. A well-known illumination in an English thirteenth-century Apocalypse manuscript shows a monk painting a statuette of the Virgin and Child which, although probably too big to be of ivory, again illustrates admirably the widespread use of

8 Rear view of *Virgin and Child*, Central Italian, mid-thirteenth century (no. 14)

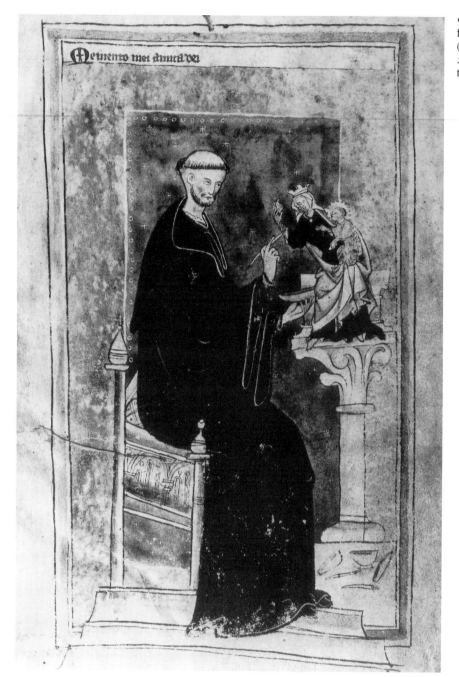

9 A monk painting a statue; frontispiece to an Apocalypse (Lambeth Palace Library, MS 209); last quarter of the thirteenth century

colour on all sorts of sculpture (fig. 9). Other methods of colouring ivory or bone were also used, such as staining (which is described by Theophilus), and a number of pre-Gothic ivories were decorated with semi-precious stones, gold leaf and gilded metal strips.[16]

Enamel

Enamel is made up of glass, flint or sand, red lead and soda or potash, which are heated together to form a clear flux; to this flux is added a metallic oxide as a colouring agent (copper for green, cobalt for blue, iron for red or brown). This is then allowed to cool into a solid slab and ground into a fine powder before use. The powder is then washed to remove any dirt and laid on the prepared metal surface, allowed to dry, and fired in an enclosed kiln at a temperature of

between 700° and 800° C. Several different firings are often needed to build up a greater thickness of enamel and a wide range of colours. The final stage, after cooling has taken place, is the polishing of the surface to remove imperfections and to add brilliance to the colours.[17]

A number of types of enamelling, involving different methods of preparing the metal surfaces, were used in the Middle Ages. Only the two most common forms, *cloisonné* and *champlevé* enamelling, are found on the medieval enamels in the Thyssen-Bornemisza Collection.[18]

Cloisonné (cell-work)

Thin strips of metal are bent to form the outline of a design and are soldered edge-on to the surface of the metal ground. The resulting cells are then filled with enamel, often restricted to one colour per cell. This method was suitable for use with a gold ground and was the form of enamelling most often used by the Byzantines.

Champlevé

The design is gouged out of the surface of the metal and enamel is poured into the resulting troughs and depressions. Different colours could be included in a single compartment, but the metal ground had to be substantially thicker than with *cloisonné* enamelling, and copper or bronze was usually employed. This technique was used by the Limoges enamellers of the twelfth and thirteenth centuries.

NOTES

1 See the excellent essays and supporting catalogue entries in *Ornamenta Ecclesiae*, I (Cologne, 1985), 117–384 [exhibition catalogue: Joseph-Haubrich-Kunsthalle]. For the names of numerous English masons (and sculptors), see J. Harvey: *English Mediaeval Architects: A Biographical Dictionary down to 1550* (Gloucester, rev. 1984)

2 The best annotated translation is C. R. Dodwell: *Theophilus: The Various Arts* (London and Edinburgh, 1961)

3 For a good selection of illustrations, see V. W. Egbert: *The Mediaeval Artist at Work* (Princeton, NJ, 1967)

4 See, for instance, the descriptions applied to the sculptor William of Ireland – *cementarius* and *imaginator* – in accounts relating to the building of the Eleanor Cross at Hardingstone in 1291–94 (Harvey, *op. cit.*, 158). For a brief discussion of this problem, see also R. Wittkower: *Sculpture: Processes and Principles* (London, 1977), 40–41

5 *Ibid.*, 40

6 *Ibid.*, 51–4; Egbert, *op. cit.*, 40–41; *La Sculpture, Méthode et Vocabulaire* (Paris, 1978), 150–53

7 For tools, see *Ornamenta Ecclesiae*, 288–9 and *La Sculpture*, 194–210, 590–621

8 L. Stone: *Sculpture in Britain: The Middle Ages* (Harmondsworth, 2/1972), 3

9 *Ibid.*, 134–5

10 M. Baxandall: *The Limewood Sculptors of Renaissance Germany* (New Haven, CT, and London, 1980), 27–48

11 F. Schweingruber: 'Botanisch-holztechnologische Bemerkungen zu den Untersuchungen mittelalterliche Skulpturen', *Zeitschrift für schweizerische Archäologie und Kunstgeschichte*, xxx (1973), 84–8

12 There is a large literature on polychromed wood sculpture, but two recent surveys provide good accounts and cite older literature – J. Taubert: *Farbige Skulpturen: Bedeutung, Fassung, Restaurierung* (Munich, 1978), and E. Vandamme: *De polychromie van gotische houtsculptuur in de Zuidelijke Nederlanden: Materialen en technieken* (Brussels, 1982)

13 See R. H. Randall, Jr. *et al.: Masterpieces of Ivory from the Walters Art Gallery* (New York, 1985), and A. Cutler: *The Craft of Ivory: Sources, Techniques, and Uses in the Mediterranean World: A.D. 200–1400* (Washington, DC, 1985)

14 For the possible effect of the material on style in the Gothic period, see P. Williamson: *An Introduction to Medieval Ivory Carvings* (London, 1982), 18–19

15 Cutler, *op. cit.*, 1–6

16 For staining and encrustation, see P. Williamson and L. Webster: 'The Decoration of Anglo-Saxon Ivory Carvings', *Early Medieval Wall Painting and Painted Sculpture in the British Isles*, ed. S. Cather and D. Park (Oxford, 1987). For the decoration of Gothic ivories, see Randall, *op. cit.*, 186–7

17 This description (and those detailing *cloisonné* and *champlevé* enamelling) relies heavily on the account given in M. Campbell: *An Introduction to Medieval Enamels* (London, 1983), 6–7. See also Theophilus's guide in C. R. Dodwell, *op. cit.*, 105–7, and P. England: 'A technical investigation of medieval enamels', in H. Swarzenski and N. Netzer: *Catalogue of Medieval Objects in the Museum of Fine Arts, Boston. Enamels & Glass*, (Boston, MA, 1986), xix–xxiv

18 For other types of enamelling employed in the medieval period, see Campbell, *op. cit.*, 6–7

Bibliographical abbreviations

Fastes du Gothique
 Les Fastes du Gothique: le siècle de Charles V (Paris, 1981) [exhibition catalogue: Grand Palais]
Feulner (1941)
 A. Feulner: *Stiftung Sammlung Schloss Rohoncz, III Teil, Plastik und Kunsthandwerk* (Lugano, 1941)
Koechlin
 R. Koechlin: *Les Ivoires Gothiques Français*, 3 vols (Paris, 1924, repr. 1968)
Munich, 1930
 Sammlung Schloss Rohoncz. Plastik und Gewerbe (Munich, 1930) [exhibition catalogue: Neue Pinakothek]
Rohoncz (1949)
 Aus dem Besitz der Stiftung Sammlung Schloss Rohoncz (Lugano, 1949) [exhibition catalogue]
Rohoncz (1952)
 Aus dem Besitz der Stiftung Sammlung Schloss Rohoncz (Lugano, 1952) [exhibition catalogue]
Rohoncz (1958)
 R. J. Heinemann: *Sammlung Schloss Rohoncz* (Lugano, 1958)
Sauerländer (1972)
 W. Sauerländer: *Gothic Sculpture in France 1140–1270* (London, 1972)
Schnitzler *et al.* (1964)
 H. Schnitzler, F. Volbach and P. Bloch: *Sammlung E. und M. Kofler-Truniger, Luzern, Band I, Skulpturen* (Lucerne, 1964)
Schnitzler *et al.* (1965)
 H. Schnitzler, P. Bloch, C. Ratton and F. Volbach: *Mittelalterliche Elfenbein- und Emailkunst aus der Sammlung E. und M. Kofler-Truniger, Luzern* (1965) [*Aachener Kunstblätter*, XXXI]

CATALOGUE

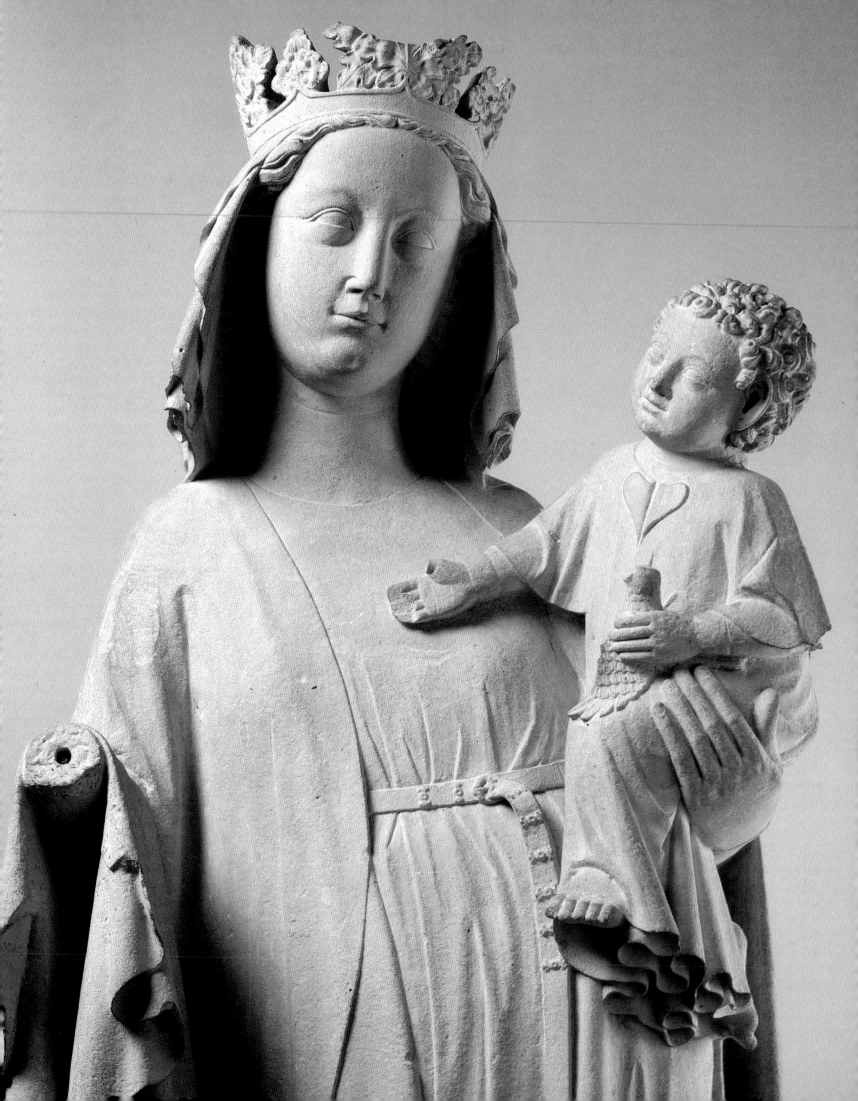

Stone and marble sculptures

1 A seated Prophet

Northern French (Oise region; Noyon?), *c.* 1180–85
Limestone

Dimensions
Height: 125 cm; width (at base): 44 cm; depth (at base): 32 cm

Provenance
Collection of Dr Lécorché, St Mards-en-Othe (Aube)
Probably bought in Paris in 1937[1]
K41A

The figure is seated on a simple bench, the ends of which are visible on both the left and right sides. In his left hand he holds a scroll which is unfurled diagonally across his lower body. With his right hand he holds his long, pendulous beard in a gesture of deep contemplation. The sculpture has been crudely stripped of the dirt (paint?) layer that once covered it, the remains of which are still visible on the beard, the hair and elsewhere on the figure. This stripping has reduced the folds of the drapery so that the surface contours are more gentle than was originally the case: it appears to have been carried out with a claw chisel, the marks of which have been left on the surface of the stone in places.[2] Apart from this drastic restoration the figure is in good condition, although it had been weathered prior to stripping: the most serious damage is the loss of the nose. The nose must have been repaired and then lost again, as there is a large dowel-hole for fixing it to the face. The back is completely flat with a large iron ring attached below the shoulders, presumably to hold the figure in its original position. There are also two large circular holes at the left and right sides, which would have held iron clamps for the same purpose. There is a label on the left side of the base with the number 8035.

In style the figure is extremely close to the smaller seated figures of patriarchs and prophets on the archivolts of the west portal of Senlis Cathedral of *c.* 1170 (fig. 1) and on the slightly later centre doorway of the west portal at Notre-Dame, Mantes.[3] As Willibald Sauerländer has pointed out, it appears that these figures were influenced by developments in metalwork in Lorraine and the Meuse region in the second half of the twelfth century, and the present figure does in fact bear comparison with the small bronze seated figure of Moses in the Ashmolean Museum, Oxford, once attributed to Nicholas of Verdun.[4]

Notes
1 Sold with a letter from M Paul Gouvert, rue Fourcroy, Paris, dated 3 November 1937, unconvincingly attributing the sculpture to the church of S Bénigne at Dijon. Gouvert gives the earlier provenance
2 See no. 7, n. 4
3 Sauerländer (1972), pls. 44–7
4 *Ibid.*, 49. The Oxford *Moses* is illustrated in H. Swarzenski: *Monuments of Romanesque Art* (London, 1954), pl. 226

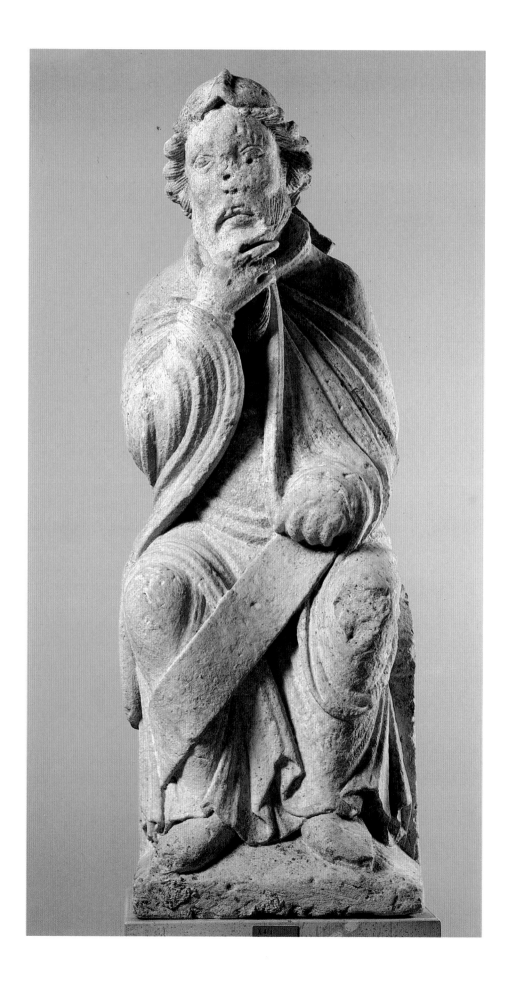

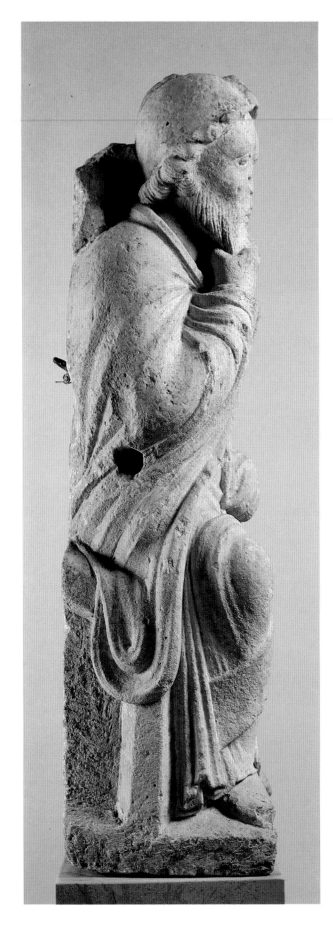
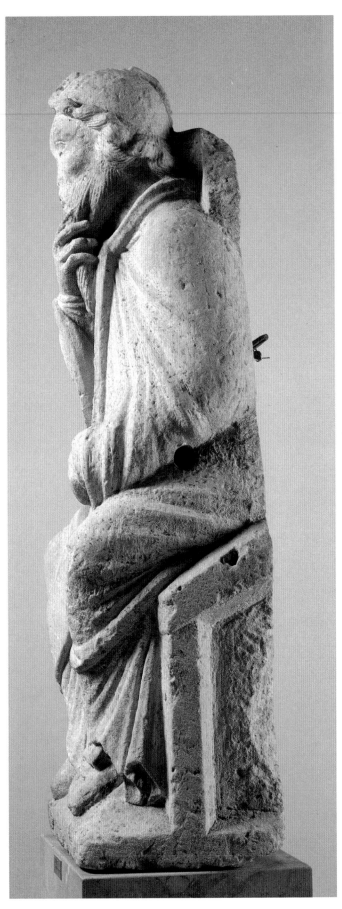

[1] *Seated Prophet*
two views

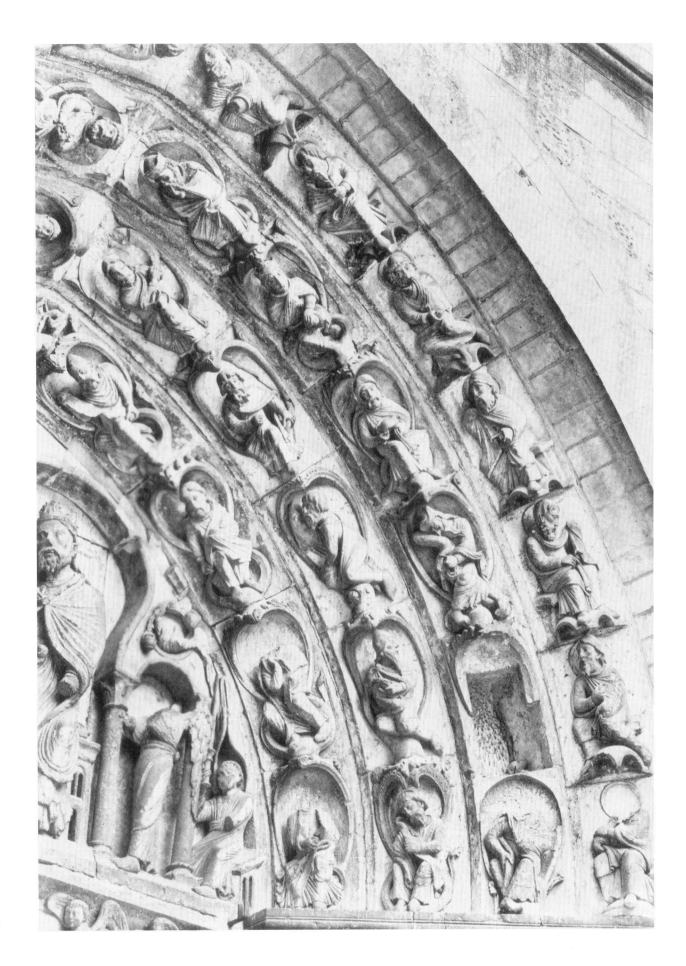

1 Detail of west portal
of Senlis Cathedral, *c.* 1170

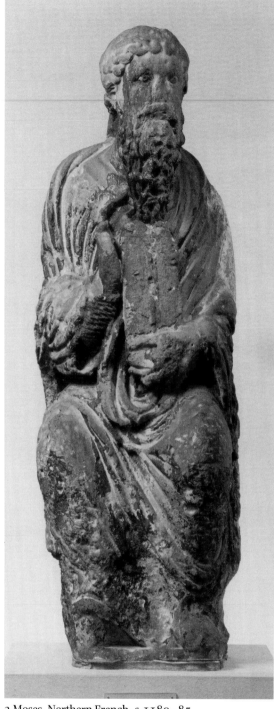
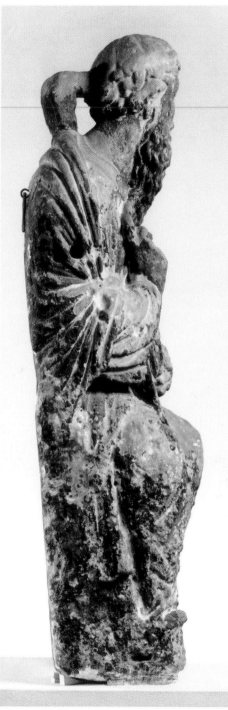
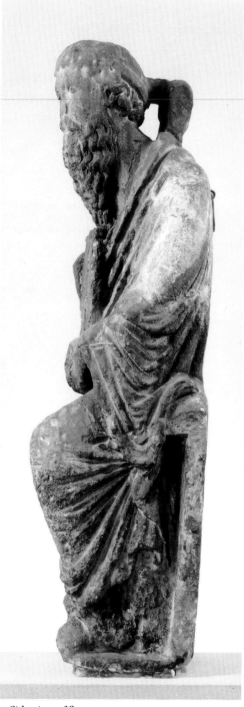

2 Moses, Northern French, c. 1180–85 3 Side view of fig. 2 4 Side view of fig. 2
(Metropolitan Museum of Art, Cloisters Collection, New York; Gift of Raymond Pitcairn, 1965)

In New York are two seated figures which undoubtedly come from the same building as the Thyssen-Bornemisza figure (figs. 2–7): one is clearly to be identified as Moses, as he holds the Tablets of the Law, while the other is probably a prophet and holds a scroll.[5] In size the figures are almost identical:

NEW YORK *Moses*	NEW YORK *Prophet*	THYSSEN *Prophet*
H 125 cm	H 128 cm	H 125 cm
W 40 cm	W 44 cm	W 44 cm
D 34 cm	D 33.5 cm	D 32 cm

Further evidence for the close relationship of the three figures is the halo of the present figure,

Notes
5 Metropolitan Museum of Art, New York, inv. no. 65.268 (Moses) and 22.60.17 (Prophet); the figure of Moses was discussed and illustrated in *Radiance and Reflection: Medieval Art from the Raymond Pitcairn Collection* (New York, 1982), cat. no. 42 [exhibition catalogue: Metropolitan Museum of Art]. The Thyssen

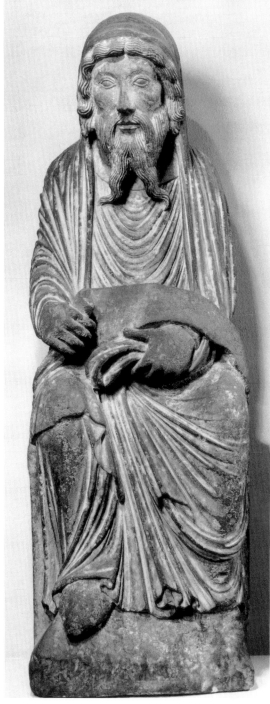

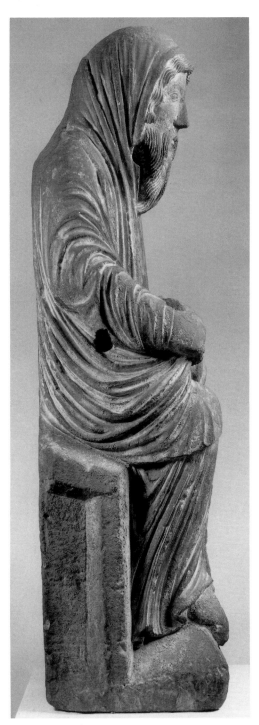

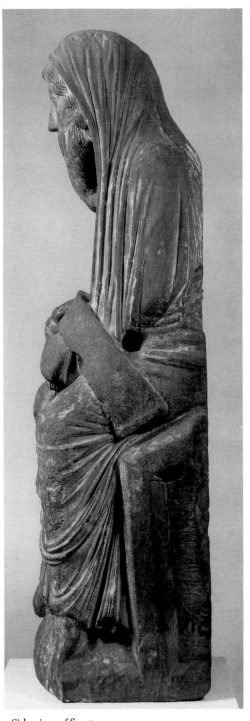

5 Prophet, Northern French, *c.* 1180–85
(Metropolitan Museum of Art, New York)

6 Side view of fig. 5

7 Side view of fig. 5

Notes

figure was not mentioned in
the catalogue entry.

6 I would like to thank Charles
Little for supplying me with
the measurements of the New
York figures and for sending
me excellent photographs;
I am also grateful to him for
discussing the figure with me,
both in Lugano and by
correspondence

now broken off at the right and left, but attached to the back of the head with a supporting bridge of stone in exactly the same way as that of the *Moses*, and the fact that both these figures were covered in exactly the same dirty residue, now mostly cleaned off the Thyssen-Bornemisza figure but largely remaining on the surface of the *Moses*. In addition, the bench upon which the New York *Prophet* sits is identical to that under the present figure, and all three figures have large circular holes in their sides for securing: the New York *Prophet* and the present figure have these holes in the same positions on the left and right sides, all the holes being roughly the same diameter.[6]

Although the three figures come from the same ensemble, the New York *Prophet* appears to be by a different hand, with crisper, more agitated draperies, this difference being exaggerated by the condition of the *Moses* and the Thyssen-Bornemisza figure and the fact that it has received a certain amount of recarving.

There can be no doubt that the present figure is to be identified as a prophet. He holds his beard in exactly the same way as the aforementioned figure of Moses in the Ashmolean Museum, although this pose is also sometimes adopted by seated figures of evangelists, such as the small figure of St John at the base of the famous crucifix foot in the Musée Hôtel Sandelin in Saint-Omer, of the third quarter of the twelfth century.[7] Its relationship to the New York *Moses*, the appearance of age given by the long beard and the identification of the other New York figure as a prophet provide further evidence for this identification, as does the cap worn by the figure, which is also worn by many of the smaller prophets on the archivolts at Senlis.

The most important evidence for the original provenance of the three figures appears to be the now-fragmentary *Virgin and Child* in the cloister at Noyon Cathedral (fig. 8). Until 1918 this figure had occupied a place on the *trumeau* of the central doorway of the west portal at Noyon; it was damaged in the bombardment suffered by the Cathedral and the heads of both the Virgin and Child were lost.[8] However, the Noyon *Virgin and Child* could not have been placed originally on the *trumeau* of the central doorway as the west front at Noyon was only completed *c.* 1235, and the style of the figure is unequivocally that of *c.* 1180.[9] It was presumably placed there after the revolutionary destruction of the west portal in 1793; as a result its original position is unclear. Seymour suggested that it was originally designed for the west portal.[10] By this he presumably meant that because the building programme took so long to complete the figure was not eventually used: by *c.* 1185 only the third phase of the building had been completed – this took in the upper regions of the choir including the interior arcades and the vaults of the tribunes, the north and south arms of the transept including the communicating Salle du Trésor and episcopal chapel and the last bay of the nave.[11] It should be noted that nowhere on the exterior of the present transept is there a suitable place for such a figure.

The Noyon *Virgin and Child* is intimately linked with the Lugano and New York figures. The drapery folds are arranged remarkably closely, with heavy looping swags of cloth hanging from the Virgin's arms and twisting below her left knee. She sits on a narrow bench of the same form as those upon which the other figures sit, the back of the sculpture is entirely flat, so that it could be fitted flush against a wall (fig. 9), and she has a large circular hole, now filled with plaster but still visible, on each side (near her elbow) in the same manner as the other figures. The *Virgin and Child* would have been slightly larger than the New York and Lugano figures, as in its now-fragmentary state it measures 125 cm high and 52 cm wide.

If it is accepted that the four figures originally belonged together it must then be asked from what sort of ensemble might they have come? Seated figures of this size are extremely rare in portal compositions in the twelfth century; as was pointed out in the catalogue entry for *Moses* in the exhibition of medieval art from the Pitcairn Collection held in New York in 1982, such figures are commonly found in niches on the facades of churches in Poitou, most famously at Notre-Dame-la-Grande at Poitiers.[12] They are seen more rarely elsewhere, but do occur in the Ile-de-France at Bertaucourt and Châteaudun and on the lintel at Saint-Loup-de-Naud of the 1160s: in the latter they are slightly smaller than the figures under discussion, but there is a similar difference in size between the Virgin and the surrounding figures, in this case apostles.[13] Their depth does not preclude such a use.

Although at present it cannot be proved beyond doubt that the four figures originally formed part of the decoration of Noyon Cathedral – there is the unlikely possibility that the *Virgin and Child* was brought to the Cathedral after the Revolution from a destroyed church in the neighbourhood – it is incontestable that they fit firmly into the Senlis-Mantes *milieu* and should be dated *c.* 1180–85.

Notes

7 Swarzenski, *op. cit.*, fig. 396

8 For a photograph of the Noyon *Virgin and Child* before 1918, see Sauerländer (1972), ill. 27. The latest discussion of the Noyon sculpture is to be found in *Senlis, un moment de la sculpture gothique* (Senlis, 1977), cat. no. 41 [exhibition catalogue: La Sauvegarde de Senlis, no. 45–6]; no mention is made there of the Lugano or New York figures

9 For the history of the building programme at Noyon, see C. Seymour: *Notre-Dame of Noyon in the twelfth century: a study in the early development of Gothic architecture* (New Haven, CT, 1939) [p. 67 for a summary chronology; the *Virgin and Child* is illustrated on the frontispiece and discussed briefly on p. 168]; Seymour's book has been reissued in translation, with additions: *La Cathédrale Notre-Dame de Noyon au XIIe siècle* (Geneva, 1975)

10 Seymour (1939), 168; idem (1975), 108

11 Seymour (1939), 67

12 B. Rupprecht: *Romanische Skulptur in Frankreich* (Munich, 1975), pls. 95–6

13 Sauerländer (1972), pl. 24; see also F. Salet: 'Saint-Loup-de-Naud', *Bulletin Monumental*, XCII (1933), 129–69 (esp. 156–68). For facade design at this date, see A. Lapeyre: *Des Façades occidentales de Saint-Denis et de Chartres aux portails de Laon; études sur la sculpture monumentale dans l'Ile de France et les régions voisines au XIIe siècle* (Mâcon, 1960)

Additional bibliography

Rohoncz (1949), no. 442
Rohoncz (1952), no. 442
Rohoncz (1958), 130

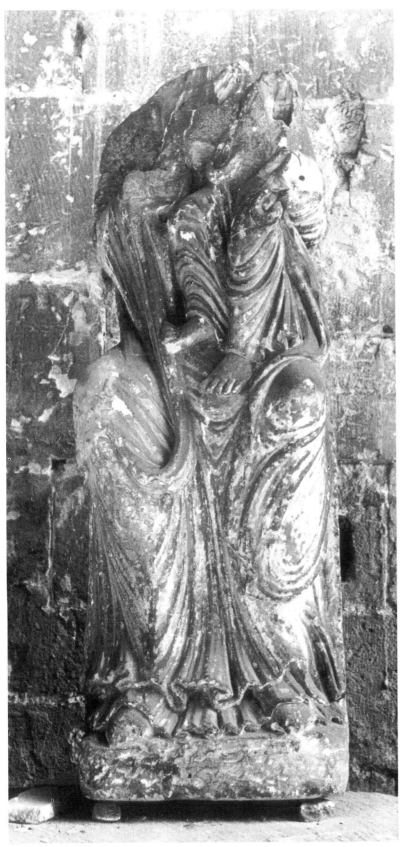

8 Virgin and Child, Noyon Cathedral, *c.* 1180–85

9 Side view of fig. 8

2 Virgin and Child

Northern French (Ile-de-France or Champagne), *c.* 1250–75
Sandstone

Dimensions
Height: 181 cm; width (at front of base): 39 cm

Provenance
Formerly in a niche in the main street of Sionviller, near Lunéville (Meurthe-et-Moselle), until after 1920[1]
Bought by Baron Heinrich Thyssen-Bornemisza (1875–1947) between 1930 and 1938
K43

The Virgin stands upright and frontally, on a small hexagonal base, holding the Christ-Child on her left side. She wears a short veil on her head, held in place with a bejewelled crown, and she looks towards the Child. Around her shoulders is a long mantle which falls to the ground and is held in place with a strap at her neck, fastened by a bulbous *agrafe*. Underneath she is dressed in a belted gown. The Christ-Child is supported by the Virgin's left hand, while she holds His left foot with her right hand, and He reaches out with His right hand to touch the *agrafe*. He wears a long tunic. The Virgin's mantle and the Christ-Child's tunic are blue with gilding and the Virgin's gown is red, although none of this visible paint is probably original (there are several layers of paint in places). The left hand of the Christ-Child is broken off, but otherwise the group is in good condition.

This monumental group of the Virgin and Child has its closest affinities with the great *trumeau* figures of the same subject on two of the most famous French cathedrals, Reims (west portal, centre doorway) and Amiens (the so-called *Vierge dorée*). All three figures share the same stance, although the Thyssen-Bornemisza *Virgin and Child* is nearer to the Amiens figure with its heavy, crumpled drapery and rather stiff pose (fig. 1). The *Vierge dorée*, executed between 1259 and 1269, has been shown to derive from Parisian models of the mid century, and may well have been carved by a Parisian workshop.[2] The Thyssen-Bornemisza *Virgin and Child*, showing a sweetly-smiling countenance and noble dignity, has also been influenced by the sculptures of the capital, but it shows obvious points of contact with sculpture of the Reims west portal, especially that of the so-called Joseph Master of about 1245–55 (fig. 2).[3]

The original context of this *Virgin and Child* is not known, but there is the possibility that it stood as a *trumeau* figure, like the *Virgins* at Reims and Amiens. Notwithstanding our ignorance of its intended setting, the Sionviller *Virgin and Child* is a very rare example of a monumental sculpture from the period around the middle of the thirteenth century, the 'High Gothic' era.

Notes
1 I am very grateful to the Director of the Musée Historique Lorrain, Nancy, for clarifying the former site of the sculpture at Sionviller, for giving me information on the circumstances of the sculpture's sale and for supplying me with a photograph of the piece in the niche at Sionviller (page 42); I am also indebted to Jan Burns for checking details for me at Sionviller
2 Sauerländer (1972), 495
3 *Ibid.*, 59–61, 476–88

Additional bibliography
E. Delorme: *Lunéville et son arrondissement*, II (Lunéville, 1927), 59–60 (fig. on p. 59)
Feulner (1941), 25–6, pl. 16
Rohoncz (1949), no. 423
Rohoncz (1952), no. 423
Rohoncz (1958), 130–31, pl. 102

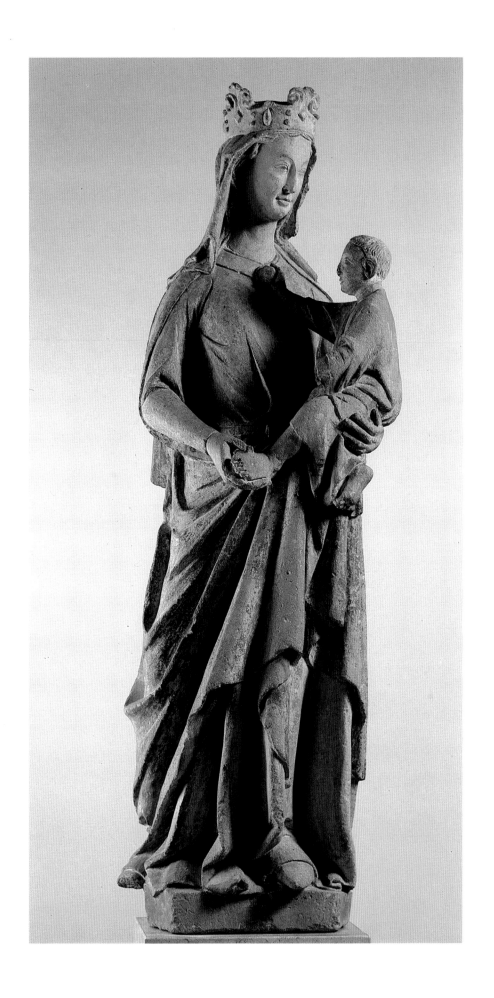

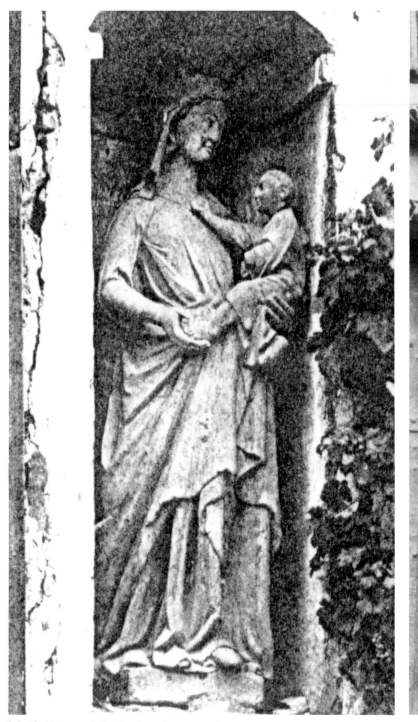

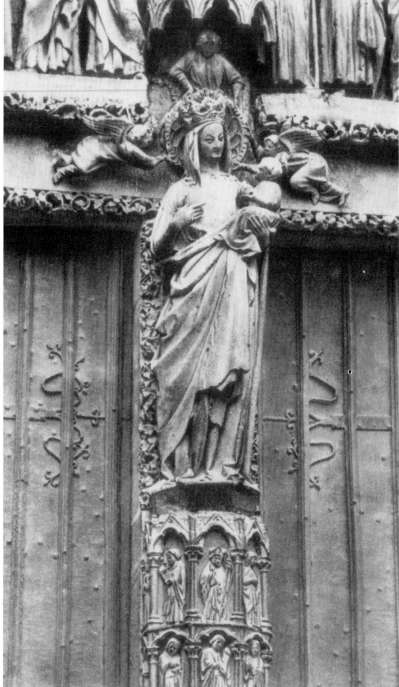

[1] *The Virgin and Child in the niche at Sionviller* 1 The *Vierge dorée*, Amiens Cathedral, 1259–69

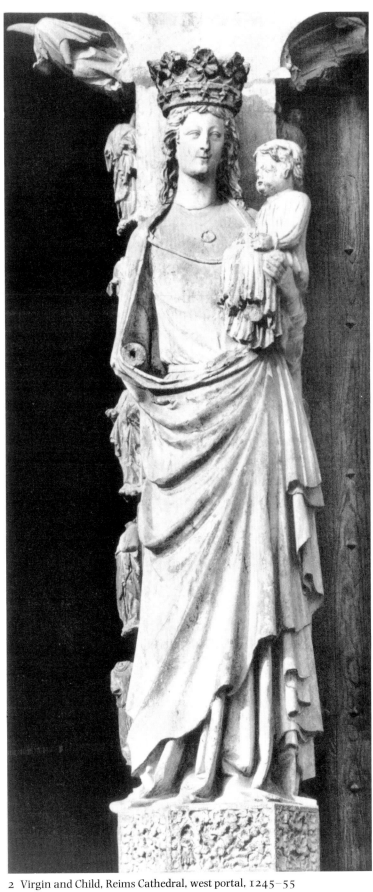

2 Virgin and Child, Reims Cathedral, west portal, 1245–55

3 Head of a Prophet

Northern French (region of Bourges?), second half of the thirteenth century
Limestone

Dimensions
Height: 38 cm; width: 26.5 cm

Provenance
Bought by Baron Heinrich Thyssen-Bornemisza (1875–1947) before 1938
K41

Because of the cap it wears, this bearded head may be identified as a prophet.[1] It has been broken from its body at the neck and the beard has sustained some damage; the cap is also damaged and there are pitted flaws in the stone. The nose has been restored. The back of the head is only crudely carved, so that it may be assumed that the figure originally occupied a niche and could only be viewed from the front. Judging by its size it is conceivable that the head once belonged to a jamb figure on a portal.

Feulner stated that this head was said to come from a religious foundation near Bourges, without giving any further evidence for this provenance.[2] It is not close enough to any of the surviving mid-thirteenth-century figures on the west facade of Bourges Cathedral to support an attribution to that workshop, and stylistically it appears to derive from sculpture produced further north.[3] Several of the male full-length figures of *c.* 1250–60 on the interior west wall of Reims Cathedral show a similar treatment of the facial features, such as the carving of the beard and hair.[4] However, the influence of Reims was felt throughout northern France in the second half of the thirteenth century, so that it is possible that the present head did in fact emanate from the region of Bourges.

Notes
1 See analogous figures at Reims in Sauerländer (1972), pls. 216, 231
2 Feulner (1941), 24
3 T. Bayard: *Bourges Cathedral: The West Portal* (New York and London, 1976)
4 Sauerländer (1972), pls. 232–3

Additional bibliography
Rohoncz (1949), no. 425
Rohoncz (1952), no. 425
Rohoncz (1958), 130

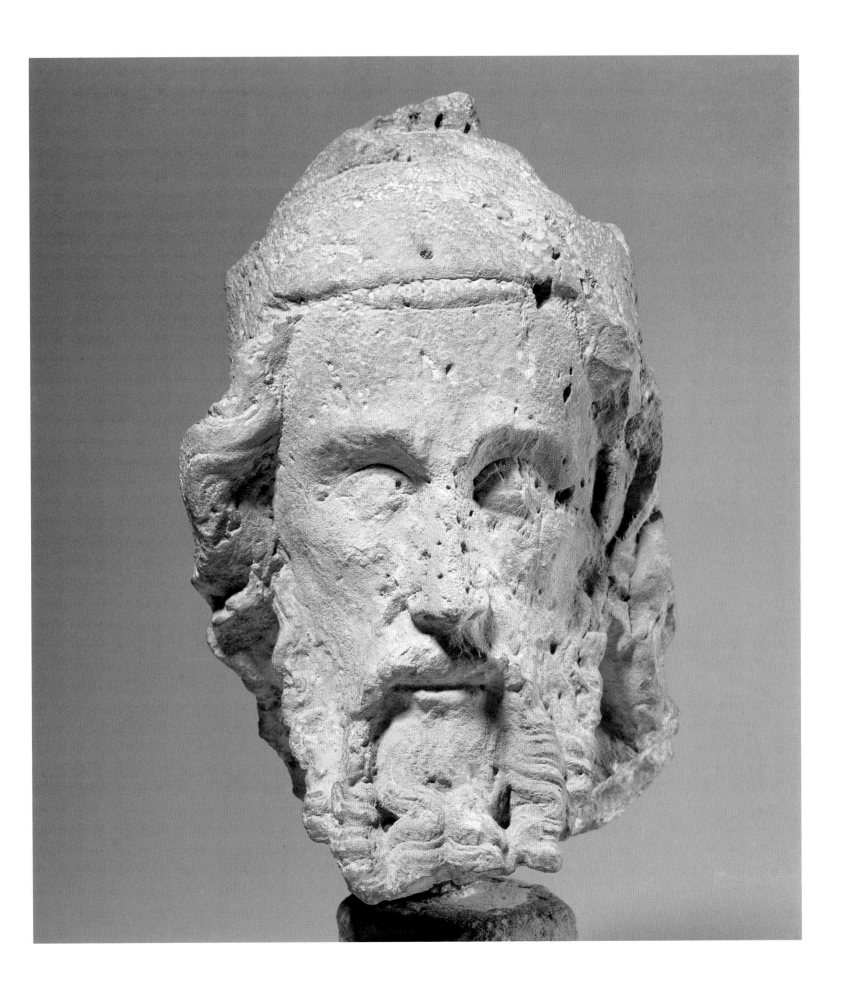

4 Two altar candlesticks

Central Italian (Rome), thirteenth century
Marble with inlaid coloured and gold glass

Dimensions
Height (not including pricket): (a) 24.4 cm; (b) 24.3 cm

Provenance
Said to come from S Maria Maggiore, Rome
Bought from Mercuria AG, Lucerne, 19 March 1934
K721

1 Paschal candelabrum, Terracina Cathedral, *c.* 1245

Both candlesticks are three-sided at the base, topped by a spiral knop and a short cylindrical shaft. Below the shaft the candlesticks are inlaid with glass and mosaic patterns in gold, red, black and blue. The prickets are probably original. On the base of (b) is a small label with the number 3788. The candlesticks are in good condition with only minor chips to the bases and some restoration of the *tesserae*.

Although the veracity of the provenance of the candlesticks cannot be established with certainty, the style of their decoration is unquestionably that of the Cosmati workshop, the *marmorari romani* of twelfth- and thirteenth-century Rome.[1] Various workshops were active in Rome and Latium for over 150 years producing inlaid floors, altars, episcopal thrones, choir screens, *amboni*, ciboria and paschal candelabra: characteristic of their work is the combination of patterns of gold and coloured glass mosaic with marble.[2] The most famous paschal candelabra in the cosmatesque style are the works of Vassallettus in S Paolo fuori le mura in Rome and in Anagni Cathedral, and others in S Clemente, S Lorenzo fuori le mura and S Maria in Cosmedin in Rome, but these are much more ambitious sculptures than the present pair of candlesticks and they served a different function. Small-scale works such as these, presumably simple altar candlesticks, are surprisingly less common, perhaps because they were more portable than the more impressive paschal candelabra. The spirally-decorated knop is similar in form to that on top of the grander paschal candelabrum of *c.* 1245 in the Cathedral at Terracina (fig. 1); although impossible to date accurately, the smaller candlesticks are most probably of the same century.[3]

Notes
1 The Roman provenance is given by Feulner (1941), 209, but there is no reference to them in X. Barbier de Montault: *Inventaire de la basilique de Sainte Marie Majeure à Rome* (Arras, 1873); however, it should be noted that the absence of a reference to the candlesticks in old descriptions of the basilica is not necessarily conclusive proof that they were not at some time in the church – small objects of everyday use such as these may not have been deemed worthy of description
2 For an account of the Cosmati workshops, see G. Clausse: *Les Marbriers Romains et le mobilier presbytéral* (Paris, 1897), 343–416; E. Hutton: *The Cosmati, the Roman Marble Workers of the XIIth and XIIIth centuries* (London, 1950); D. Glass: *Studies on Cosmatesque Pavements* (Oxford, 1980), 9–15 [B.A.R. International Series, 82]
3 Hutton, *op. cit.*, 21, pl. 44A

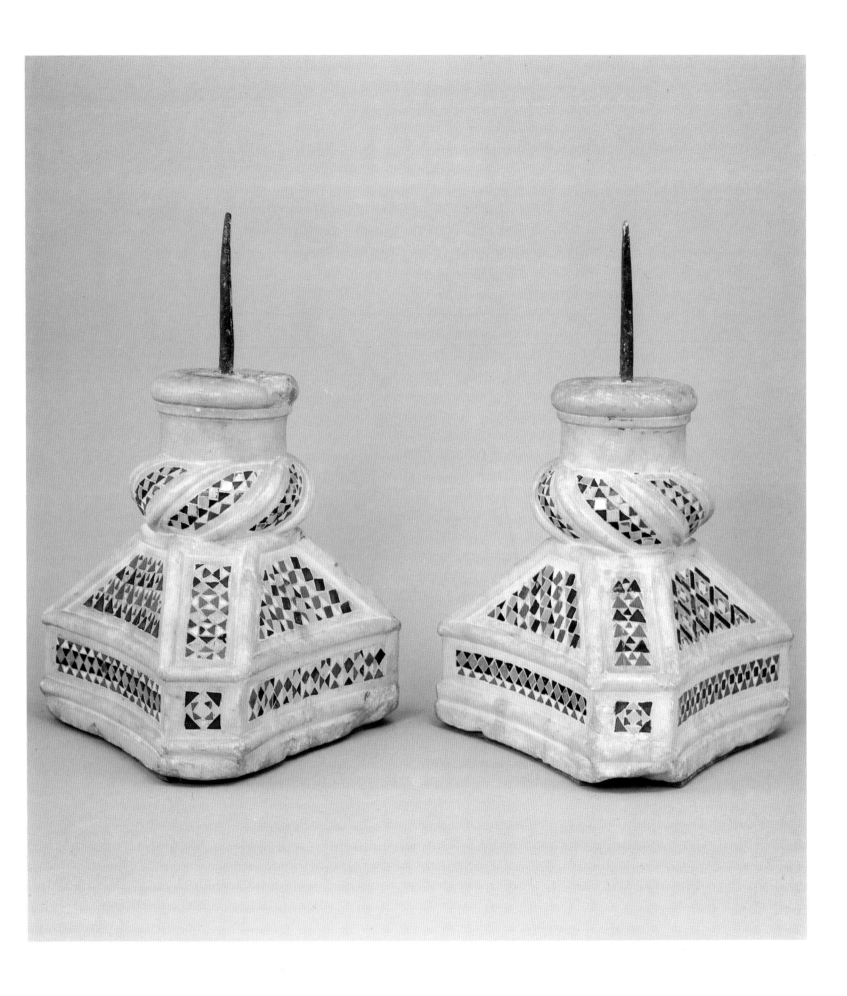

5 Lion of St Mark

Southern Italian (Campania), thirteenth century
Marble

Dimensions
Height: 38.8 cm; length (of base): 49 cm; depth (of base): 14.9 cm

Provenance
Camillo Castiglione Sale, Amsterdam, 17–20 November 1925, lot 83
Bought from Z. M. Hackenbroch, Frankfurt, 23 August 1934
K9

The winged lion, the symbol of the Evangelist Mark, stands on three feet while holding a rectangular tablet in its remaining paw. The surface has been unevenly discoloured with dirt over the years, resulting in a not-displeasing patina. The pupils of the eyes are filled with lead, and there is a circular hole in the top of the head.[1] There is a carved halo in the midst of the mane. The figure is in good condition, the only serious damage being to the tips of both wings and the front left corner of the base. In red paint on the right side of the base is the number 1132 (presumably an earlier inventory number – Castiglione?).[2]

Feulner attributed this sculpture to Venice and dated it to the middle of the twelfth century, describing it as a 'Portallöwe'.[3] However, quite apart from the lion's relatively diminutive size, which makes it unsuitable for supporting a column at the side of a door, there are no marks on the back of the animal, which precludes it from having a supporting function.[4] In addition, its unweathered condition indicates an internal setting originally. Nor are there any convincing parallels to be found in Venice for this type of figure, although the lion of St Mark was, of course, always a popular image in that city.

The key to the lion's origin and function appears to lie in Campania. In the Cathedral at Ravello there are the remaining sculptural fragments from a marble ciborium erected over the high altar in 1279 by the sculptor Magister Matheus de Narnia. This ciborium was pulled down in 1773, but its appearance was noted by the local historian Pansa in 1724 and in an unpublished manuscript describing the Cathedral of Ravello up to 1792.[5] From these descriptions and from the remaining fragments at Ravello it may be seen that the ciborium was supported by four columns with capitals and that the cupola of the ciborium was a two-tiered construction composed of 24 small columns on the first level and 16 on the second, similar in type to a number of other ciboria in Rome and Southern Italy, as for example at S Nicola in Bari.[6] There were three architraves with inlaid glass decoration at the back and sides, and at the front was an architrave bearing the inscription with the artist's name and that of the patron, Matteo Rufolo. The eighteenth-century manuscript describes four figures of the Evangelist symbols at the corners of the ciborium above the architrave, with the eagle at the front right, the lion at the front left, the bull behind the eagle and the angel behind the lion.[7] Until recently, three of these Evangelist symbols could still be seen in Ravello: the eagle is now in the museum of the Cathedral after being set above the main portal of the church for many years, but the lion and the bull, which had been placed on bases on each side of the *Fontana Moresca* in Ravello, have been stolen.[8] The angel of St Matthew presumably disappeared shortly after the dismantling of the ciborium in the eighteenth century.

Notes
1 In all probability the lead in the eyes is original: lead was commonly used to emphasise the eyeballs in Italian Romanesque sculpture – see for example a fragment from a Southern Italian marble *ambone*, now in the Victoria and Albert Museum, of two lions with lead eyes devouring a sheep (P. Williamson: *Catalogue of Romanesque Sculpture, Victoria and Albert Museum* (London, 1983), no. 27). The circular hole was probably a later addition, perhaps to facilitate fixing a halo

2 See a similar painted number on the North German lion *aquamanile* in the Thyssen-Bornemisza Collection (no. 35), which also emanates from the Camillo Castiglione Collection

3 Feulner (1941), 12; it was also described as the work of a 'maître vénitien, vers 1300' in the Castiglione sale catalogue, of which Feulner was unaware

4 For lions supporting columns, see E. Bertaux: *L'Art dans l'Italie Meridionale* (Paris, 1904; repr. in three vols, Paris and Rome, 1968), figs. 299, 309, pls. XXXI, XXXII

5 F. Pansa: *Istoria dell'antica repubblica di Amalfi* (Naples, 1724), 82; for the manuscript, see C. G. Faldi: *Il Duomo di Ravello* (Salerno, n.d.), 53, n. 92

6 For the ciborium in S Nicola at Bari, see F. Schettini: *La basilica di San Nicola di Bari* (Bari, 1967), pl. 148

7 Faldi, *op. cit.*, 53, n. 96. It
should be noted, however,
that there is a conflict in the
written sources on this point,
as Pansa (*op. cit.*) describes the
capitals as being decorated
with the signs of the
Evangelists and does not
mention any figures in the
round

8 *Ravello, Il Duomo e il Museo*
(Salerno, 1984), 54

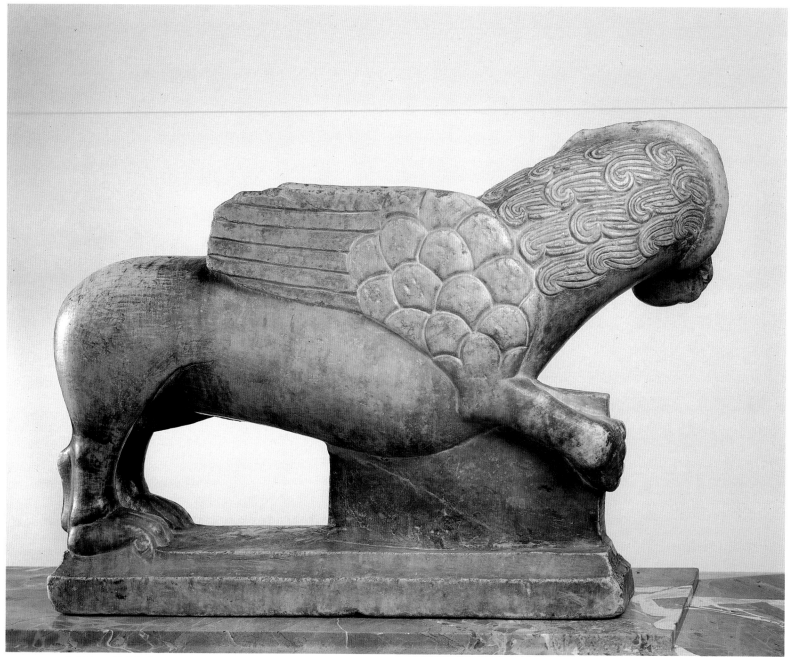

[5] *Lion of St Mark*

The Ravello sculptures are slightly larger than the present lion, but in type are very close.[9] Comparing the Ravello lion (fig. 1) it may be seen that both examples share the furrowed brow and wrinkled snout, that the wings are pressed back along the body and that the tail curls up between the back legs in both instances. Further support for a Campanian provenance for the Thyssen-Bornemisza lion is provided by comparing its head with those on a number of other sculpted lions from the same area.[10] By analogy to the Ravello sculptures it is highly likely that this lion also decorated a ciborium or, less likely, another piece of church furniture such as a pulpit: symbols of the Evangelists adorn the pulpit of 1229 in Bitonto Cathedral in Apulia, but it must be noted that these are much smaller.[11] There are of course numerous churches in the

Notes

9 The eagle at Ravello is 63 cm high

10 See, for instance, Bertaux, *op. cit.*, pl. XXXV (Ravello and Teggiano), and also A. Prandi, ed.: *Aggiornamento dell'opera di Emile Bertaux*, 3 vols, numbered 4–6 (Rome, 1978), pls. CLII–CLIII

11 Bertaux, *op. cit.*, pl. XXX *bis*, and Prandi, *op. cit.*, pls. CLXV–CLXVI

1 Lion from the *Fontana Moresca*, Ravello, marble, *c.* 1279

Additional bibliography
Rohoncz (1949), no. 403
Rohoncz (1952), no. 403
Rohoncz (1958), 123

vicinity of Ravello, such as those at Amalfi, Scala and Maiori, which might have accommodated such a ciborium. As with its place of origin, it is not possible to be precise about the lion's date; the Romanesque style was remarkably long-lived in South Italy, where it is possible to find sculpture in a twelfth-century style well into the fourteenth century. For example, the larger pulpit in the Cathedral at Ravello is dated to 1272, although it differs very little from the pulpits at Salerno Cathedral, of the second half of the preceding century. In view of this, and given its functional similarity to the ciborium figures at Ravello, the present lion probably dates from around the middle or the second half of the thirteenth century.

6 Virgin and Child with Moses and the Burning Bush

Central French (South Champagne/North Burgundy), 1310–30
Limestone

Dimensions
Height: 155 cm; width (at front of base): 58.8 cm; depth of base: 30.5 cm

Provenance
At the château at Betz (Oise) until 1904[1]
Seligmann, Paris
Bought by Baron Heinrich Thyssen-Bornemisza (1875–1947) before 1938
K44

The Virgin stands frontally, swaying to the right, with the Christ-Child resting on her supporting left arm. She rests her weight on her left foot. She is dressed in a simple long gown which falls to the ground with curving deep folds of drapery, over which she wears a shorter open mantle around her shoulders, which in turn hangs over her outstretched right arm. On her head is a short veil held in place by a crown decorated with tall foliate crestings. High around her waist she wears a girdle, the end of which trails down towards the ground, following the curving line of the draperies; its end is realistically carved with tassels at the side, a quatrefoil design at the tip and a *fleur-de-lys* device hanging from it.[2] The Christ-Child wears a long tunic with distinctive reversed lapels at the collar, and He holds a bird in His left hand while reaching out across the Virgin's chest with His right hand. At the Virgin's feet are, on the right, a small burning rose-bush, and at the left the diminutive figure of the kneeling Moses, hands joined in prayer and with his head covered with a hood. He is barefoot, and behind him are his tall boots standing on the ground.[3] The sculpture is in good condition, the major damage being to the right hand of the Christ-Child, the front of the Virgin's crown, both hands of Moses and Moses's boots; part of the Virgin's girdle is now missing, as is her right hand, which has been dowelled for a later repair. There are minor chips throughout and two large holes at just below waist level, at the front (filled with plaster) and at the right. The group has been thoroughly stripped of paint, although traces (blue and red) do remain in the area of Moses's boots and at the back.

It is only comparatively recently that some sort of order has been made of the vast numbers of Virgin and Child groups carved in France in the late thirteenth and fourteenth centuries, so that it is now possible to form groups of the material carved in the Ile-de-France, Champagne, Burgundy, Lorraine, Normandy and elsewhere. Due to the studies of Koechlin, Lefrançois-Pillion, Forsyth and Schaefer, and more recently by Schmoll gen. Eisenwerth, Quarré, Didier and Baron, we are in a position to be more precise in the dating and localisation of the different

Notes

1 Published by L. Marsaux: 'Une statue de la Sainte Vierge du château de Betz', *Mémoires de la société académique d'archéologie, sciences et arts du département de l'Oise*, XIX (1904), 480–84 (I would like to thank Elisabeth Taburet-Delahaye for supplying me with a photocopy of this article); see also C. Schaefer: *La sculpture en ronde-bosse au XIVe siècle dans le duché de Bourgogne* (Paris, 1954), 100–101: Schaefer, following Marsaux, assumed that the sculpture had been exported to America

2 This realistic detail may be compared with an actual girdle of the fourteenth century (albeit Italian), now in the Cleveland Museum of Art (W. M. Milliken: 'Girdle of the Fourteenth Century', *Cleveland Museum of Art Bulletin*, XVII (Mar 1930), 35–41)

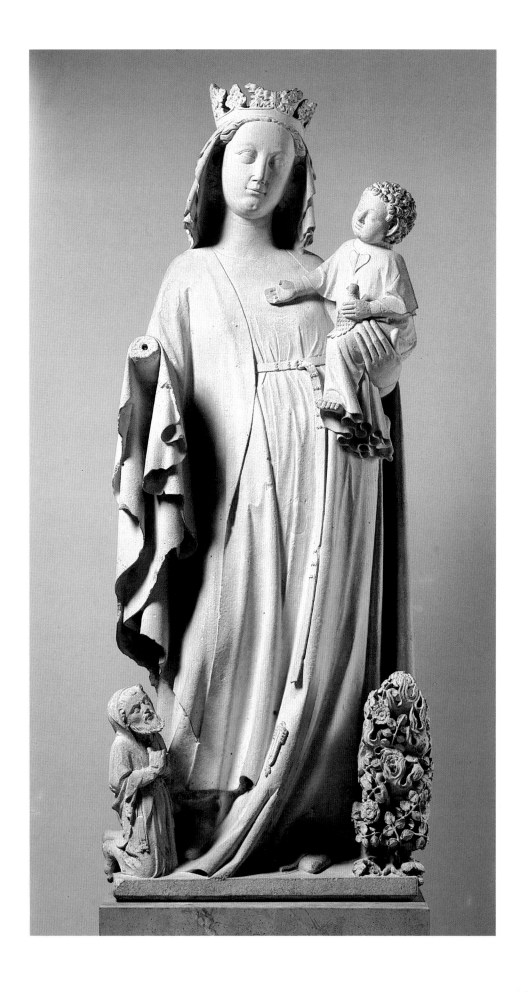

types.[4] Because a number of important Virgin and Child groups may be associated with a particular place of origin and in some cases may be dated accurately with the aid of documents, it has been possible to group other related pieces around them.

The Thyssen-Bornemisza *Virgin and Child* was set into a niche above the door of the neo-Gothic chapel in the grounds of the château at Betz (Oise); the chapel was built between 1780 and 1786 and was largely destroyed in 1817.[5] With the dispersal of the estate in 1904 the present sculpture passed into the hands of the Paris dealer, Seligmann. It was probably bought shortly after that, although its exact date of acquisition is not known. The sculpture, in spite of its eighteenth-century provenance, has its closest parallels with works produced in the region of South Champagne/North Burgundy. It was presumably moved to the château at Betz from elsewhere specifically to decorate the exterior of the neo-Gothic chapel built for the Princess of Monaco. Probably by the same master sculptor is a slightly larger *Virgin and Child with Moses and the Burning Bush* (fig. 1) set high up on a later altar in the Hôtel-Dieu in Tonnerre (between Troyes and Auxerre), which has been convincingly dated by Schaefer, Schmoll gen. Eisenwerth and Quarré to the early years of the fourteenth century.[6] Other Virgin and Child groups with the same iconography, showing a small Moses and the Burning Bush, are to be found at Langres (fig. 2), Epinal, Le Mans and Dijon.[7] Also very close in style, but without Moses and the Burning Bush at the feet of the Virgin, are groups of the Virgin and Child at Brion-sur-Ource (Côte-d'Or), Thieffrain (Aube) and Mussy-sur-Seine (Aube):[8] all these groups show the Virgin with an open mantle, holding the Christ-Child in exactly the same way on her left arm. There are, of course, connections with the Virgin and Child groups produced in neighbouring Lorraine: the Christ-Child, with his tightly-curled hair and lapelled tunic, is close to many of the Christ-Childs of that region, and the Virgin herself, with her broad, well-rounded face, is also similar to several Virgins undoubtedly produced in Lorraine, such as that in the cloister of the Cathedral at Saint-Dié (Vosges).[9]

The association of the Virgin with Moses and the Burning Bush, substituted in place of the usual God the Father, seems to have been established well before the date of the present sculpture, and was especially popular in the twelfth century in the writings of Cistercian scholars; the Virgin was also associated with Moses and the Burning Bush in St Augustine's tracts and Rabanus Maurus.[10] According to medieval typology the bush which burned but was not consumed by the flames was a symbol of Mary, who remained a Virgin after her maternity.[11] The visual manifestation of this theme does not seem to have become popular until the fourteenth century, the most famous representation of the scene being the central panel of the fifteenth-century triptych *Le Buisson Ardent* (Cathedral, Aix-en-Provence) by Nicolas Froment.[12]

Notes

3 Feulner (1941), 26, suggested that the two boots behind Moses might indicate that the sculpture had been commissioned by a league of shoemakers: this is unlikely, as Moses is usually shown in this context either undoing his boots or barefoot, and the boots therefore simply form part of the scene

4 R. Koechlin: 'La sculpture du XIVe et du XVe siècle dans la région de Troyes', *Congrès archéologique de France . . . à Troyes et Provins en 1902* (1903), 239–72; *idem*: 'Essai de classement chronologique d'après la forme de leur manteau des Vierges du XIVe siècle debout, portant l'Enfant', *Actes du Congrès d'Histoire de l'Art: Paris, 26 Septembre–5 Octobre 1921*, II, part 2 (Paris, 1924), 490–96; L. Lefrançois-Pillion: 'Les statues de la Vierge à l'Enfant dans la sculpture française au XIVe siècle', *Gazette des Beaux-Arts*, XIV (1935), 129–49, 204–26; W. H. Forsyth: 'Medieval statues of the Virgin in Lorraine related in type to the Saint-Dié Virgin', *Metropolitan Museum Studies*, V/2 (1936), 235–58; *idem*: 'The Virgin and Child in French fourteenth-century sculpture: a method of classification', *Art Bulletin*, XXXIX (1957), 171–82; Schaefer, *op. cit.*; J. A. Schmoll gen. Eisenwerth: 'Lothringische Madonnen-Statuetten des 14. Jahrhunderts', *Festschrift Friedrich Gerke* (Baden-Baden, 1962), 119–48; *idem*: 'Neue Ausblicke zur hochgotischen Skulptur Lothringens und der Champagne (1290–1350)', *Aachener Kunstblätter*, XXX (1965), 49–99; P. Quarré: 'Les Statues de la Vierge à l'Enfant des confins burgundo-champenois au début du XIVe siècle', *Gazette des Beaux-Arts*, LXXI (1968), 193–204; R. Didier: 'Contribution à l'étude d'un type de Vierge française du XIVe siècle', *Revue des Archéologues et Historiens d'Art de Louvain*, III (1970), 48–72; R. Didier, M. Henss, J. A. Schmoll gen. Eisenwerth: 'Une Vierge tournaisienne à Arbois (Jura) et le problème des Vierges de Hal. Contribution à la chronologie et à la typologie', *Bulletin Monumental*, CXXVIII/2 (1970), 93–113; F. Baron, Fastes du Gothique, 55–166

Notes

5 See Note 1
6 Schaefer, *op. cit.*, 100, 175–6;
Schmoll gen. Eisenwerth,
op. cit. (1965), 62, fig. 17;
Quarré, *op. cit.*, 196–8,
figs. 9, 13; see also L. Marsaux:
*La statue de Tonnerre, La vierge
au Buisson ardent* (Beauvais,
1900)
7 The Epinal and Le Mans
figures are referred to by
Forsyth, *op. cit.* (1957), 178,
n. 34. Quarré discusses and
illustrates the *Virgin and Child*
in a Dijon private collection
(Quarré, *op. cit.*, 197, fig. 10).
I would like to thank William
Forsyth for generously sending
me a photograph of the
Langres group and for
discussing the Thyssen-
Bornemisza *Virgin and Child*
with me
8 Quarré, *op. cit.*, figs. 4, 5, 7
9 Forsyth, *op. cit.* (1936), fig. 3
10 Schaefer, *op. cit.*, 39–40
11 For a discussion of this
analogy, see E. Harris: 'Mary
in the Burning Bush: Nicolas
Froment's Triptych at Aix-en-
Provence', *Journal of the
Warburg Institute*, 1 (1937–8),
281–6
12 *Ibid.*, pl. 41, and G. Ring:
*A Century of French Painting
1400–1500* (London, 1949),
cat.no. 216, pl. 126

Additional bibliography
Rohoncz (1949), no. 426
Rohoncz (1952), no. 426
Rohoncz (1958), 131

1 Virgin and Child with Moses and the Burning Bush,
North Burgundian, early fourteenth century
(Hôtel-Dieu, Tonnerre)

2 Virgin and Child with Moses and the Burning Bush,
Burgundian, early fourteenth century (Cathedral, Langres)

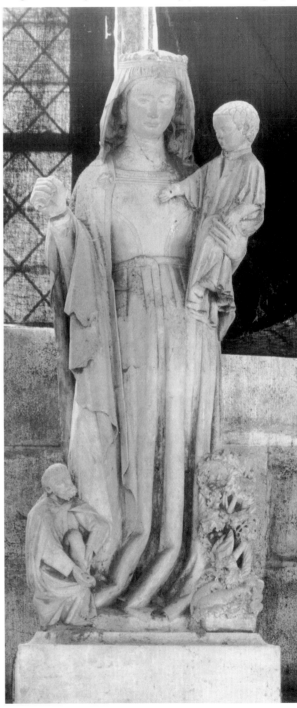

7 Standing warrior

Central French (Burgundy?), mid-fifteenth century
White stone, with remains of polychromy[1]

Dimensions
Height: 86 cm

Provenance
Said to have come from Auniers, near Fougeré (Maine-et-Loire)
Paul Gouvert, Paris, 1934[2]
Bought from A. Seligmann, Rey & Co. Inc., New York, 1934
K48

The standing figure holds a shield in his left hand and would probably originally have held a large sword in his right. On his head he wears an arming-cap, a padded circlet to protect the head under the helm, and on his body a *pourpoint* covers a mail *haubergeon*, his arms and legs being protected by separate pieces of plate armour, *vambraces* and *cuisses* respectively; his neck is covered with a *camail*, a shoulder-cap of mail.[3] The design on the shield is now indecipherable, but it clearly originally incorporated a large cross. The figure stands on a rocky base, the rocks forming a small mound behind his legs. The remains of blue paint are clearly visible on the *pourpoint*, on the shield and on the rocky ground, and the face retains a considerable amount of flesh-coloured paint. The surface has suffered very badly from being stripped, using a claw chisel, apparently because it was covered with lime: this has left deep parallel lines all over the sculpture.[4]

Adolf Feulner, following the report of Paul Gouvert prepared at the time of acquisition, identified the present figure as Guillaume d'Auniers, a noble who is recorded as having married one Jean Dubois in 1400: he dated it *c.* 1410.[5] However, at present there is no compelling reason to associate the figure with that particular person, there being no firm evidence that the sculpture did in fact originate from Auniers. Nevertheless, the style, costume and pose of the figure suggest that it should indeed be placed in the first half or middle of the fifteenth century although the question of location is more problematic.

While costume is not always helpful for the dating of works of art the combination of *haubergeon*, *pourpoint* and *camail* points to a date after *c.* 1385, but probably before *c.* 1460, when the *haubergeon* had been replaced by full plate-armour.[6] The figure itself has points of contact with the standing statue of Dunois, the Bastard of Orléans, in the Castle Chapel at

Notes
1 The stone has not been identified
2 Letter and short report on file in Lugano
3 For details of military and civil dress worn in the fourteenth and fifteenth centuries, see J. Evans: *Dress in Medieval France* (Oxford, 1952), 28–9 (*haubergeon, camail, pourpoint*); for the arming-cap, see C. Blair: *European Armour circa 1066 to circa 1700* (London, 1958), 34, figs. 11–12. My thanks to Anthony North for discussing the armour with me
4 This misguided restoration was carried out in Paris, presumably for Paul Gouvert, in 1934. In a short report on the figure Gouvert candidly stated: 'Cette statue recouverte de chaux à été tres soigneusement décapée, et grâce à cette couche protectrice se trouve actuellement dans un état de conservation remarquable.' The same treatment was received by the *Seated Prophet*, K41A, which had also been in the possession of Gouvert (see no. 1)
5 Feulner (1941), 28, pl. 20
6 Evans, *op. cit.*, 45, 50

Châteaudun, of the middle of the fifteenth century (fig. 1);[7] although Dunois wears plate armour around his chest and waist (and is thus probably later), he wears the *camail* at his neck and the plate armour on his legs and arms is of the same type as that on the present figure. The facial characteristics may be compared with the detached head of St Maurice in the Museum at Orléans, of *c.* 1475, which still retains its polychromy;[8] both heads have the same heavy-lidded eyes, although the Orléans head retains the painted pupils which so enliven the face. Closest to the present sculpture is a standing figure of St Bavo, now in the Metropolitan Museum of Art in New York (fig. 2). Although slightly more mannered and elegant than the Thyssen-Bornemisza figure, the New York saint is very similarly attired and the mounds of rock behind the figures are carved almost identically. Theodor Müller placed the New York *St Bavo* in the North Netherlands and dated it *c.* 1460; however a Burgundian origin cannot be ruled out.[9] Both figures are imbued with the naturalism which characterises the later Gothic sculpture of the region, ultimately deriving from Claus Sluter.

The original context of the figure is unclear. It could have stood as a single sculpture, perhaps in a chapel as does the statue of Dunois, or it may have had funerary associations, perhaps flanking a tomb. It seems likely that it does actually represent a particular person rather than being an anonymous warrior, but any identification can only remain speculative in the absence of further evidence about its original provenance and documents pertaining to it.

Notes

7 *Ibid.*, pl. 33
8 M. Aubert: *La Sculpture française au Moyen-âge* (Paris, 1946), ill. p. 411
9 T. Müller: *Sculpture in the Netherlands, Germany, France, and Spain: 1400–1500* (Harmondsworth, 1966), 82–3, pl. 96(B)

Additional bibliography

Rohoncz (1949), no. 430
Rohoncz (1952), no. 430
Rohoncz (1958), 312, pl. 101

1 Statue of Dunois, Central French, mid-fifteenth century (Castle Chape Châteaudun)

2 St Bavo, Burgundian?, *c.* 1450–6 (Metropolitan Museum of Art, New York, Bequest of Michael Dreicer, 1922)

1

2

8 The Assumption of the Virgin

English (probably Nottingham), second half of the fifteenth century
Alabaster

Dimensions
Height: 40.7 cm; width: 25.8 cm

Provenance
Bought at Sotheby's, London, 15 December 1977, lot 36
Now at Daylesford House
K91K

The Virgin, crowned and wearing a gown and cloak, stands at the centre of the panel in a *mandorla* held by two pairs of angels, her hands raised upwards in an attitude of prayer. Above her in a division of the panel representing Heaven is the haloed, crowned and bearded figure of God the Father, an orb in His left hand, His right hand raised in blessing. He is flanked by two angels, the one on the left playing a small harp, the other on the right playing a lute with a plectrum. On the left at the Virgin's feet kneels the bearded figure of St Thomas wearing a gown and cloak. His hands are together in prayer and hold the Virgin's belt, which is shown with a buckle and clasp.[1]

There are considerable remains of original paint, of red and blue and gilding. The *mandorla* behind the Virgin has a zig-zag pattern around the edge of black and gold (the gold has in many places worn away, leaving the brownish-red bole exposed underneath). The carving is in reasonably good condition, the worst damage being to the face of the angel at the top right: the top right corner is broken away. The back of the panel (page 62) bears five incised lines, presumably assembly marks indicating its original position in an altarpiece.[2] There are two original holes, lead-plugged and holding latten wire, for fixing the panel to the wooden housing of the altarpiece from which it came, and four recently-made screw-holes.[3] The bottom of the back of the panel has been cut away, a standard practice on English medieval alabaster panels to make handling easier both during and after carving.[4]

Alabaster panels with scenes from the lives of Christ, the Virgin and certain saints were produced in large numbers in England from the end of the fourteenth century until the Reformation in the middle of the sixteenth century, when religious image-making stopped and there was widespread destruction of the sculptures already existing. Indeed, a large proportion of the surviving English alabaster panels were only saved because they were exported to other countries. Their exact dating and localisation is still far from settled, although it seems certain that Nottingham was the major centre for the production of the panels, as there are numerous documentary records of alabaster carvers in that city and the two principal quarries of alabaster in the Middle Ages were just outside Nottingham to the southwest, at Tutbury and Chellaston Hill.[5] There are, however, contemporary references to alabastermen in other towns and cities, such as Burton-on-Trent and York, and it is probable that workshops also existed in London. The present panel must have been made in the fifteenth century, probably in the second half of the century.[6]

Notes
1 As recounted in *The Golden Legend*, the belt of the Virgin was a demonstration to the doubting Thomas of the truth of the Assumption (*The Golden Legend*, trans. and adapted from Latin by G. Ryan and H. Ripperger (New York, 1969), 454). The diminutive figure of Thomas appears in numerous other alabaster panels of the Assumption of the Virgin: see, for instance, seven examples in the Victoria and Albert Museum (F. Cheetham: *English Medieval Alabasters. With a catalogue of the collection in the Victoria and Albert Museum* (Oxford, 1984), cat. nos. 126–7, 129–31, 133–4)
2 Five incised lines also appear on the back of an Assumption of the Virgin panel in the Victoria and Albert Museum (*ibid.*, cat. no. 126)
3 For this method of fixing, *ibid.*, 24
4 *Ibid.*, 25
5 *Ibid.*, 12–17
6 For the problem of dating, *ibid.*, 31–44

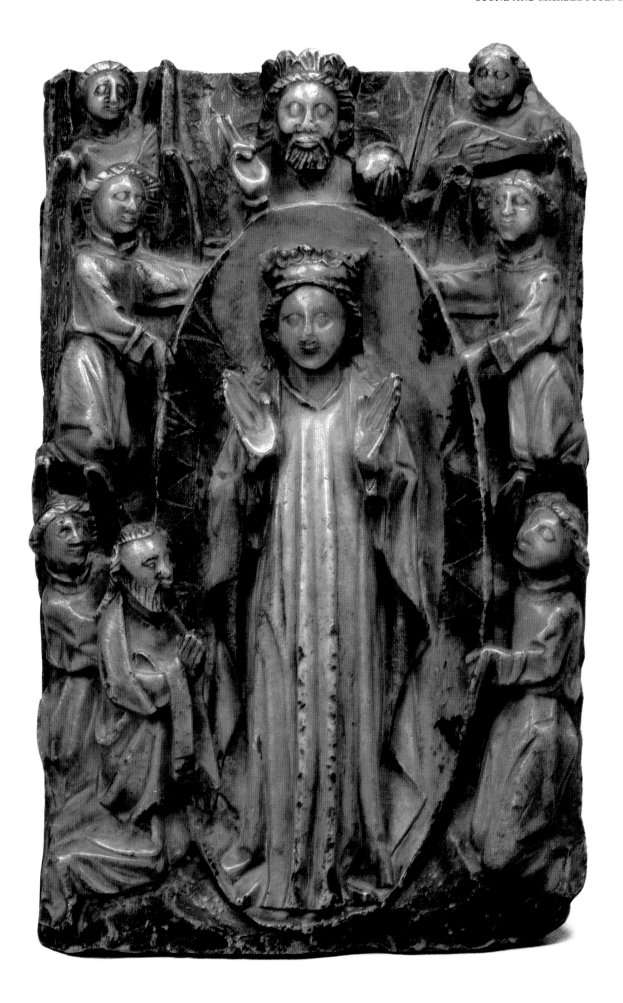

[8] *The Assumption of the Virgin*
Back view

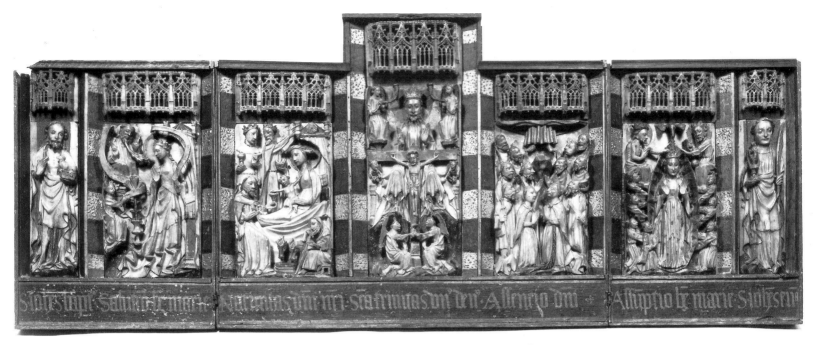

1 'The Swansea Altarpiece', English, second half of the fifteenth century (Victoria and Albert Museum, London)

Notes
7 *Ibid.*, 70–71, colour pl. 1
8 *Ibid.*, 56, 199

Panels of this shape were made as individual devotional images or as part of a large altarpiece, usually containing five panels in a row, the central panel taller than the others. Because of the subject matter and the five lines incised on the back of the present panel it is likely that it was the fifth panel in an altarpiece showing the Joys of the Virgin, resembling the so-called Swansea Altarpiece in the Victoria and Albert Museum (fig. 1).[7] Francis Cheetham, in his catalogue of the English alabasters in the Victoria and Albert Museum, mentions the existence of over 70 panels showing the Assumption of the Virgin.[8]

9 Virgin and Child

In the Romanesque manner
Tufaceous limestone

Dimensions
Height: 70.7 cm; width (at base): 25 cm; depth (at base): 24.1 cm

Provenance
Otto H. Kahn Collection, New York[1]
Mogmar Art Foundation, New York
Bought by Baron Heinrich Thyssen-Bornemisza (1875–1947) before 1938
K42

The Virgin sits on a two-tiered square bench with round arches on the sides and back. The Christ-Child sits on her left knee, holding a book with a cross on its cover with His left hand and blessing with His right. The Virgin holds Him at the left shoulder, leaving her right hand free, as if to hold the customary lily. The group is in good condition; it owes its dark appearance to a layer of paint applied directly onto the stone.

This *Virgin and Child* clearly follows the type produced in the Auvergne region of France in the second half of the twelfth century, which is invariably carved from wood, not stone, and is often made in many pieces and fitted together.[2] Although it does not appear to be copied exactly from any particular *Virgin and Child*, there are a number of features which link it with products of the Auvergnat Romanesque: the sides of the throne are very close to one supporting a seated Virgin at Clermont-Ferrand,[3] and the drapery and general bearing of the figures can be paralleled in many instances.[4] The crudeness of the carving and iconographic misunderstandings serve to question further the authenticity of the piece, the most noticeable mistakes being the treatment of the Virgin's clenched right hand – which is not cut through, but forms a container – and the shortness of the Virgin's feet: the Auvergnat *Virgins* usually wear pointed slippers. It may well be that the artificial colour of the *Virgin and Child* was applied in the mistaken belief that the original twelfth-century Madonnas were also 'Black Virgins'.[5]

Notes
1 Said to have come from a cloister in Clermont-Ferrand (Feulner (1941), 24–5)
2 For the most comprehensive treatment of these Virgin and Child groups, see I. H. Forsyth: *The Throne of Wisdom: Wood Sculptures of the Madonna in Romanesque France* (Princeton, NJ, 1972)
3 *Ibid.*, fig. 103
4 The head-gear of the Virgin is seen on many other Virgins of the second half of the twelfth century: see, for instance, an example in the Louvre in Paris (*ibid.*, fig. 98). The way in which the drapery below the Virgin's knee loops across from one leg to the other can also be matched (*ibid.*, figs. 121–3)
5 For a discussion of the 'Black Virgin', *ibid.*, 20–22

Additional bibliography
Rohoncz (1949), no. 424
Rohoncz (1952), no. 424
Rohoncz (1958), 130

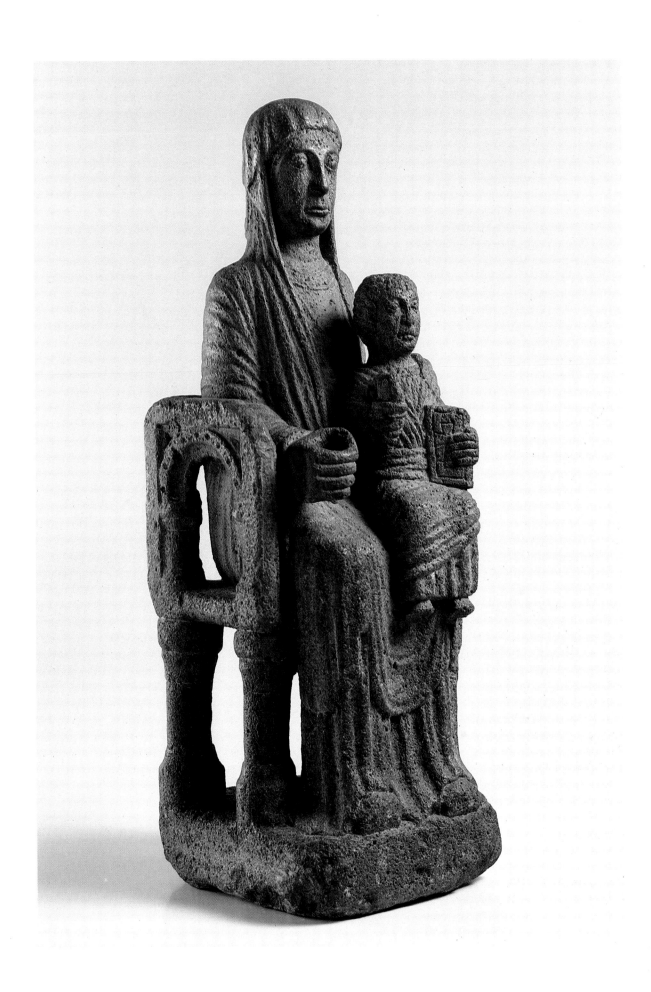

10 Virgin and Child

Italian, probably twentieth century
In the manner of Tino di Camaino (*b c.* 1285; *d* 1337)
Marble

Dimensions
Height: 33.8 cm

Provenance
Bought in Florence, 1977
K12C

The statuette was tested with hydrochloric acid to establish whether it was in marble or, like many of the small statuettes of this general type, white Castellina alabaster opacified after carving ('*marmo di Castellina*').[1] Effervescence proved that the material was marble. The surface is worked in an abrasive technique with no sharp cutting: it is smooth and rounded and covered by fine scratches. The Virgin's neck-band and the lozenge-shaped clasp for her cloak are defined only by scoring in the surface. There is patchy yellow-brown staining (possibly caused by treatment with hydrofluoric acid), and a small trace of red pigment is on the Child's right sleeve. The head of the Child is missing, broken off at the base of the neck, and the Virgin's crown is abraded away at the top and at the front above the brow. There are deposits of dirt in the break in the Child's neck and in the Virgin's eyes, but not in the crevices of the drapery. The statuette is mounted on a modern moulded irregular octagonal base, artificially distressed, to which it is attached by a forged iron dowel set in lead.

Hitherto unpublished, the statuette was acquired in 1977 with an ascription to Tino di Camaino, which it has borne since, and indeed all the comparisons which it suggests are to be found in Tino's work. In its general scheme, with the Child supported on the Virgin's left arm and the Virgin's right hand gathering up her cloak, the statuette follows a Madonna-type evolved by Giovanni Pisano which was adopted and exploited by Tino. The type originates in Giovanni Pisano's great Madonna of the Pisan Baptistry (*c.* 1285–1305) now in the Camposanto, and was later developed by him in his now headless Madonna for the tomb of Margaret of Brabant (*c.* 1312–13) preserved in the Palazzo Rosso at Genoa and in his *Madonna della Cintola* in the Cathedral of Prato (after 1312).[2] It seems to have been exploited by Tino first in his signed Madonna statuette (height 60 cm) in the Museo Civico, Turin (fig. 1), which must be contemporary with Giovanni Pisano's Madonna in Genoa (*c.* 1312), and may possibly have been made for the chapel of S Ranieri at Pisa.[3] It was taken up by him again in his unfinished Madonna formerly in the Camposanto at Pisa and now in the Museo di San Matteo, which must date from a little later (*c.* 1315) and was perhaps made for the tomb of Henry VII in the Cathedral of Pisa.[4]

Notes
1 The so-called *marmo di Castellina* was much used in Florence in the nineteenth and early twentieth centuries for reproductions and forgeries of small marbles. The fine white alabaster quarried at Castellina in Chianti is opacified after carving by being simmered in hot water near to boiling point, resulting in a deceptive appearance of true marble
2 For these Madonnas, see E. Carli: *Giovanni Pisano* (Pisa, 1977), 125–37, pls. 156, 160, 162–3
3 L. Mallé: *Catalogo del Museo Civico di Torino: le sculture del Museo d'Arte Antica* (Turin, 1965), 88. For a full analysis of this and its relationship to the Madonnas of Giovanni Pisano, see N. Dan: *Omaggio al VII Centenario della nascita di Tino di Camaino: la Madonna di Torino e la Carità Bardini, opere pisane di Tino* (Florence, 1981), 33–44 [with full citation of earlier literature]
4 N. Dan: 'Ricostruzione della tomba di Arrigo VII di Tino di Camaino', *Michelangelo*, VI/22 (1977), 28. Ill. in W. Valentiner: *Tino di Camaino: a Sienese sculptor of the fourteenth century* (Paris, 1935), pl. 5A

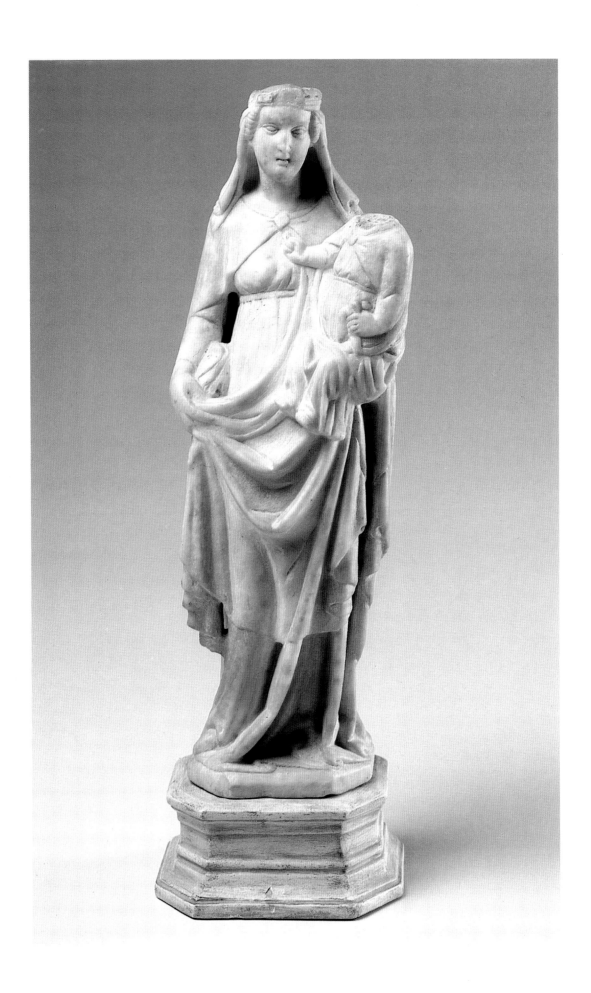

Tino was to return to this type in the standing Madonna statue which surmounts his last great monument, that to Mary of Valois in S Chiara, Naples (*c.*1332–7).[5] A small statuette (height 48.9 cm) generally ascribed to Tino, now in the Detroit Institute of Arts (fig. 2), also follows the same basic compositional scheme.[6] This, which carries a strong reminiscence of Tino's early Madonna in Turin, has, because of the softening of its forms, been assigned to Tino's period in Naples (*c.*1324–37), but its close resemblance to the votive relief of Queen Sancia in the National Gallery of Art, Washington, DC, which probably dates from after 1343, suggests that it might be the work of a follower of Tino in Naples.[7]

As regards the figure of the Child, which varies markedly in treatment in all the works of Tino so far cited, the present statuette may be compared with two of Tino's latest Madonna statues. The first of these, the standing Madonna of the tomb of Mary of Valois referred to above, offers a parallel for the fully-robed figure of the Child sitting with legs placed closely together on the Virgin's forearm.[8] The second, the seated Madonna of the tomb of Charles of Calabria in S Chiara, Naples, offers precise correspondences for the little goldfinch cruelly squeezed in the Child's left hand and for the Child's right hand in the attitude of blessing pressed awkwardly against the Virgin's breast.[9]

The comparison with Madonnas by Tino throws into prominence certain features which immediately rule out the possibility of Tino's authorship of the present statuette. The first is the columnar character of the figure, without any of the sinuosity of pose which informs all his Madonnas. Second is the fact that the Virgin does not look at the Child, but stares straight ahead: in all of Tino's Madonnas but one the Virgin looks at the Child, the exception being the seated Madonna on the tomb of Mary of Hungary in S Maria Donnaregina, Naples, in which both she and the Child direct their gazes downwards to their right to the adoring figure of Mary of Hungary herself.[10] Third is the physiognomy of the Virgin, with round face, bulbous nose, thick lips, large regular almond eyes and heavy double chin: this has nothing in common with the generally long, finely carved faces of Tino's Madonnas.

With the exception of his peculiar physiognomy, Tino's style, with its linear, smoothly-flowing quality has always been easy to imitate, making him a target for copyists and forgers. Most popular with copyists is precisely this type of standing Madonna statuette deriving from his Madonna in Turin. The most remarkable such derivative is a statuette in the Museo Nazionale di Villa Guinigi at Lucca, in which the drapery forms are misunderstood, ascribed to Tino by Valentiner, but properly rejected as a forgery by Carli.[11] Other, smaller derivatives have appeared from time to time on the art market.[12]

In the present statuette the figure of the Virgin appears to be derived from the Madonna of Detroit rather than directly from the Madonna of Turin. When viewed from the front the scheme of the drapery agrees, but at the sides and back the resemblance ceases, and this suggests that its author did not know the Detroit Madonna in the original. A comparison of the present statuette with the Detroit Madonna reveals certain features which indicate a lack of understanding on the part of its maker: the form of the Virgin's crown incised with simple parallel lines; the crudely-shaped bunches of hair protruding from the front of the veil; the confused incised treatment of the clothing above the Virgin's breast, where the neck-band seems to belong to the cloak and the top of the gown is lost behind it, and where the incised lozenge-shaped clasp is truncated at the top in line with the upper edge of the cloak; the Virgin's right hand, of which the fingers do not grasp, but merge into the drapery folds; and the improbable bunching of the drapery at the sides. Also to be noted are the curious proportions of the Child, with long body and very short legs, and the abrupt truncation below the Child's feet.[13]

These features suggest the hand of a forger, and this impression is reinforced by the unconvincing nature of the breakages on the top of the Virgin's crown and at the neck of the Child, and by the deposits of dirt, which are not naturally distributed, but seem to have been rubbed into the break in the Child's neck and the Virgin's face, leaving the crevices in the drapery clean. The Detroit Madonna did not come to general notice until 1925. AFR

Notes

5 Valentiner, *op. cit.*, pl. 66A
6 Purchased in Florence in 1925 from Alessandro Contini-Bonacossi (no. 25.147). W. Valentiner: 'Gothic sculpture from Siena and Pisa', *Bulletin of the Detroit Institute of Arts*, VII/3 (1925), 26–8; *idem: op. cit.* (1935), 119; *idem: Catalogue of an exhibition of Italian Gothic and early Renaissance sculpture* (Detroit, 1938), no. 11 [exhibition catalogue: Detroit Institute of Arts]
7 Kress Collection (no. K1386). U. Middeldorf: *Sculptures from the Samuel H. Kress Collection: European schools, XIV–XIX century* (London, 1976), 5, 6 [with full citation of earlier literature]. Ascribed to Tino by Valentiner, the relief was shown by Middeldorf to date probably from after the widowing of Queen Sancia in 1343, and thus to be a product of Tino's posthumous workshop in Naples. Valentiner (*op. cit.* (1925), 27) had already noted the correspondence with the Madonna in Detroit. Like the latter, this was also formerly in the possession of Alessandro Contini-Bonacossi
8 See note 5 above
9 Valentiner, *op. cit.* (1935), pl. 66B
10 *Ibid.*, pl. 54
11 W. Valentiner: 'Observations on Sienese and Pisan trecento sculpture', *Art Bulletin*, IX (1926–7), 198 [as Tino, with reservation]; *idem: op. cit.* (1935), 15, ill. pl. 5c [as Tino]; E. Carli: *Tino di Camaino scultore* (Florence, 1934), 97
12 *E.g.* a small marble statuette (height 31 cm) sold at Christie's, London, 21 April 1982, lot 141, which derives from the Turin Madonna, with, once again, misunderstood drapery forms
13 A closely similar treatment of the Child, with the same proportions and abrupt truncation can be seen in a small marble Madonna statuette (height 42.4 cm) ascribed to Tino in the Fogg Art Museum, Cambridge, MA. See D. Gillerman: 'Gothic sculpture in American collections. The Checklist: I. The New England Museums', *Gesta*, XIX/2 (1980), 129, no. 67. My thanks to Paul Williamson for this observation

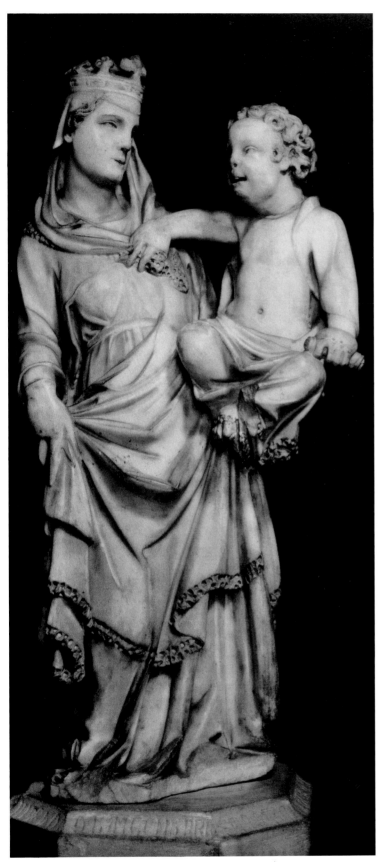

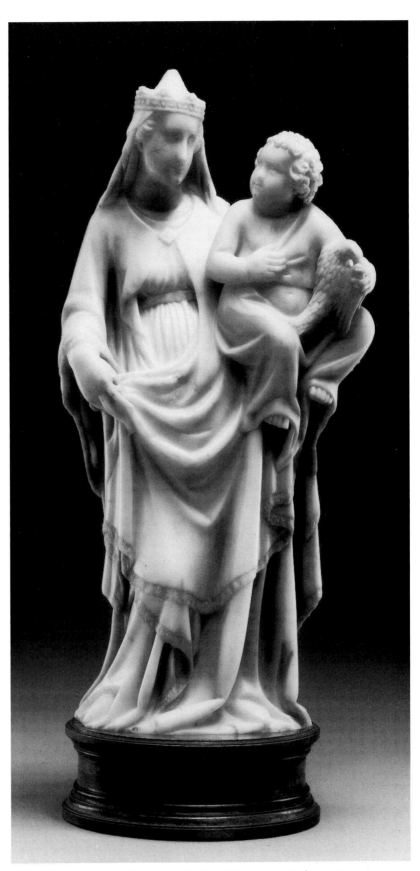

1 Virgin and Child, marble, by Tino di Camaino, Pisa, c. 1312
(Museo Civico, Turin)

2 Virgin and Child, marble, ascribed to Tino di Camaino, Naples, c. 1330–40
(Detroit Institute of Arts)

11 A Virtue

Italian, twentieth century
After Tino di Camaino (*b c.*1285; *d*1337)
Marble

Dimensions
Height: 105 cm

Provenance
Private collection, Rome, 1934/5
Acquired before 1937
K12

The statuette is carved from a re-used block of Greek island marble with very large crystals. The back of the block shows signs of heavy weathering before cutting, with four large holes caused by water action (the block must have lain for some time with that face upwards). Between the shoulder-blades is a square cut hole for a fixture. There is some plaster in it but no staining from metal corrosion. Except for some large chips on the upper surface of the front of the base, some losses at the top of the crown and some minor scoring on the nose it is in excellent condition.

First published by Colasanti in 1935, the statuette was then in an anonymous private collection in Rome.[1] Colasanti, who identified it as representing a female saint, ascribed it to Tino di Camaino, dating it to his period in Siena (1318–20) on the strength of a comparison with two of the supporting figures, at that time in the Opera del Duomo at Siena, of the monument to Cardinal Riccardo Petroni in Siena Cathedral.[2] He was followed by Feulner.[3] The comparison with the figures of the Petroni tomb is, however, invalid. Unaccountably, Colasanti failed to recognise that the statuette is a full-sized copy of the figure of Hope (fig. 1) on Tino's last documented work, the monument to Mary of Valois in the church of S Chiara, Naples (*c.* 1333–7), which it reproduces in all respects save for the omission of the lamb carried in the left hand of the original.[4]

The copy, while generally close to the original, is coarsely carved, with an insensitive use of the drill in the flowers of the posy and in the hair. The drapery forms are misunderstood at the bottom, where two large shoes project. The re-use of a weathered block suggests the hand of a forger anxious to give the figure some semblance of age. This impression is reinforced by the omission of the attribute of the lamb (rendering the iconography of the figure non-specific), and by the apparently artificial nature of the breakages at the base, which occur on the upper, rather than the lower edges, and of the slight damages elsewhere, none of which seriously mars the appearance of the figure (the original has an unsightly breakage on the nose).

The head of the figure, in which Tino's characteristic physiognomy has been rounded out and conventionalised, is virtually identical to the head placed by a modern restorer on a statuette of Justice, one of a pair of fragmentary figures of Virtues supplied with new heads, now in the Detroit Institute of Arts,[5] and it seems likely that the restorer of the *Justice* in Detroit was also the carver of the present statuette. In its general character the figure recalls the work of the Cremonese sculptor Alceo Dossena (*b* 1878; *d* 1937), who was active as a forger in Rome between 1918 and his exposure in 1928.

AFR

Notes
1 A. Colasanti: 'Tino di Camaino inedito', *Bollettino d'arte*, XXVIII, (1934–5), 422–4
2 For the Petroni monument, see J. Pope-Hennessy: *Italian Gothic Sculpture* (London, 2/1972), 184, pls. 30, 31, fig. 26. The two figures cited by Colasanti are reproduced individually by W. Valentiner: *Tino di Camaino: a Sienese sculptor of the fourteenth century* (Paris, 1935), pl. 20. These figures were in the Opera del Duomo until 1951, when the monument was restored and they were replaced in their original positions
3 Feulner (1941), 13
4 For the monument of Mary of Valois, see Pope-Hennessy, *op. cit.*, 185–6, pl. 35
5 Acquired in 1943 (no. 43.53); formerly in the collection of Ralph H. Booth, Detroit. W. Valentiner: 'Observations on Sienese and Pisan trecento sculpture', *Art Bulletin*, IX (1926–7), 203, fig. 32. The figures, ascribed by Valentiner to the workshop of Tino, with the suggestion that they might have come from one of the two dismembered late tombs by Tino in S Domenico Maggiore, Naples (those of Filippo di Taranto and Giovanni di Durazzo), seem to relate to the work of Giovanni and Pacio da Firenze

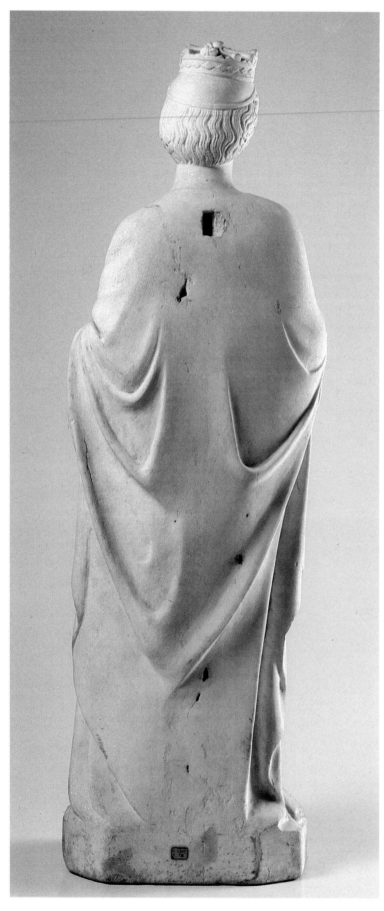

[11] *A Virtue*
Back view

1 Hope, marble, by Tino di Camaino,
c. 1333–7 (monument to Mary of Valois,
S Chiara, Naples)

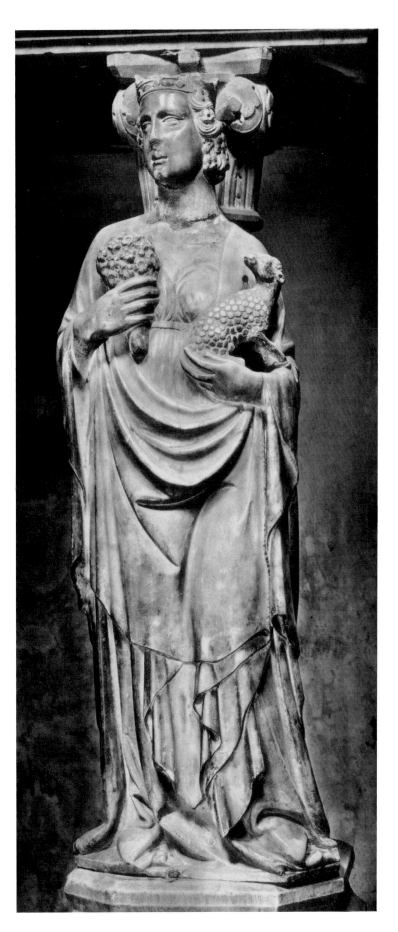

Additional bibliography
Rohoncz (1949), no. 407
Rohoncz (1952), no. 407
Rohoncz (1958), 124

12 Virgin and Child

In the Burgundian manner
Fine-grained limestone

Dimensions
Height: 118 cm

Provenance
Said to have come from a village church in the region of Dijon[1]
Bought by Baron Heinrich Thyssen-Bornemisza (1875–1947) before 1938
K47

The Virgin holds the half-naked Christ-Child on her left arm and an orb[2] with her right. The Child reaches forward and grasps two broken projections on the orb. The sculpture is in very good condition, with only minor surface abrasions, and there are traces of a pinkish-red paint all over the Virgin's draperies.

Stylistically the present sculpture loosely follows models of Lorraine and Burgundian origin from the late fourteenth century and the first half of the fifteenth. The drapery is based on Burgundian prototypes in the circle of Claus Sluter and his followers, such as the standing figure of St Anthony in the Musée de Cluny in Paris, of c. 1390:[3] common to both figures are the heavy, thick folds of the drapery falling in vertical lines, curving slightly as they reach the ground. However, the arrangement of the drapery on the Thyssen-Bornemisza *Virgin* is misunderstood and inconsistent: see, for instance, the way that the edge of the Virgin's mantle above her right arm disappears behind her sleeve and does not emerge again below. Two other features serve to reinforce doubts over the figure's authenticity. Firstly, the form of the orb, with two projections at right angles to one another, is unprecedented and seemingly confused, the Christ-Child grasping the broken projections in the same way as numerous examples of the Christ-Child in French fourteenth-century sculpture grasp the wings of the small bird so often seen in groups of this kind. But perhaps the most damning evidence against the figure of the Virgin is the form and pristine condition of the crown she wears, with its carefully-carved gemstones set in mounts against a cross-hatched background. It is significant that the closest comparison can be made with a crown on the head of a Virgin of the late fourteenth century in the Musée de Cluny:[4] this head is a modern restoration. The faces of the Virgin and Child are also rather lifeless and bland, a characteristic failing in the work of later copyists, however gifted.

Notes
1 Feulner (1941), 28
2 Erroneously described by Feulner as an apple (*ibid.*, 27)
3 See G. Troescher: *Claus Sluter und die burgundische Plastik um die Wende des XIV. Jahrhunderts*, I (Freiburg im Breisgau, 1932), pl. VIII
4 W. H. Forsyth: 'Mediaeval statues of the Virgin in Lorraine related in type to the Saint-Dié Virgin', *Metropolitan Museum Studies*, V/2 (1936), 251, fig. 13

Additional Bibliography
Rohoncz (1949), no. 429
Rohoncz (1952), no. 429
Rohoncz (1958), 131–2

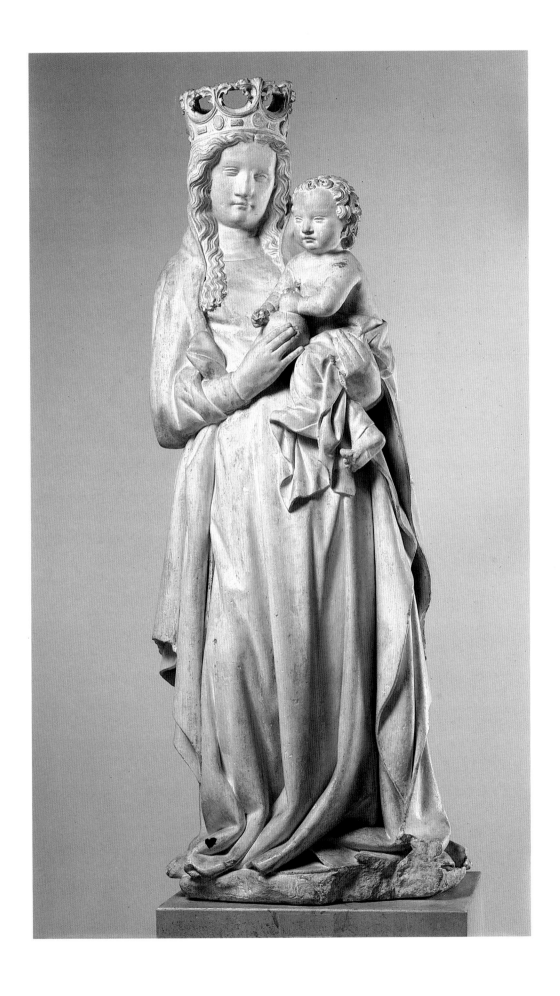

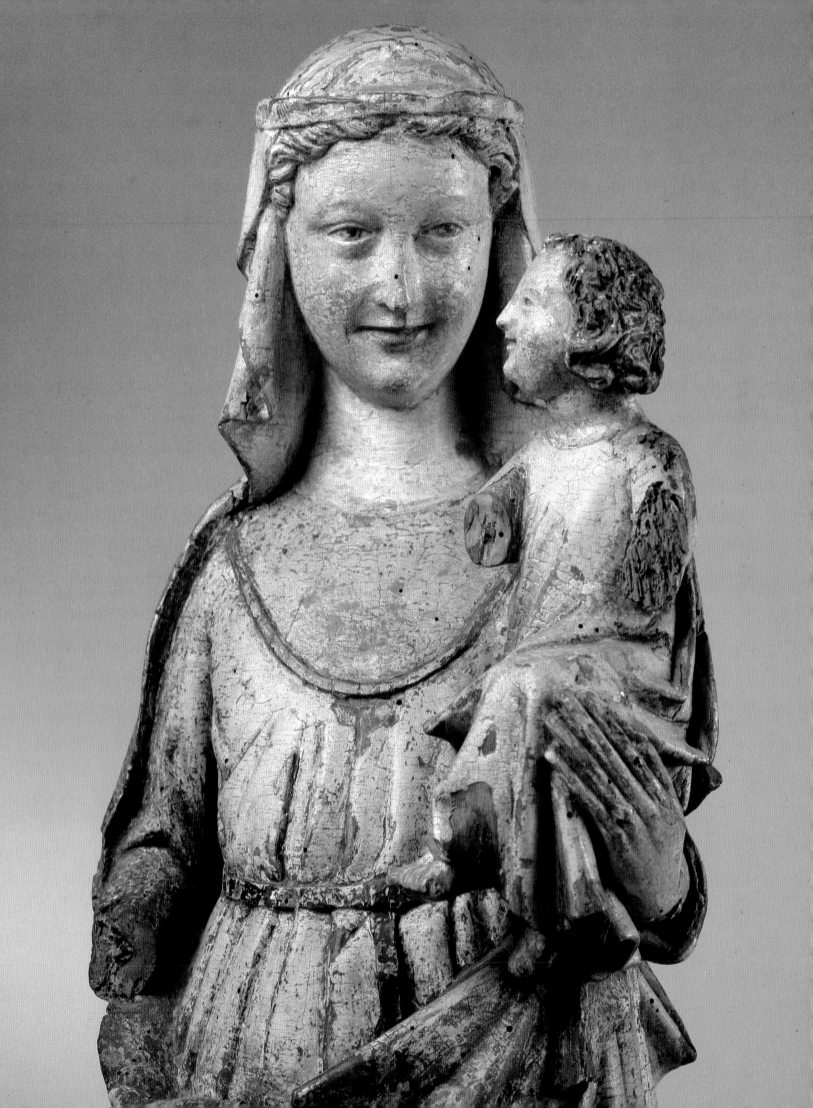

Wood sculptures

13 The Dead Christ

Central Italian (Umbria?), *c.*1230–50
Polychromed poplar

Dimensions
Height: 174 cm

Provenance
Said to have left Italy in the 1950s
Bought from a Swiss private collection, 1964
K9A

The figure of Christ, clad in a short knotted perizonium, is shown at the moment known as the Deposition, when, already dead, He is lowered from the Cross. At the time of its acquisition the *Christ* was in a bad state of conservation and was restored by Mr Marco Grassi.[1] Mr Grassi removed three layers of later over-painting, arriving at the superb original polychromy now visible: in the areas of paint loss at this level Mr Grassi used a readily recognisable watercolour to blend in with the original egg tempera. Apart from the later over-paint and minor surface damage, the most serious harm to the sculpture had been done by the repositioning of Christ's arms into a more closed position: this had been done by inserting wedges at the shoulders (page 80). There is a possibility that this change was made when the figure was separated from its original context, and it may have been incorporated into an Entombment group, with Christ lying in the tomb; these were especially popular in Italy and France in the fifteenth and sixteenth centuries.[2] The arms were rearranged into a more open position at the time of the restoration. The large pin seen set into Christ's left temple on page 80, presumably inserted to hold a later halo, was removed at the time of the restoration. The figure of Christ is made up of five separate pieces of wood: the major part is the torso, the two legs were fixed at a point just above the lower edge of the perizonium, and the two arms were originally attached in a diagonal line from the neck to the armpit.[3] In places under the paint and gesso there is a linen underlay: this is normally over the joints, but sometimes it is applied over rough, uneven areas of wood.[4] The back has been hollowed out (to reduce the likelihood of the wood cracking) and the recess has been covered with two panels of wood, held in place with wood pegs: exactly this technique is used on the back of a closely-related figure of Christ now in the Musée du Louvre, to be discussed in detail below (page 80 and fig. 1). The figure is now in good condition, although the rusting of nails below the paint level in the upper chest region has caused a certain amount of blistering.

The Thyssen *Dead Christ* would originally have formed part of a group showing the Deposition of Christ, probably with four flanking figures at the foot of the Cross – the Virgin, St John, Joseph of Arimathea and Nicodemus. A complete example of a Deposition group is still preserved in the Cathedral at Tivoli (fig. 2), and the Thyssen *Christ* is closely similar to the Christ of that group: the perizonium is similarly arranged in both examples and the facial type and the hair are close in style. It is probable that the right arm of the Thyssen *Christ* was originally further from the body in a more open gesture, so that the pose would have even more closely resembled that of the Tivoli group. Jean-René Gaborit, in an article on a similar group to

Notes
1 I would like to thank Mr Grassi for discussing with me his methods of conservation and the physical state of the figure
2 For a detailed treatment of these Entombment groups, see W. H. Forsyth: *The Entombment of Christ: French Sculptures of the Fifteenth and Sixteenth Centuries* (Cambridge, MA, 1970), and T. Verdon: *The Art of Guido Mazzoni* (New York and London), 1978, 19–27
3 This method of fixing was common practice for most Romanesque wood *corpora*, and may be seen most clearly when a *corpus* has lost its arms (for example, see P. Verdier: 'A Romanesque Corpus', *The Bulletin of the Cleveland Museum of Art* (March 1981), figs. 1, 5–7, 8–12)
4 It shares this feature with the Italian figures of Christ stylistically closest to it: see J.-R. Gaborit: 'Un groupe de la descente de croix au Musée du Louvre', *Monuments et Mémoires. Fondation Eugène Piot*, LXII (1979), 149–83

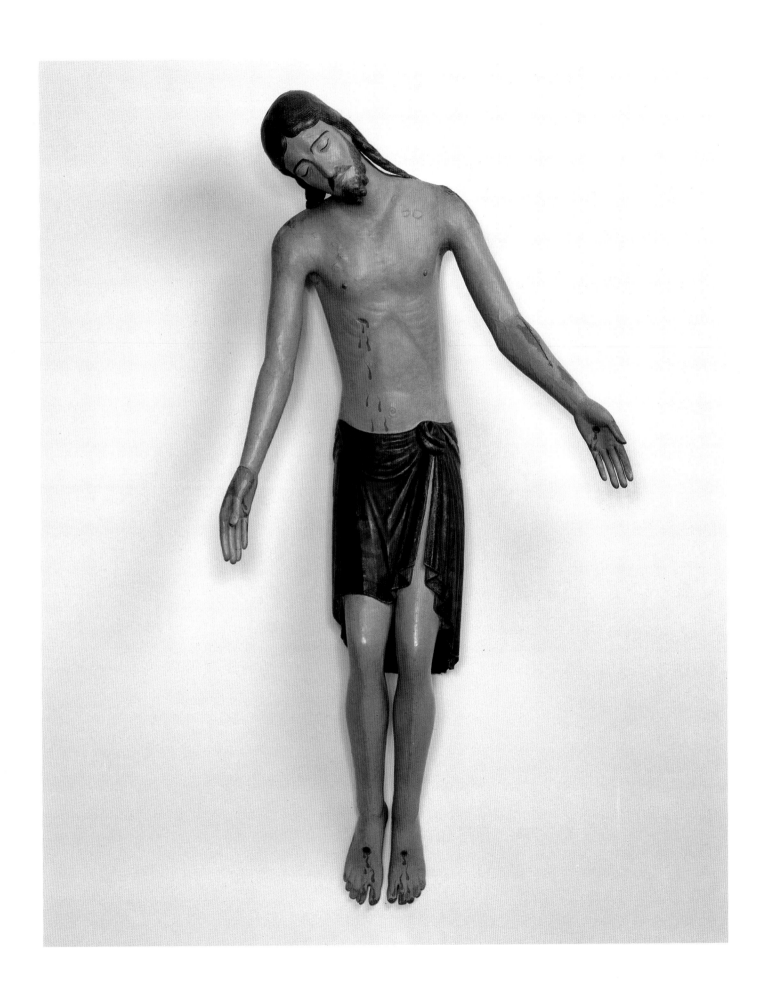

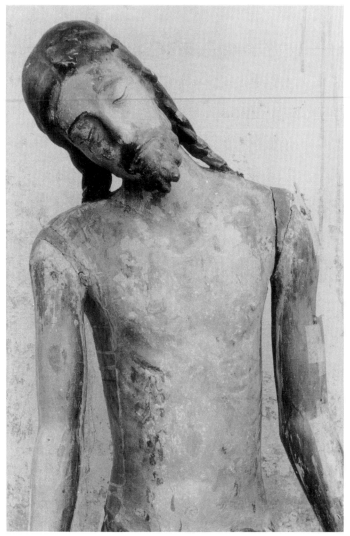

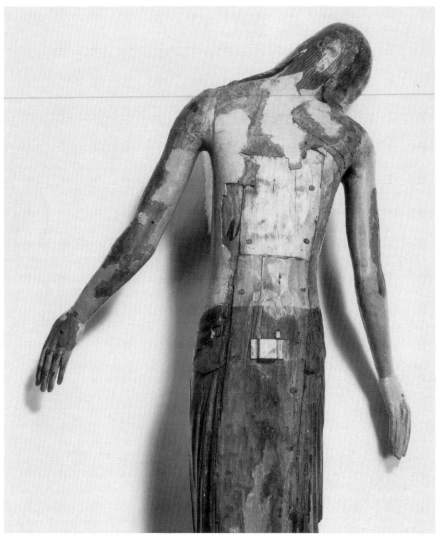

[13] *The Dead Christ, before restoration* [13] *Back of the Dead Christ*

the Tivoli *Deposition* acquired by the Musée du Louvre in 1967 (fig. 3), formed a small group of sculptures which he felt came from the same workshop; this group consisted of the Tivoli and Louvre ensembles, a *Dead Christ* in the Galleria Nazionale dell'Umbria in Perugia (fig. 4), another *Christ* in the Castello Sforzesco in Milan (fig. 5), and a fragmentary figure of Joseph of Arimathea in the Stoclet Collection in Brussels.[5] Gaborit illustrated the Thyssen *Christ* in his study but considered it to be 'une copie fidèle et alourdie de ceux de "l'atelier de Tivoli": même chevelure, perizonium presque semblable, mais les proportions sont moins heureuses et les articulations plus lourdes'.[6] However, the similarities with the rest of the group are more marked than the differences, and it seems sensible to include the Thyssen *Christ* with the other pieces.

Comparing the Thyssen *Christ* with those at Perugia and Milan it is immediately apparent that they are intimately linked. As with the Tivoli *Christ*, the perizonia are very similarly treated (although the Milan *Christ* has a curving edge at the front of the perizonium) and the general bearing is remarkably close. The arrangement of the hair on all three examples is very similar, the Milan *Christ* even retaining the dark brown lines to indicate the hairs on the head, and the beard, with its curling ends, is virtually the same.[7] Another feature which links the Thyssen and Milan *Christs* is the painted decoration around the lower edge of the perizonium, in the form of a patterned border.

Notes

5 *Ibid.*, 158. I am most grateful to Jean-René Gaborit for discussing the Thyssen-Bornemisza *Christ* with me and for supplying photographs of the Louvre ensemble

6 *Ibid.*, 173, fig. 23

7 A close similarity is also clearly apparent with what remains of the hair of the Paris *Christ* (fig. 1). The St John in the Paris group also shares this same treatment of the hair (Gaborit, *op. cit.*, fig. 5)

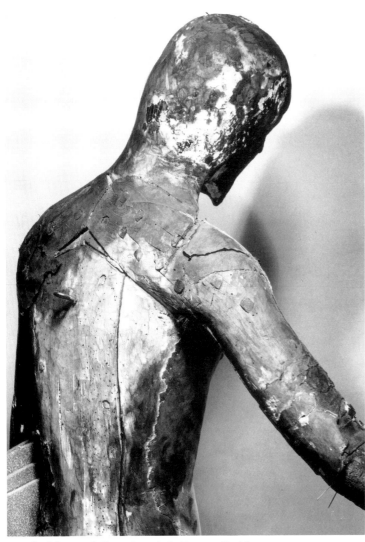

1 Back of the Dead Christ (Musée du Louvre, Paris)

2 Group of the Deposition of Christ, *c.* 1220–30 (Tivoli Cathedral)

3 Group of the Deposition of Christ, *c.* 1230–40 (Musée du Louvre, Paris)

It has been proposed by Gaborit that the workshop responsible for producing the pieces in this group probably operated in the area of northern Latium and Umbria, possibly travelling to the churches where their sculptures were erected. This is reinforced by their provenances: the Tivoli *Deposition* was made for the Cathedral there, the Perugia *Christ* was formerly in the abbey at Roncione, and both the Paris and Milan sculptures were on the art market in Rome at the beginning of the century. Their dating is helped by the fact that an inscription at the foot of the Perugia Cross, albeit of eighteenth-century date, gives 1236 as the time of its execution.[8] Given that the above-mentioned group has such a close family resemblance it is unlikely that they are divided by more than one or two generations, and their time-span would therefore fall within the years 1220–60. It does not seem possible to be more precise than that, and Gaborit's stylistic progression of the Tivoli *Deposition* first (1220–30), followed by the Paris group (1230–40) and finishing with the Milan *Christ* (1240–50) cannot be considered as final.[9] Because of its close similarity to the Perugia and Milan *Christs* it seems reasonable to date the Thyssen *Christ* within the date-bracket 1230 to 1250.

It has not proved possible to re-unite the present *Christ* with any of the members of its erstwhile ensemble, which are now presumably lost. Several figures, obviously Central Italian and of the first half of the thirteenth century, now divorced from their ensembles, do exist, for instance a Virgin and St John in the Musée de Cluny in Paris, the already-mentioned Joseph of Arimathea in the Stoclet Collection, and two figures in the Acton Collection in Florence, but they cannot be linked with any of the isolated *Christs* previously discussed.[10]

The Thyssen-Bornemisza *Dead Christ*, in its restored state, is a sculpture of the first importance for the history of Italian medieval wood sculpture. The pristine condition of its polychromy, preserved for hundreds of years beneath later layers of paint, is at first difficult to reconcile with a medieval work of art. However, it is precisely this life-like appearance – with the vivid red drops of blood running from Christ's lance-wound and His feet and the carefully-rendered hairs of His beard and moustache – which would have most impressed the thirteenth-century audience gathered in front of such a Deposition group.

Notes

8 For the wording of the inscription, see Gaborit, *op. cit.*, 157, n. 19

9 *Ibid.*, 172

10 For the Cluny *Virgin and St John*, see Gaborit, *op. cit.*, figs. 14–5; for the Stoclet *Joseph of Arimathea, ibid.*, fig. 9

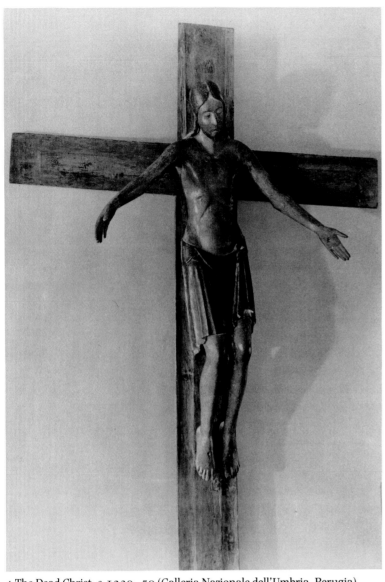

4 The Dead Christ, *c.* 1230–50 (Galleria Nazionale dell'Umbria, Perugia)

5 The Dead Christ, *c.* 1230–50 (Castello Sforzesco, Milan)

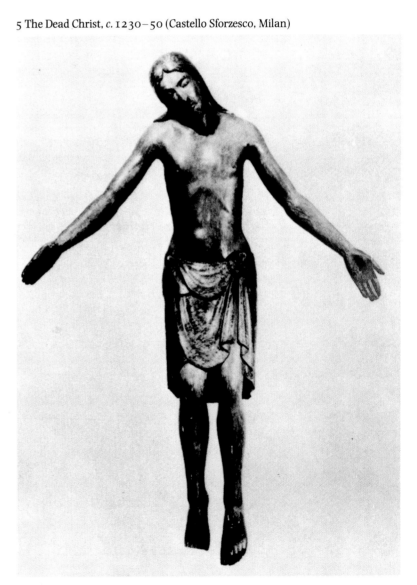

14 Virgin and Child

Central Italian (Umbria?), mid-thirteenth century
Polychromed poplar

Dimensions
Height: 115.5 cm; width (at base): 27.5 cm

Provenance
Bought by Baron Heinrich Thyssen-Bornemisza (1875–1947) before 1938
K7

The Virgin sits stiffly upright, holding the Christ-Child on her knees in front of her: He blesses with His right hand and holds a fruit in His left. The Virgin wears a white veil, checked with dark blue, red and orange lines, which drops over her shoulders to cover her upper chest; the veil has threads hanging from it. She wears a full-length blue garment with triangular arrangements of small white dots underneath a now pale green – blue behind the Child's head – cloak with a red lining (visible inside the sleeves). Both garments have decorative borders with alternating panels of cross-hatching and quadrilobed designs. She wears red slippers. The Christ-Child wears a red tunic decorated with triangular arrangements of three small white dots over a dark blue undergarment only visible at the sleeves and around His feet. He wears red shoes. Around His waist is a decorated girdle with the same design as on the hem of the Virgin's garments, an alternation of cross-hatching and quadrilobed devices.

The amount of over-painting the sculpture has received is difficult to ascertain at present without restoration. Certain areas, such as the hair of the Christ-Child, show clear indications of several different layers of paint, although in most cases the later colour seems to be based on what is underneath. The piece is substantially intact, the major damage being to the Child's right hand, where the thumb and the first two fingers are broken. The back has been hollowed out (fig. 8, page 25). Substantial amounts of the linen canvas strengthening still remain around the edges, and new pieces of canvas have been added at the bottom of the hollowed-out area. Various methods for securing the group have been used: the earliest were two butterfly loops driven right through each shoulder of the Virgin and opening out at the front. At the back between the two loops is a circular hole which was probably never used as it is too shallow. The present hanging is facilitated by two steel eyes driven into the sides of the hollow approximately 6 cm below the older loops. About 40 cm from the bottom are two 6-cm cut-outs at the back: these are clearly original, as there is paint over the cuts, but their function is not clear. They possibly accommodated the back or arms of a throne.

This *Virgin and Child* may be associated with a number of similar painted groups, mostly in Italian collections, which for stylistic reasons can be dated to the thirteenth century. The present *Virgin and Child* probably originally had a painted background and throne behind it, as

Additional bibliography
Feulner (1941), 11
Rohoncz (1949), no. 404
Rohoncz (1952), no. 404
Rohoncz (1958), 123

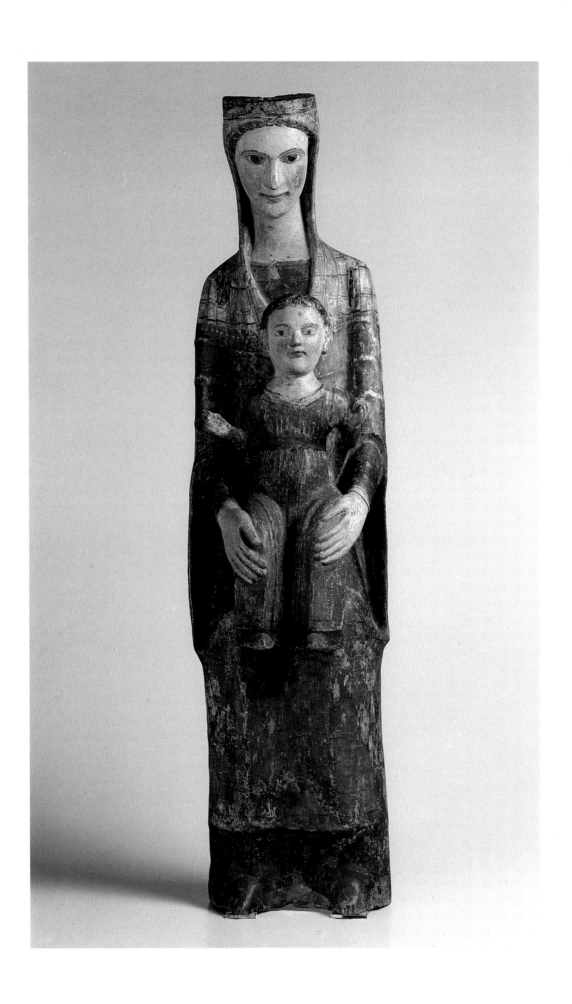

may be seen by comparing it with a similar group now in the Bargello in Florence (fig. 1). The Bargello group also corresponds to the Thyssen-Bornemisza *Virgin and Child* in its colour scheme: the Christ-Child wears a red tunic and the Virgin's garment is blue with red on the insides of the sleeves; in addition it seems likely that the present Virgin once wore a crown, which is now missing.[1] Apart from the Bargello *Virgin and Child*, a similar group may be found in the Museo di Palazzo Taglieschi (from the church of S Maria a Casale) at Anghiari (Arezzo) (fig. 2), while another was in a private collection in Rome in 1969.[2] They all appear to derive from the famous *Virgin and Child* from Borgo San Sepolcro (or works like it), now in the Staatliche Museen Preussischer Kulturbesitz in Berlin-Dahlem, which has an inscription identifying it as the work of a Presbyter Martinus and firmly dating it to 1199 (fig. 3).[3]

No detailed study of the late Romanesque painted Virgin and Child groups of Central Italy has yet been attempted, so that the chronological development of the type and the specific localisation of particular groups is still far from clear.[4] There can be no doubt that sculptures such as the present example were made in large numbers and were placed in churches throughout Central and Northern Italy. The standard of the workmanship obviously varied greatly and in some cases scarcely rises much above the level of peasant art; to add to the difficulty in studying the material, which is still only patchily published, many of the existing pieces have been severely over-painted or damaged, and very few can be dated accurately by means of inscription or documentary evidence. While the present sculpture is not of the highest standard, it nevertheless represents a typical example of this particular type of cult image, an Italian version of the late twelfth-century 'Auvergne' Madonna.[5] Although impossible to date accurately, it does not seem likely that it was made much later than the middle of the thirteenth century.

Notes

1 For a colour illustration of the Bargello *Virgin and Child*, see E. Carli: *La scultura lignea italiana dal XII al XVI secolo* (Milan, 1960), pl. 1

2 M. Pericoli: *Frate Jacopone e un'antica statua della Madonna in Todi* (Todi, 1982), pl. XXV; *Sculture antiche, catalogo dal II secolo a C. al XV* (Abbazia S Maria di Chiaravalle, 1969), pl. V [Centro Studi Piero della Francesca]

3 Carli, *op. cit.*, fig. XVII

4 But see O. Pächt: 'Eine Ducento-Madonna', *Belvedere*, VI (1924), 7–14; G. Castelfranco: 'Madonna romaniche in legno', *Dedalo*, X (1929–30), 768–78; G. de Francovich: 'A Romanesque School of Wood Carvers in Central Italy', *Art Bulletin*, XIX (1937), 5–57

5 I. H. Forsyth: *The Throne of Wisdom: Wood Sculptures of the Madonna in Romanesque France* (Princeton, NJ, 1972)

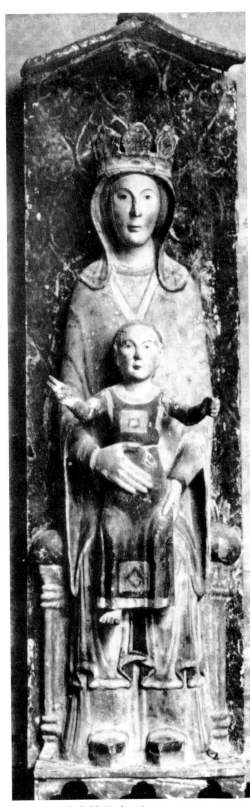

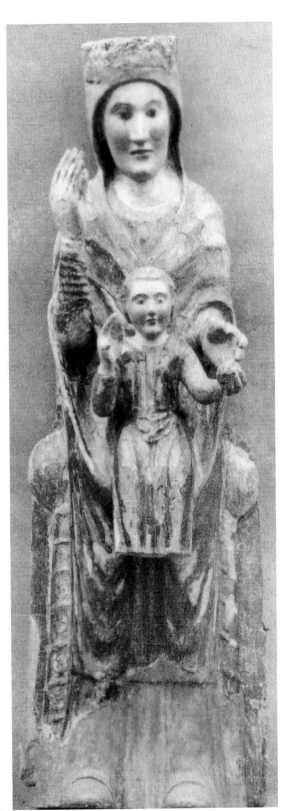

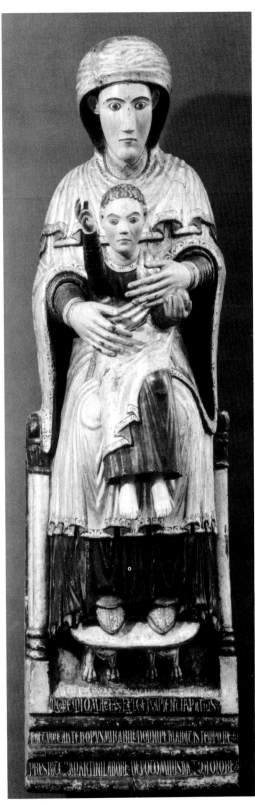

1 Virgin and Child, Umbria?,
mid-thirteenth century
(Museo Nazionale del Bargello, Florence)

2 Virgin and Child, Umbria?,
mid-thirteenth century
(Museo di Palazzo Taglieschi, Anghiari)

3 Virgin and Child, 1199
(Staatliche Museen Preussischer Kulturbesitz,
Berlin-Dahlem)

15 Virgin and Child

Mosan (Liège?), first half of the fourteenth century
Polychromed wood

Dimensions
Height: 101 cm; diameter of base: 25 cm

Provenance
Bought by Baron Heinrich Thyssen-Bornemisza (1875–1947) before 1938
K45

The Virgin stands on a circular base looking to her left, smiling towards the Christ-Child, whom she holds in the crook of her left arm. She wears a belted gown, over which is a long, voluminous mantle drawn across her body, the deep folds of the drapery falling in heavy curves towards her feet. On her head she wears a short veil held in place by a plain headband. The Child is dressed in a simple long tunic and turns to look at the Virgin. The Virgin's right arm is broken, as are both those of the Child, but the group is in generally good condition, although there is evidence of worm infestation, especially on the base. Substantial traces of polychromy, much of it original, survive. The mantle of the Virgin retains its gilding and traces of later blue paint; where the inside of the mantle has been exposed at the top there is a red and gold pattern. The gown of the Virgin was substantially blue and much paint survives on the faces of both the Virgin and the Child, in the cheeks and the eyes. The back is fully carved, with the drapery falling in long parallel folds.

Feulner described this *Virgin and Child*, for no stated reason, as coming from the 'Isle de France, um 1320'.[1] It clearly derives from famous Northern French prototypes such as the *Virgin* from the *trumeau* of the west portal of Reims Cathedral of the middle of the thirteenth century and other, slightly later versions of the type such as at Compiègne, but there are a number of small differences and refinements which point to a somewhat later date and a different centre of production.[2] The thick curving folds are more pronounced in the present sculpture, and the way that the drapery falls to the ground and crumples as it makes contact with the base is a feature alien to the Ile-de-France and the immediately surrounding areas in the second half of the thirteenth century. The head of the young Christ, with His long curly hair, is also more characteristic of later German sculpture than that of the Ile-de-France.

Very close to the Thyssen-Bornemisza *Virgin and Child* is an oak Virgin in the Musée royaux d'Art et d'Histoire in Brussels (fig. 1).[3] The fall of the drapery folds on the mantle in heavy, deep curves and the pose of the Christ-Child are especially close. The Brussels *Virgin and Child* was convincingly ascribed to Liège, *c.* 1300–10, by Robert Didier in the catalogue of the *Rhein und Maas* exhibition in 1972.[4] As Didier pointed out, this particular type of Virgin and Child would have been inspired by Ile-de-France models, probably transmitted by small-scale copies such as silver, ivory and wood statuettes: the well-known ivory Sainte-Chapelle Virgin, now in the Louvre (fig. 2), is of this type.[5] Two other very close examples to the Thyssen-Bornemisza and Brussels *Virgins*, also from the Liège-Maastricht region, are a little-known Virgin and Child in the parish church at Rijckhoven in the Netherlands (fig. 3) and a group formerly in the Collard-Bovy collection in Brussels.[6] The Thyssen *Virgin and Child* is probably later than the Brussels group and may be as late as 1350.

Notes
1 Feulner (1941), 27
2 Sauerländer (1972), pls. 189 (Reims) and 275 (Compiègne)
3 Inv. no. 4549; ill. in *Rhein und Maas: Kunst und Kultur 800–1400* (Cologne and Brussels, 1972), cat. no. N11 [exhibition catalogue: Kunsthalle, Cologne]
4 *Ibid.*
5 D. Gaborit-Chopin: *Ivoires du Moyen Age* (Fribourg, 1978), 204, fig. 199
6 See E. G. Grimme: 'Beobachtungen zu einigen Madonnenskulpturen des hohen mittelalters in Lüttich–Aachener Raum', *Aachener Kunstblätter*, XXIV–XXV (1962–3), 158–70, figs. 10 and 15; Grimme also discusses the influence of silver statuettes for the dissemination of the style

Additional bibliography
Rohoncz (1949), no. 427
Rohoncz (1952), no. 427
Rohoncz (1958), 131, pl. 103

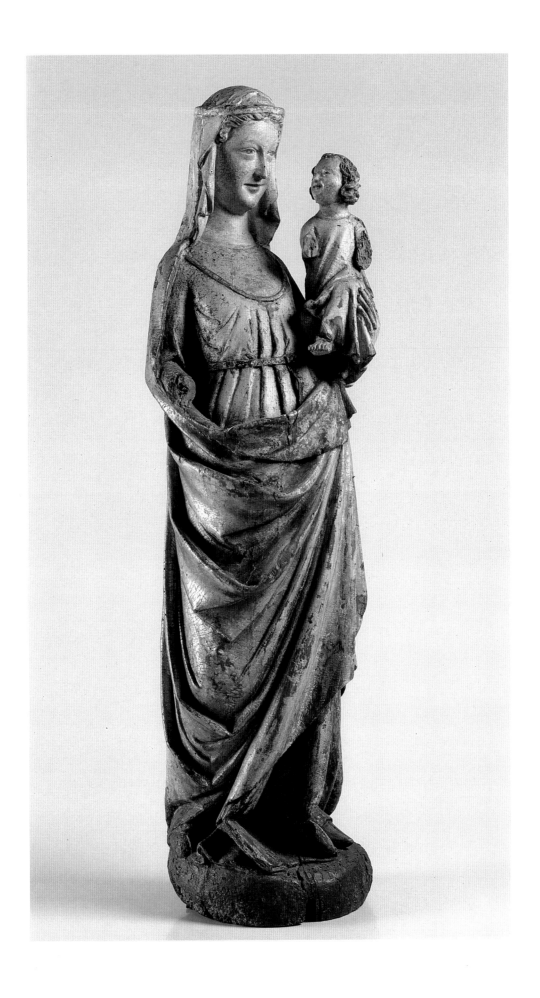

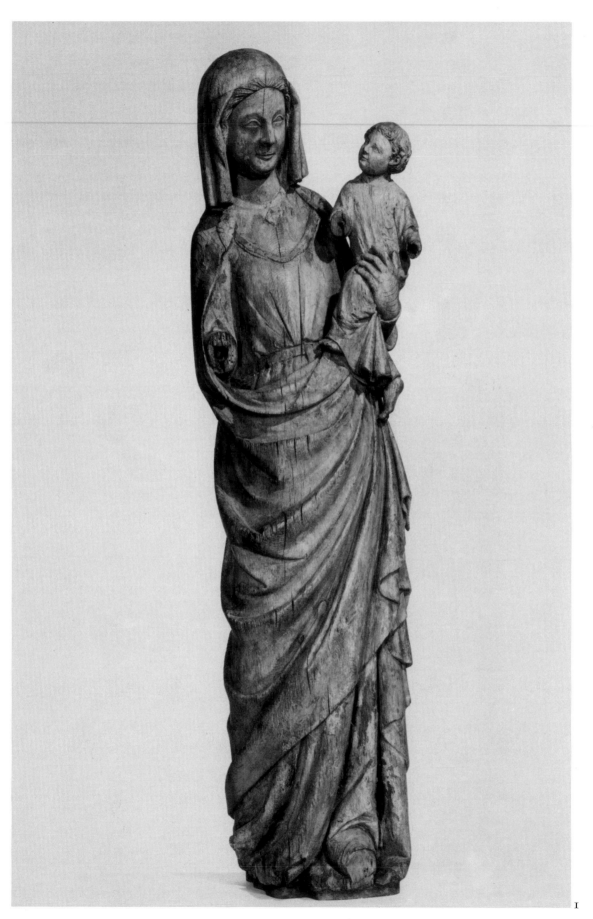

1 Virgin and Child, oak, Liège, *c.* 1300–10 (Musées royaux d'Art et d'Histoire, Brussels)

2 Virgin and Child from the Sainte-Chapelle, ivory, Paris, *c.* 1250–60 (Musée du Louvre, Paris)

3 Virgin and Child, oak, *c.* 1320–30 (parish church, Rijckhoven)

1

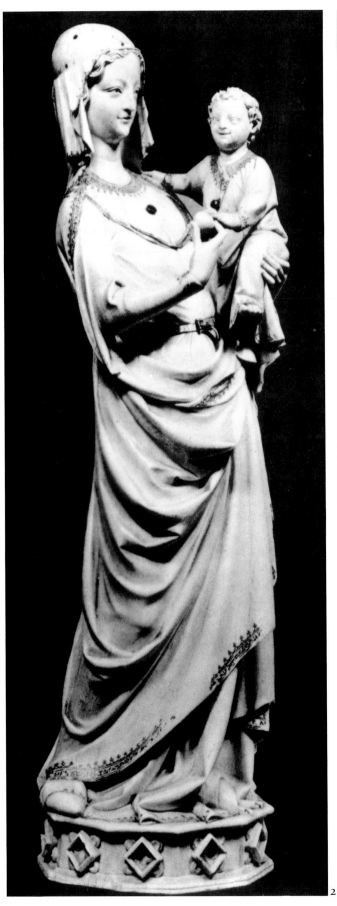

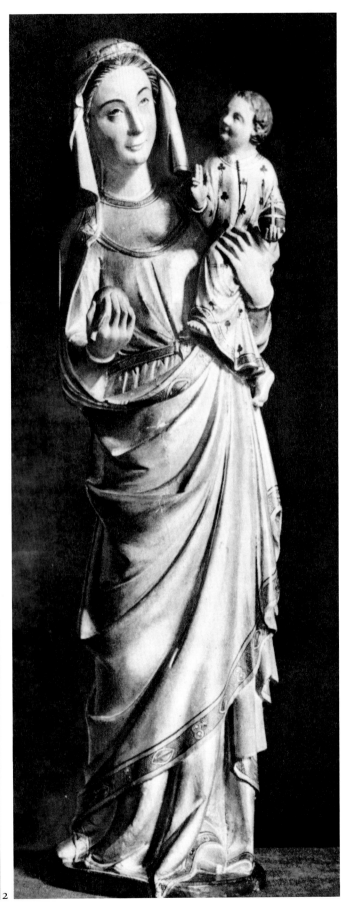

2

3

16 The Education of the Virgin
(St Anne teaching the Virgin to read)

Northern French (Ile-de-France?), mid-fourteenth century
Oak, with traces of polychromy

Dimensions
Height: 95 cm

Provenance
Bought by Baron Heinrich Thyssen-Bornemisza (1875–1947) before 1938
K46

St Anne, with veil and wimple, holds an open book in her left hand and rests her right on the infant Virgin's shoulder. The young Virgin, bare-headed, holds the book open with her left hand and reads from it. The group is carved in the round and there are small traces of polychromy remaining on the Virgin's left shoulder, dark blue, black, gilding and red.[1] There are not sufficient remains, however, to allow even a tentative reconstruction of the original colour scheme. The sculpture is in excellent condition.

The earliest examples of the iconographic type of St Anne teaching the Virgin to read are to be seen in the first half of the fourteenth century in England, in the wall-paintings at Croughton and in a set of apparels dedicated to the Life of the Virgin, now in the Victoria and Albert Museum.[2] Its exact origins are unclear and it falls outside the textual tradition of the Apocryphal Life of the Virgin.[3] After the middle of the fourteenth century the image had become widespread, appearing in a range of different media: it was especially popular in Books of Hours and in English alabaster carvings (Francis Cheetham mentions the existence of no less than 17 examples), and the configuration of the figures in the present group are closely matched in two later English groups on tombs of the late fifteenth century and early sixteenth, in Burton Agnes and Ross-on-Wye.[4]

The style of the group is clearly not English, its closest parallels being with sculpture produced in Paris and the North of France in the second quarter of the fourteenth century and later. The elegantly carved draperies and the slightly pinched, pointed faces of the two figures recall the female figures on the *clôture* of Notre-Dame, Paris, which were probably carved *c.* 1325–35.[5] The style of the Parisian Court School spread outwards from the capital so that it is not possible always to be confident with particular attributions.[6] However, the present group is not likely to be much later than 1350 and was probably carved in the region of the Ile-de-France.[7]

Notes

1 The red paint is found in some cracks at the back of the group, suggesting that it is not original

2 See J. Lafontaine-Dosogne: *Iconographie de l'Enfance de la Vierge dans l'Empire Byzantin et en Occident*, II (Brussels, 1965), 108–9, fig. 46

3 For this, see M. R. James: *The Apocryphal New Testament* (Oxford, 1924), 38–90

4 Lafontaine-Dosogne, *op. cit.*, 108, and F. Cheetham: *English Medieval Alabasters. With a catalogue of the collection in the Victoria and Albert Museum* (Oxford, 1984), 74; A. Gardner: *Alabaster Tombs of the pre-Reformation period in England* (Cambridge, 1940), figs. 52 (Ross) and 55 (Burton Agnes)

5 See D. Gillerman: *The Clôture of Notre-Dame and Its Role in the Fourteenth Century Choir Program* (New York and London, 1977), figs. 34–5, 99

6 For the influence of the Court School on sculpture at Ecouis, for instance, see Gillerman, *op. cit.*, 137–40, figs. 99–100

7 A stone group of St Anne and the Virgin attributed to the Ile-de-France and dated to the early fourteenth century, on the London Art Market in 1928, is of dubious authenticity (*Burlington Magazine*, LIII (1928), suppl., pl. 30)

Additional bibliography
Feulner (1941), 27
Rohoncz (1949), no. 428
Rohoncz (1952), no. 428
Rohoncz (1958), 131

17 Reliquary bust

Lower Rhenish (Cologne), 1350–70
Polychromed walnut[1]

Dimensions
Total height: 47.6 cm; height (without base): 41.6 cm; width (at base): 33.4 cm

Provenance
Bardini Collection, Florence[2]
Emil Weinberger Collection, Vienna
Bought at the Weinberger Collection Sale, Vienna, 22–4 October 1929, lot 357 (ill.)
K57

Exhibition
Munich, 1930, no. 1

This reliquary bust portrays a female saint facing frontally. She wears a red tunic with gilded bands and her face and neck are painted in a naturalistic flesh tone; there is a black cross painted on her neck. On her head, covering her hair, she wears a ruffled hood, known as a *Rüschenhaube* or *Kruseler*. The base is not original, but has been skilfully fitted to the bottom of the bust and the join concealed.[3] The back has been cut down exposing the inside of the bust, and originally there would have been a separate top to the head, as may be seen by referring to a similar reliquary bust in St Ursula, Cologne (fig. 1). The present bust has been restored on more than one occasion, although there is good reason to believe that the original colours have been retained; in the illustration in the Weinberger sale catalogue the tip of the saint's nose has lost all its paint and there are wide cracks on the left of her face. These have been filled and the paint surface has been restored.

This type of reliquary bust was a common product of fourteenth-century Cologne. There are numerous examples in Cologne churches and in the Schnütgen Museum, the largest group being in the *Goldene Kammer* in St Ursula, a reliquary chapel containing the bones and other relics of St Ursula and the 11,000 virgin martyrs who supposedly followed her; the majority are dated *c.* 1310–70.[4] Most of the busts of the female saints have small round windows in the front of their chests, so that the relics could be seen from outside, a feature missing on the present example. Setting the Thyssen-Bornemisza bust further apart from the majority of Cologne busts is the *Rüschenhaube* she wears, a feature she shares with only a small number of other examples, in St Ursula, Cologne (fig. 1), and in the Cistercian abbey church of Marienstatt,

Notes
1 Erroneously described as limewood by Feulner (1941), 31
2 Illustrated in a general view of a room in the catalogue of the Bardini Sale, London (Christie's), 27 May 1902, the bust is not described in either the 1899 or 1902 Bardini sale catalogues and consequently does not appear to have been sold on either of those occasions
3 This was done before 1902, probably in Italy, giving the bust the air of an Italian portrait bust rather than a reliquary; it is not without significance that other polychromed wood busts still in the Bardini Collection have similar bases. The design around the base was presumably chosen to complement the pattern of the ruffled hood
4 Still the most convenient survey is O. Karpa: *Kölnische*

1 Reliquary bust, walnut, Cologne, c. 1350–75 (St Ursula, Cologne)

Notes

Reliquienbüsten der gotischen Zeit aus dem Ursulakreis (von. ca. 1300 bis ca. 1450) (Dusseldorf, 1934) [Rheinischer Verein für Denkmalpflege und Heimatschutz, 27]

5 On the Marienstatt altar, see F. Lübbecke: *Die Gotische Kölner Plastik* (Strasbourg, 1910), 36–44, pls. IV–V; Karpa, *op. cit.*, 60–66, places the Marienstatt busts and other related examples in his 'Typus 10, Die St Martialis Gruppe', 1340–60; F. Witte: *Tausend Jahr deutscher Kunst am Rhein* (Berlin, 1932), 91, 99, pl. 113; H. Keller: 'Der Flügalter als Reliquienschrein', *Studien zur Geschichte der europäischen Plastik: Festschrift Theodor Müller* (Munich, 1965), 128–9

6 Witte, *op. cit.*, 91; Keller, *op. cit.*, 129

7 Most obviously the sculptures of the High Altar; see most recently *Verschwundenes Inventarium: Der Skulpturenfund im Kölner Domchor* (Cologne, 1984), cat. nos. 55–74 [exhibition catalogue: Schnütgen Museum]

8 See for instance the profile portrait of an abbess on a Zurich Pfennig of 1377–80 and a Swiss terracotta figure of 1356–82 (H.-U. Geiger: 'Die Abtissin mit der Rüschenhaube: Zu einem seltenen Zürcher Pfennig des 14. Jahrhunderts', *Schweizer Münzblätter*, XXVI/101 (Feb 1976), 10–13 [Thyssen-Bornemisza bust ill. p. 13]). See also E. Nienholdt: *Die deutsche Tracht im Wandel der Jahrhunderte* (Berlin, 1938), 49, pls. 13 and 15; M. Davenport: *The Book of Costume* (New York, 1948), 233, pl. 654 (German brass, 1377); and Karpa, *op. cit.*, 30–31. The fashion for the *Rüschenhaube* seems to have continued into the early years of the following century: see the tomb monument of King Ruprecht I and Elisabeth von Hohenzollern of *c.* 1410 in the Heiliggeistkirche in Heidelberg (E. Zahn: *Die Heiliggeistkirche zu Heidelberg* (Karlsruhe, 1960), fig. 21)

where there are six similar busts in the central part of the winged reliquary altar (fig. 2).[5] This altar was probably made *c.* 1360 as a document records that in that year a certain Gerhard Nagel, recently dead, had left 100 marks '*ad tabulam in summo altari*'.[6] There can also be little doubt that the altar is the product of a Cologne workshop, given the form of the reliquary busts and the style of the sculptures on the upper level, showing the seated Christ and the Virgin and standing saints, which are related to sculptures from the first half of the century in Cologne Cathedral.[7] The presence of the *Rüschenhaube* also reinforces a date in the third quarter of the fourteenth century, as there is evidence in other media of a fashion for this particular type of headdress at that date.[8]

Additional bibliography
Rohoncz (1949), no. 434
Rohoncz (1952), no. 434
Rohoncz (1958), 134

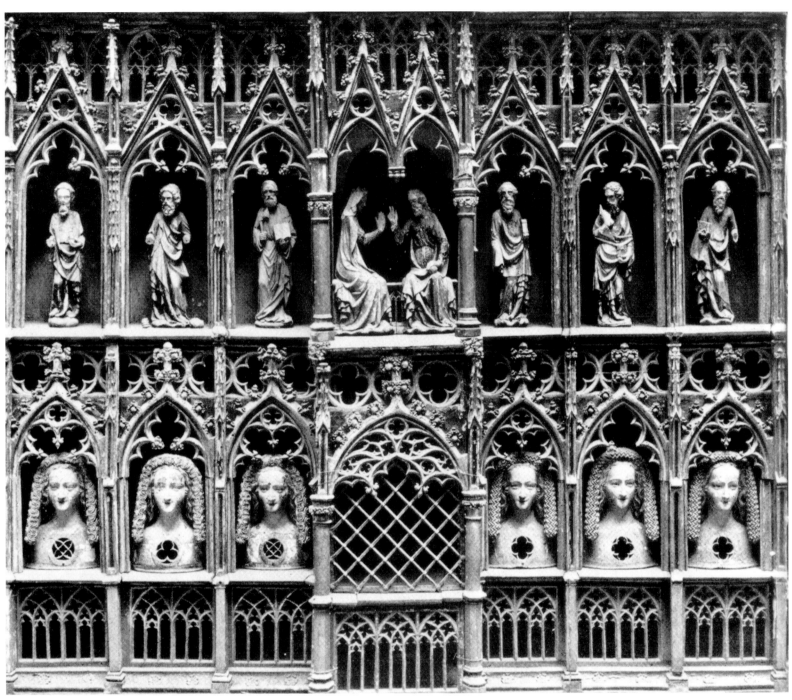

2 Central part of the Marienstatt altar, *c.* 1360

18 The Virgin Annunciate

Italian (probably Sienese), *c.* 1360–80
Wood and gesso painted and parcel-gilt

Dimensions
Height: 68.8 cm

Provenance
Robert von Hirsch Collection, Frankfurt-am-Main and Basel
Bought at the von Hirsch Sale, London (Sotheby's), 22 June 1978, lot 383
K42A

Exhibition
Leipzig, *Internationale Buchkunst Ausstellung*, 1927

Of fruit-wood, probably pear (*pyrus communis*), the statuette is basically constructed from two logs mitred together at right-angles, the horizontal log split in half to form a flat base. The forearms are carved separately and pieced on at the elbows. The crown of the head is formed of a separate piece of wood secured by three iron nails (no doubt to cap the end-grain of the log and facilitate the carving of the top of the head). An iron nail projects 8 mm from the breast (its purpose not apparent). The layer of gesso is exceptionally thick, especially on the head, where the hair and the features of the face appear to be very largely modelled in it. The borders of the cloak, the wristbands of the sleeves, and the neckband of the gown are punched in the gesso with a conventional repeating pattern of seven points disposed in a hexagon. The statue is heavily worm-eaten, especially at the bottom where little sound wood remains, and it is clear that it has undergone substantial restoration. At the bottom the wood has been consolidated with wax, and an attempt has been made to rebuild the surface with paper and cloth over which new gesso has been laid. At the back, approximately where the ankles should be, the wood is sawn off square (either because there was a further piece-on at this point, or because the wood was too hopelessly decayed for restoration).

Two fingers of the left hand are entirely missing and four fingers of the right hand from the first knuckle, in both cases eaten away by worm. Almost the entire visible paint surface is modern. The cloak is now painted in a light red overlaid by gilding artificially abraded to reveal the paint in patches. A piece of the original paint surface of the cloak survives in a decayed state behind the left forearm in the form of a rich red translucent glaze over a gilt ground, designed to produce a lustre effect. No trace of the original paint surface of the gown, now painted a bright blue with repeated gilt motifs, is visible. The flesh areas are painted naturalistically. The hair is wholly gilt. Under the base is an oval paper label printed in red with the legend: 'Internationale Buchkunst Ausstellung, Leipzig, 1927'.

A close parallel for the pose of the figure, kneeling with hands crossed over the breast and downcast eyes, is to be found in the figure of the Virgin in a mid-fifteenth-century polychromed wood group of the Annunciation now in the Galleria Nazionale dell'Umbria at Perugia.[1] While Annunciation groups in which the Virgin kneels are rare in Italian sculpture, it is clear by this analogy that the present statuette represents the Virgin Annunciate and originally formed part of such an Annunciation group in which both figures knelt. In the group at Perugia the Virgin kneels at a small lectern to which her eyes are directed downwards, and it is possible that the present figure originally did the same.

Notes
1 For this see E. Carli: *La scultura lignea italiana dal* XII *al* XVI *secolo* (Milan, 1960), pl. 62. Cf. also a fifteenth-century Marchigian kneeling Annunciation group in the Palazzo Ducale, Urbino, *ibid.*, 102, fig. CXIV

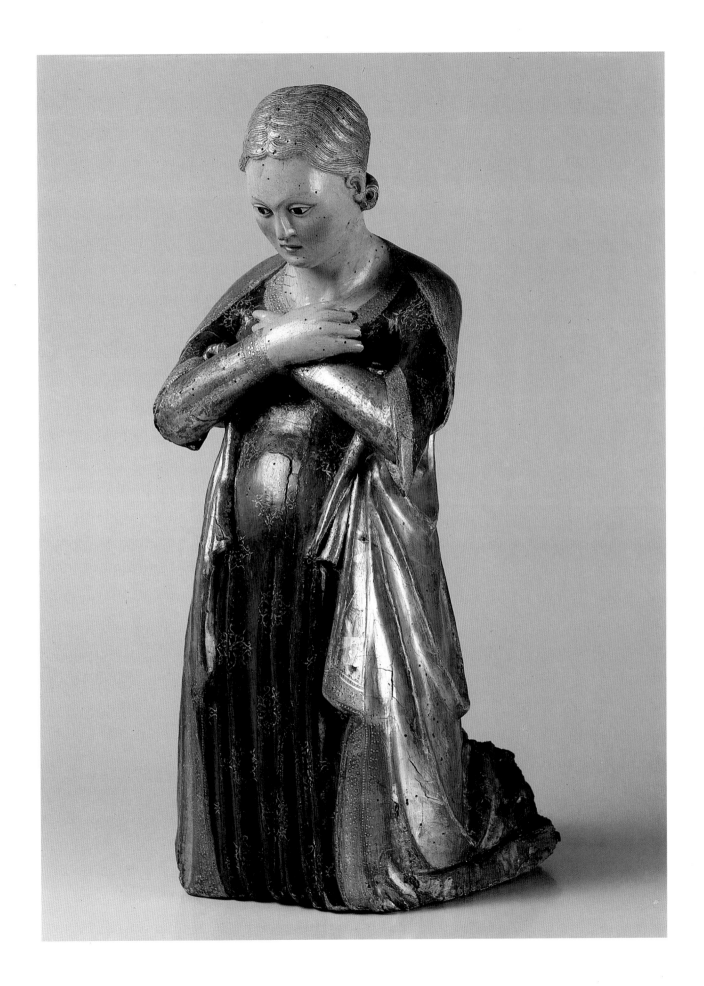

While the group at Perugia provides a close parallel for the pose of the Thyssen statuette, it offers no analogies in style or facture. Unpublished before it was catalogued for the von Hirsch Sale in 1978, the statuette was then classified as Sienese and dated *c.* 1450 with the observation that 'The same short centrally parted hair, the strong black eyes, small mouth and elegant elongated lower body is found in the Sienese standing Virgin from an annunciation group in the Bardini Museum, Florence'.[2] This is a statue in polychromed terracotta, not wood, which must date, at the latest, from the early fifteenth century.[3] Its hairstyle, combed severely back and knotted into a bun, in no way resembles that of the present figure, its physiognomy is quite different, and it seems in general to offer no useful analogies in this instance. The entry was supported by an unspecific reference to Enzo Carli's *La scultura lignea senese* (Milan, 1951), but Carli neither reproduces nor mentions in that work any sculpture which corresponds in a meaningful way with the present figure.

Sculpturally unambitious, the figure resists classification in terms of Italian polychromed wood sculpture of the fourteenth and fifteenth centuries. A striking correspondence can be found, however, in Sienese goldsmiths' work of the second half of the fourteenth century, with the reliquary bust of St Giuliana now in the Cloisters Collection of the Metropolitan Museum of Art, New York (fig. 1).[4] In this the face, with its smooth, rounded surfaces, its strongly-defined eyes under arched eyebrows and its small mouth, is treated in a closely analogous way. The short hairstyle swept back behind the ears and curled up at the bottom is also remarkably similar. There also appears to be a technical correspondence in that, as Hoving has demonstrated,[5] the face of the bust is modelled-up in thick gesso on a rudimentary base of *repoussé* copper, and it would seem that the face of the statuette was handled in the same way, being worked in exceptionally thick gesso, probably on a base which was quite summarily carved. In both pieces the finish on the face has the effect of enamelling. In both pieces the hair is gilt, and, while this is normal in a reliquary bust, it is unusual in Italian polychromed wood sculpture, in which the hair is generally painted in naturalistic colours.

The reliquary bust, according to the inscription on the gilt copper tabernacle which originally housed it (now in the Galleria Nazionale dell'Umbria at Perugia),[6] was made to contain a relic of the cranium of St Giuliana, presented to the convent of St Giuliana at Perugia in 1376. It probably itself dates from 1376 or shortly afterwards. Hoving attempted to prove that the maker of the bust re-used an earlier reliquary portraying a male. He based his argument on the disparity between the features of the face in the *repoussé* copper shell and those modelled-up in gesso over this, and on his belief that the hairstyle (formed in the copper) was not acceptable as a female style of the fourteenth century, but was a male style current in the first half of that century, citing as a typical example of this the reliquary bust of St Nicander dated 1340 in the Chiesa del Viatico at Venafro, Molise.[7] The hairstyle of the bust of St Nicander, which is indeed a common male style of its time, is not, however, properly analogous: it covers the ears, instead of being swept back behind them as in the bust of St Giuliana, and hangs loosely around the head instead of clinging tightly to it. The hairstyles of the bust of St Giuliana and of the Thyssen statuette are in fact perfectly acceptable as styles affected by young women in Siena in the middle and second half of the fourteenth century. Close analogies can be found for them, for instance, in the group of dancing girls in Ambrogio Lorenzetti's fresco of *La vita cittadina nel Buon Governo* of 1338–40 in the Sala della Pace in the Palazzo Pubblico at Siena,[8] and a precise parallel for the hairstyle of the present statuette is worn by St Agnes in the Sienese triptych of the Resurrection with Saints formerly in the church of S Chiara at Borgo San Sepolcro, and now in the Pinacoteca Comunale there, which must date from soon after 1360.[9] Comparisons adduced by Hoving for the form of the *repoussé* shell of the reliquary with reliquary busts of the first half of the fourteenth century in Dalmatia are unconvincing, and it seems likely that the copper shell and the gesso face are contemporary, the former worked simply as a rough support for the latter.

According to a fragmentary inscription attached to it, the reliquary bust was made in Rome.[10]

Notes

2 *The Robert von Hirsch Collection*, II, *Works of Art*, London (Sotheby's), 22 June 1978, lot 383 [sale catalogue]

3 Inv. no. 727/1314; see A. Lensi: 'Il Museo Bardini: stucchi e terrecotte', *Dedalo*, IV (1923–4), 499, 500, ill. on p. 505. Lensi compares it in general terms with the figure of the Virgin in the polychromed wood group of the Annunciation by Jacopo della Quercia in the Collegiata at San Gimignano (1421)

4 My thanks to Paul Williamson for this observation. For the bust, acquired in 1961 (no. 61.266), see T.P.F. Hoving: 'The Face of St. Juliana: the transformation of a fourteenth century reliquary', *The Metropolitan Museum of Art Bulletin*, XXI (Jan 1963), 173–81

5 *Ibid.*

6 See F. Santi: *Galleria Nazionale dell'Umbria*, I, *Dipinti, sculture e oggetti d'arte di età romanica e gotica* (Rome, 1969), 171–3, no. 146

7 See P. Piccirilli: 'L'oreficeria medievale a Venafro e Isernia', *Rassegna d'arte*, XV (1915), 43–4

8 Ill. E. Carli: *La pittura senese* (Milan, 1955), 97, fig. 61

9 See F. Mason Perkins: 'Pitture senesi poco conosciute', *La Diana*, V (1930), 248–56 [leaf with St Agnes ill. 252, pl. 13]

10 The surviving parts of the inscription read as follows: '(C)APUD. SANTE. IULIANE/ROMA. A. D(omino). GUILLE(lmo)'. Hoving takes it that Guglielmo was the name of the author of the bust, but Palm (see Note 13 below) opts for the more likely conclusion that it was the name of the commissioner

11 See I. Macchetti: 'Orafi senesi', *La Diana*, IV (1929), 47–50; M. Accascina: 'Oreficeria senese in Sicilia', *La Diana*, V (1930), 211, 212, ill. 210, pl. 5; F. Rossi: *Capolavori di oreficeria italiana* (Milan, 1956), 12, 223, n. 18, ill. fig. iii

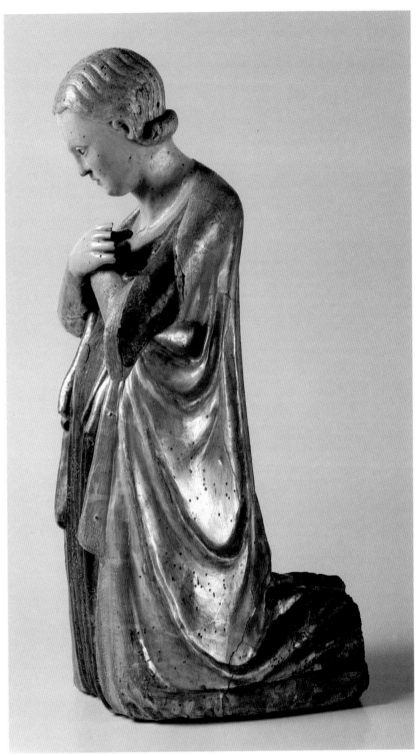

[18] *The Virgin Annunciate*
Front

[18] *The Virgin Annunciate*
Left profile

Hoving compared it with the great reliquary bust of St Agatha in the Cathedral of Catania, of silver-gilt with the face and hands painted naturalistically in opaque enamels.[11] The bust of St Agatha bears an inscription to the effect that it was completed by the Sienese goldsmith Giovanni di Bartolo in 1376. It is thus closely contemporary with the bust of St Giuliana. Giovanni di Bartolo Guidi is documented in papal service in Avignon and Rome between 1364 and 1385, apparently following Popes Urban V and Gregory XI in their movements between these two cities. He also worked intermittently in his native Siena and is last documented there in 1404. From 1369 to 1372 he worked in Rome, where he made for Urban V a great reliquary with the twin busts of SS Peter and Paul in silver-gilt, with the faces, as in the bust of St Agatha, painted naturalistically in opaque enamels (destroyed in 1799). In 1373 at the papal court at Avignon he accepted from the Bishop of Catania the commission for the bust of St Agatha. After its completion in 1376, he is documented in October of that year in Siena, and he probably followed Gregory XI back to Rome when the Pope returned there in January 1377. He is not recorded back at Avignon until 1380, after the death of Gregory.[12]

Concurring with Hoving's analogy to the bust of St Agatha, Palm has more recently linked the bust of St Giuliana to the Roman workshop of Giovanni di Bartolo.[13] This connection appears to be valid. Wherever the Thyssen statuette was made (possibly either in Siena or Rome), its closest affinities seem to lie with Sienese metalwork of the circle of Giovanni di Bartolo, and it is perhaps therefore the work of a Sienese artist, possibly more accustomed to working in metal than in wood, active c. 1360–80. It is perhaps worth noting in this connection that Giovanni di Bartolo is generally credited with the introduction into Sienese goldsmithery of plastic, as opposed to architectonic forms.

The delicate repeated gilt motif on the Virgin's blue gown is remarkably close to that which appears painted in blue and gold on the cloak of the standing Angel of the Annunciation in the Victoria and Albert Museum ascribed to Nino Pisano. As noted by Pope-Hennessy, this motif is found on Lucchese silk tissues of the second half of the fourteenth century.[14] While these motifs on the present statuette are applied to a modern paint surface, it seems possible that the restorer copied them from the remains of the original paint surface of the gown. † AFR

Notes
12 For a full account of Giovanni di Bartolo Guidi, see I. Macchetti, *op. cit.*, 43–52
13 R. Palm in *Die Parler und der schöne Stil 1350–1400*, I (Cologne, 1978), 33 [exhibition catalogue: Schnütgen Museum]
14 J. Pope-Hennessy, assisted by R. Lightbown: *Catalogue of Italian Sculpture in the Victoria and Albert Museum* (London, 1964), I, 38–40, no. 35

† A few hours before the catalogue was due to go to press, Paul Williamson drew my attention to a gilt and polychromed wooden reliquary bust of St Fina in the Museo Civico, San Gimignano which presents analogies to the present figure corroborative of a Sienese origin. The bust is plausibly ascribed by Alessandro Bagnoli to the Sienese goldsmith and sculptor Mariano d'Agnolo Romanelli (certainly recorded active in Siena 1376–91) (*L'art gothique siennois*, Avignon, 1983, pp. 294–7, no. 109 [exhibition catalogue: Musée du Petit Palais]). While clearly by a different (and sculpturally more accomplished) hand from the present figure, the bust is closely analogous in the distinctive hairstyle, the use of gilding on the hair, the separate piecing of the crown of the head (in its case to act as a cover for the receptacle for the relic), the smoothly-rounded treatment of the physiognomy and the painting of the face.

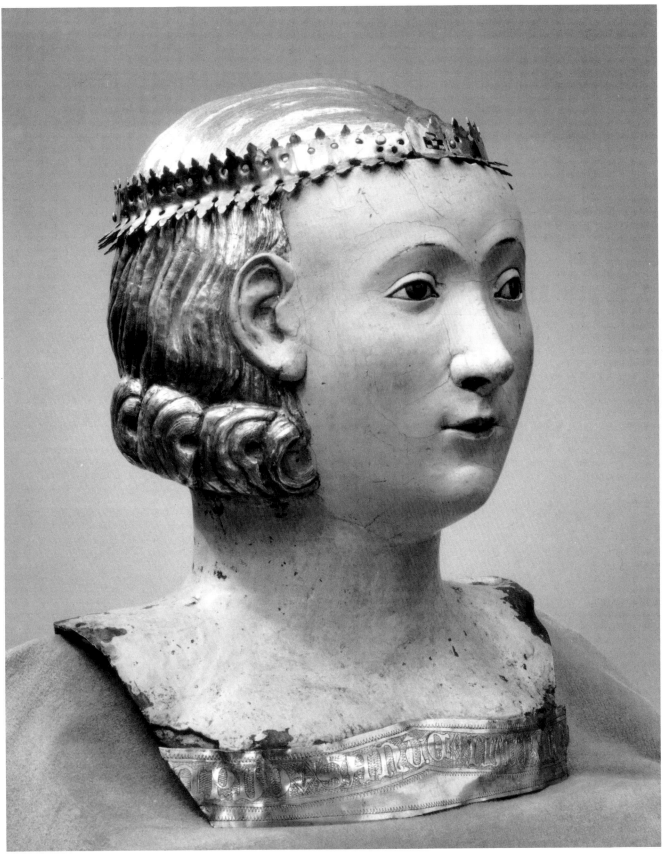

1 Reliquary bust of St Giuliana, gesso, tempera and gilding on copper, Rome, 1376 or soon after
(Metropolitan Museum of Art, Cloisters Collection, New York, 1961)

19 Virgin and Child

German (Cologne), *c.* 1380–90
Polychromed walnut

Dimensions
Height: 32 cm

Provenance
Dr Leopold Seligmann Collection, Cologne, by 1912[1]
Bought at the Seligmann Collection Sale, Berlin, 28 April 1930, lot 151[2]
K58

Exhibitions
Cologne, *Mittelalterliche Kunst aus Kölner Privatbesitz*, 1927, no. 16
Munich, 1930, no. 2, pl. 1
Cologne, Schnütgen Museum, *Grosse Kunst des Mittelalters aus Privatbesitz*, 1960, no. 45
Frankfurt am Main, Liebieghaus, *Kunst um 1400 am Mittelrhein: Ein Teil der Wirklichkeit*, 1975, no. 28
Cologne, Schnütgen Museum, *Die Parler und der schöne Stil 1350–1400*, 1978, p. 173[3]

The Virgin stands on an hexagonal base in a swaying S-shaped pose, supporting the Christ-Child on her left arm. She wears a mantle that is pulled around the upper part of the figure in a series of shallow horizontal curves; the end is bunched up over the left arm from which it cascades in rippling folds. Over her head, turned slightly towards the Child, she wears a veil from beneath which emerge delicate, curling tresses; a shallow rebate originally accommodated a metal crown. The back is flat but curved with low, more generalised folds; in the middle of the back is a compartment for relics, its edges recessed for a door now lost; a single nail remains. The curly-headed Christ-Child is partly clad in the Virgin's outer garment and plays with a bird which bites His finger.

The Virgin's right hand and the blossom are later replacements. Part of the bird and the Child's left hand have been broken but repaired. The back shows considerable worm damage around the shoulders, and the lower part of the base and drapery at the back has been renewed. The present polychromy of the draperies – light blue, off-white, green and blue – is the second of two later paint layers. The faces retain their original painted surfaces. Detailed investigation has established that the original polychromy was as follows: the Virgin wore a white veil, with both the inner and outer sides of the drapery of all three other garments gilded; her face was painted in naturalistic flesh tones with blue eyes and black irises; her hair was gilded. Her shoes were probably gilded and the base on which she stands was green with red sides. The Christ-Child's body was painted in flesh tones like those of the Virgin, and His hair was gilded. The bird was white-grey with a red beak.[4]

The figure was first published by Beitz who persuasively related it to the *Friesentor-Madonna* in the Schnütgen Museum (fig. 1), traditionally said to have come from the Friesentor in Cologne, demolished in 1882, and to a Virgin and Child seated in the sun in the same collection (fig. 2).[5] Over a dozen Madonnas, mainly of similarly small scale and associated with Cologne and the Lower Rhineland, are regarded as dependent in varying degrees on the Friesentor figure.[6] The present sculpture is the most closely comparable example, the similarities consisting principally of the poses of both Virgin and Child, the curly hair of the Child and the arrangement of the hair and thin draperies. The small features of the Virgin's face and the notable delicacy of the hair,

Notes
1 Described as in the Seligmann Collection by E. Beitz: 'Eine kölnische Standmadonna aus der zweiten Hälfte des XIV. Jahrhundert', *Zeitschrift für Christliche Kunst*, XXX (1912), 36
2 P. Clemen, O. von Falke and G. Swarzenski: *Die Sammlung Dr. Leopold Seligmann, Köln* (Berlin, 1930)
3 Ill. in colour in *Die Parler und der schöne Stil 1350–1400, Resultatband* (Cologne, 1980), pl. 66
4 Inspection and analysis carried out by Fritz Buchenrieder, Bayerisches Landsamt für Denkmalpflege, Munich
5 Beitz, *op. cit.*, 33–6. For the relationship between these three figures, see the detailed discussion by R. Palm in Cologne, Schnütgen Museum exhibition catalogue (1978), 169–73
6 Other examples less closely related to the Friesentor figure include that in the Kunstgewerbemuseum, Cologne (*ibid.*, 170–71) and that formerly in the Germanisches Nationalmuseum and Wilm Collection, Munich (for which see W. Josephi: *Die Werke plastischer Kunst, Kataloge des Germanisches Nationalmuseum* (Nuremberg, 1910), cat. no. 222)

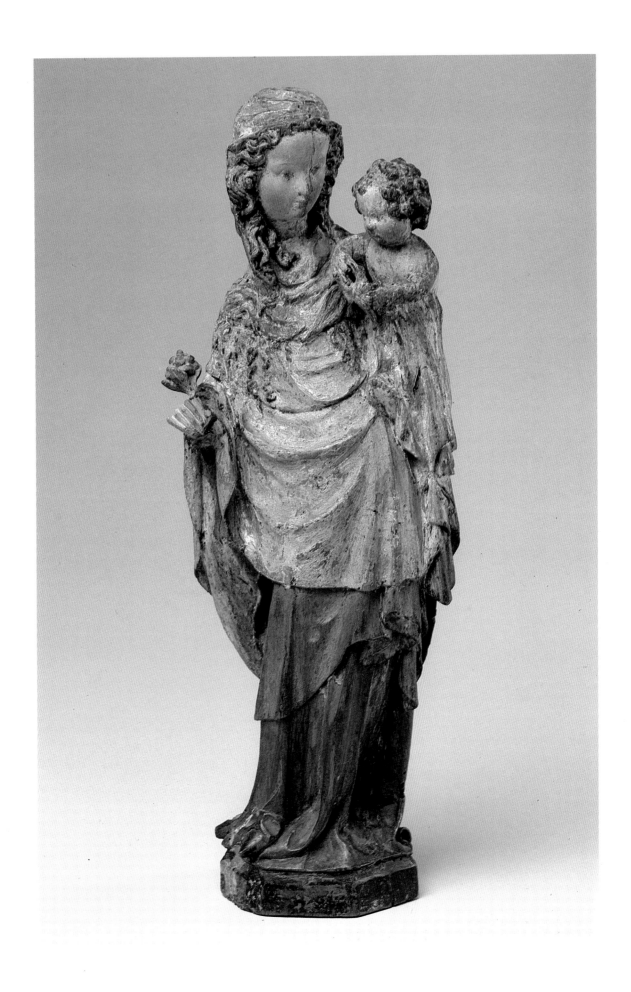

however, are still more closely paralleled by the *Virgin in the Sun* already mentioned, a *St Catherine* at Bensberg-Herkenrath[7] and a female saint now in the Schnütgen Museum.[8] All are of walnut, apparently largely gilded originally, and may be attributed to the same workshop.[9]

A Cologne origin for this group, suggested by the provenances of several of the pieces, is supported by parallels in late fourteenth-century monumental sculpture from Cologne, notably the figures on the St Peter portal of the Cathedral and the Annunciation group at Altenberg (probably from the Cathedral workshop).[10] However, Palm, citing similarities between the *Friesentor-Madonna* and a figure in a Belgian private collection, has pointed out elements derived from sculptural styles current further west in centres such as Tournai.[11] None of these figures is securely dated, but comparison with sculpture from the Überwasserkirche, Münster, dated 1374, supports an approximately contemporary dating for the *Friesentor-Madonna*. Although the discrepancy in size makes close comparison difficult, the differences between the Friesentor figure and the present piece indicate that the Thyssen-Bornemisza *Virgin* is slightly later.

The figure is above all outstanding as an example of a small-scale devotional sculpture, a category to which many of the other *Friesentor-Madonna* derivatives belong. Its precious quality would originally have been enhanced by its largely gilded surface, giving it an appearance akin to a piece of goldsmith's work, which also provides a parallel for its reliquary function, apparently unique among surviving figures from this group. The iconography of the bird biting the Christ-Child's finger is found in other figures based on the *Friesentor-Madonna*, including those in the Suermondt Museum, Aachen, and Schloss Braunfels, and apparently has its origins in Parisian sculpture of the mid-fourteenth century.[12]

[19] *Virgin and Child*
Back view

Notes

7 E. Willemesen and W. Glaise: 'Katalog der restaurierten Werke', *Jahrbuch der rheinischen Denkmalpflege*, XXVII (1967), 264–5, pls. 254–63

8 R. Palm, *op. cit.*, 172, when the work was in the Koch Collection

9 Analysis of the wood has shown the Thyssen-Bornemisza figure to be of walnut and not oak as hitherto described

10 R. Palm, *op. cit.*, 174

11 *Ibid.*, 169; see also R. Didier, M. Henss, J. A. Schmoll gen. Eisenwerth: 'Une Vierge tournaisienne à Arbois (Jura) et le problème des Vierges de Hal. Contribution à la chronologie et à la typologie', *Bulletin Monumental*, CXXVIII/2 (1970), 93–113

12 For the Aachen figure, see E. Grimme: *Suermondt-Ludwig-Museum Aachen. Europäische Bildwerke vom Mittelalter zum Barock* (Cologne, 1977), cat. no. 26. For the Schloss Braunfels example (which shows the dissemination of this type in the Middle Rhine), see Frankfurt, Liebieghaus exhibition catalogue, no. 29

Additional bibliography

E. Lüthgen: *Die abendländische Kunst des 15. Jahrhunderts* (Bonn and Leipzig, 1920), 29
——: *Rheinische Kunst des Mittelalters aus Kölner Privatbesitz* (Bonn and Leipzig, 1921), pl. 44
F. Witte: *Der goldene Schrein* (Cologne, 1928), pl. 137
R. Hamann: 'Die Madonna der Sammlung Drey', *Wallraf-Richartz Jahrbuch*, N.F. I (1930), 39
Feulner (1941), 32, pl. 24
Rohoncz (1958), 134–5, pl. 104
P. Bloch: *Kölner Madonnen* (Mönchengladbach, 1961), 19
T. Müller: *Sculpture in the Netherlands, Germany, France and Spain: 1400–1500* (Harmondsworth, 1966), 32
E. G. Grimme: *Deutsche Madonnen* (Cologne, 1966), 104–5

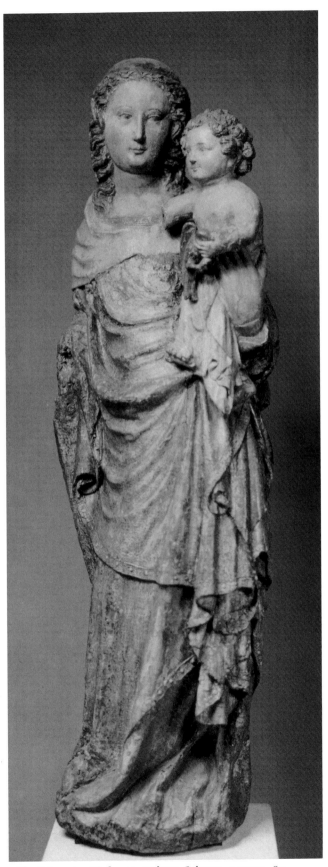

1 The Friesentor-Madonna, walnut, Cologne, c. 1370–80
(Schnütgen Museum, Cologne)

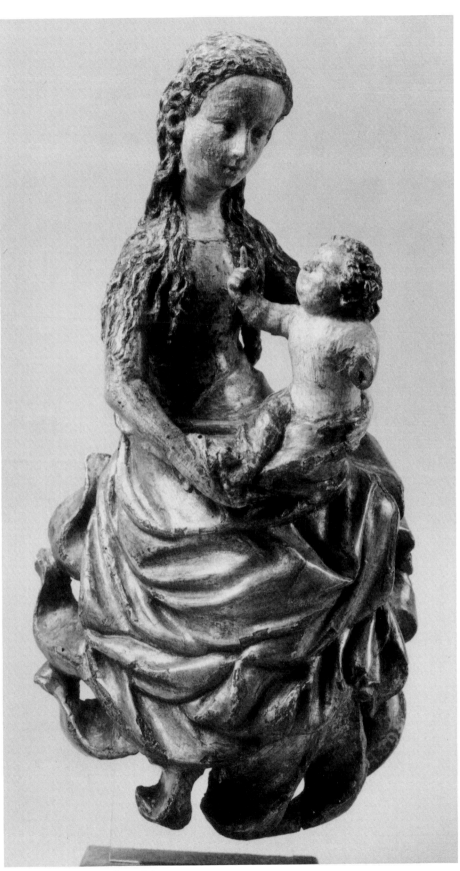

2 Virgin in the Sun, walnut, Cologne, c. 1390
(Schnütgen Museum, Cologne)

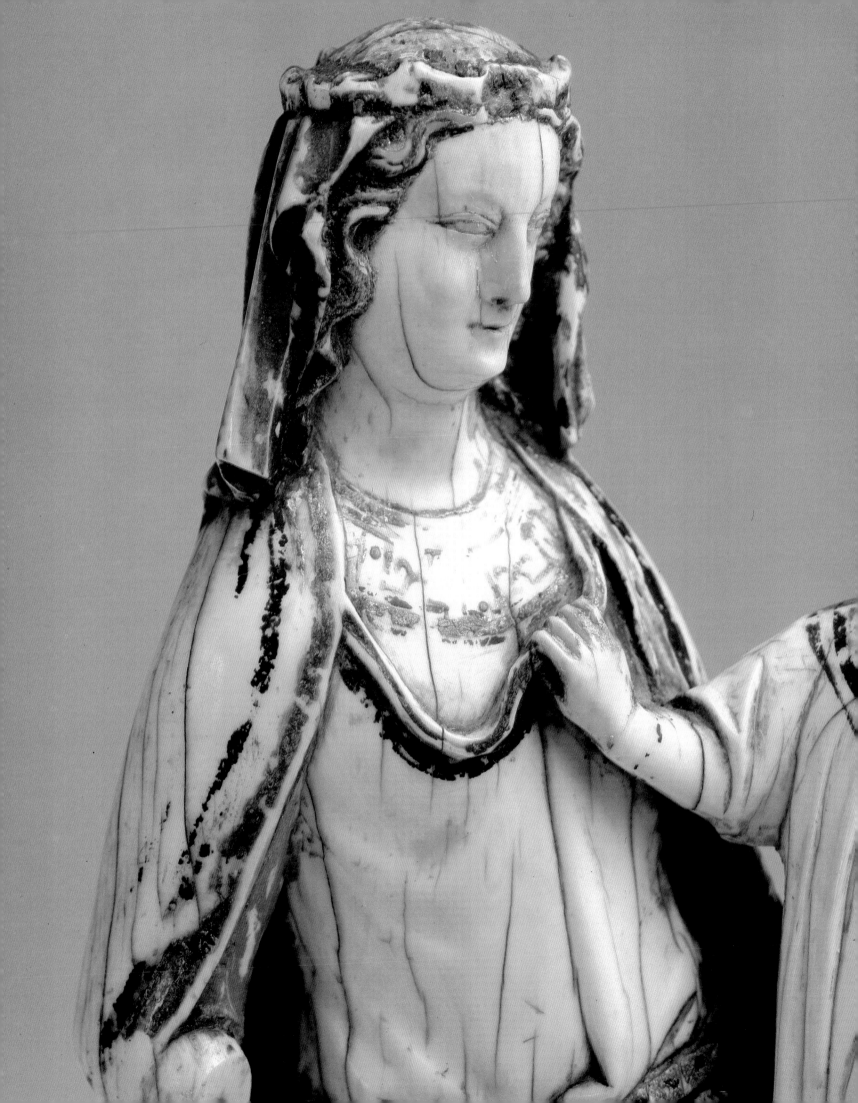

Ivory carvings

20 Virgin and Child

Byzantine (Constantinople), late tenth century
Ivory

Dimensions
Height: 15.2 cm; width: 11.4 cm

Provenance
E. and M. Kofler-Truniger Collection, Lucerne
Bought at Sotheby's, London, 13 December 1979, lot 20
K91L

Exhibitions
Ravenna, Chiostri francescani, *Avori dell'alto medioevo*, 1956, no.105
Cologne, Schnütgen Museum, *Grosse Kunst des Mittelalters aus Privatbesitz*, 1960, no. 3
Zurich, Kunsthaus, *Sammlung E. und M. Kofler-Truniger, Luzern*, 1964, no. 677

The Virgin *Hodegetria*, holding the Christ-Child on her left arm, is shown half-length under a pierced canopy supported by two spirally-fluted columns topped by stylised capitals. The panel is in very good condition, although the canopy has been broken off and repaired in the centre. The back is plain. The panel would have originally formed the centre part of a triptych: the two holes in the top and bottom borders held ivory pegs joining two separate strips of ivory to the front of the plaque, which in turn held the wings in place. This arrangement may be seen in a triptych in the Liverpool Museum, and was the normal method of fixing the wings to the central panel: hinges were not used on Byzantine triptychs of this type.[1] The four holes at the left and right, now filled with ivory plugs, were presumably for a later mounting, although the two small holes pierced in the capitals at each side have no clear function.[2]

The Thyssen-Bornemisza *Hodegetria* was not known to Adolph Goldschmidt and Kurt Weitzmann when they compiled their *corpus* of Byzantine ivory plaques in 1934; however, there are a number of other panels with exactly the same subject matter, carved in a very similar style, in various collections which they did discuss and illustrate.[3] The present panel fits into Goldschmidt and Weitzmann's 'Triptych Group', most of the pieces in the group being dated to the end of the tenth century. The closest comparisons are with panels in the Historisches Museum in Bamberg (fig. 1) and in the Fürstlich Oettingen-Wallerstein'sche Kunstsammlung, Harburg über Donauwörth (fig. 2). The latter still retains its wings: these show bust-length figures of (on the left) an angel, St John the Evangelist and St Theodore, and (on the right) an angel, St John the Baptist and St George.[4] Another member of this group, attached to the front of the early eleventh-century bookcover of the Carolingian Aachen Gospels in the Domschatz at Aachen, also retains its wings, which once formed the central part of the back cover of the same Gospels.[5] Each wing in this case only contains two saints, St John the Evangelist and St Theodore on the left and St John the Baptist and St George on the right. Judging by the size of the Thyssen-Bornemisza panel it seems most likely that its wings contained three figures on each side, and that these were the same as on the Oettingen-Wallerstein triptych.

Notes
1 A. Goldschmidt and K. Weitzmann: *Die byzantinischen Elfenbeinskulpturen des X.–XIII. Jahrhunderts*, II (Berlin, 1934, repr. 1979), cat. no. 155, pls. LIV, LXIII
2 A number of similar panels share this feature: *ibid.*, cat. nos. 131–3 (pl. XLVIII), 142 (pl. LI)
3 *Ibid.*, cat. nos. 124–40 (pls. XLVI–L)
4 *Ibid.*, cat. nos. 131, 132 (pl. XLVIII)
5 *Ibid.*, cat. nos. 129–30 (pl. XLVII); in 1870 this back cover was made into the front cover of the Ottonian gospels at Aachen (P. Lasko: *Ars Sacra 800–1200* (Harmondsworth, 1972), 285, n.114)

Additional bibliography
Schnitzler *et al.* (1964), 14, no. S14
Schnitzler *et al.* (1965), 14, no. S14

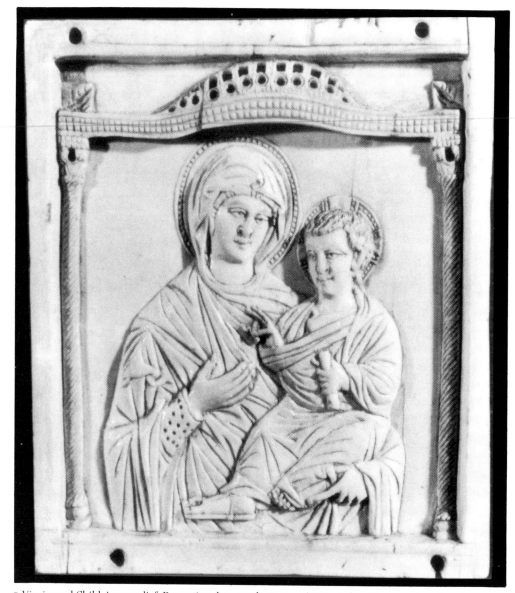

1 Virgin and Child, ivory relief, Byzantine, late tenth century (Historisches Museum, Bamberg)

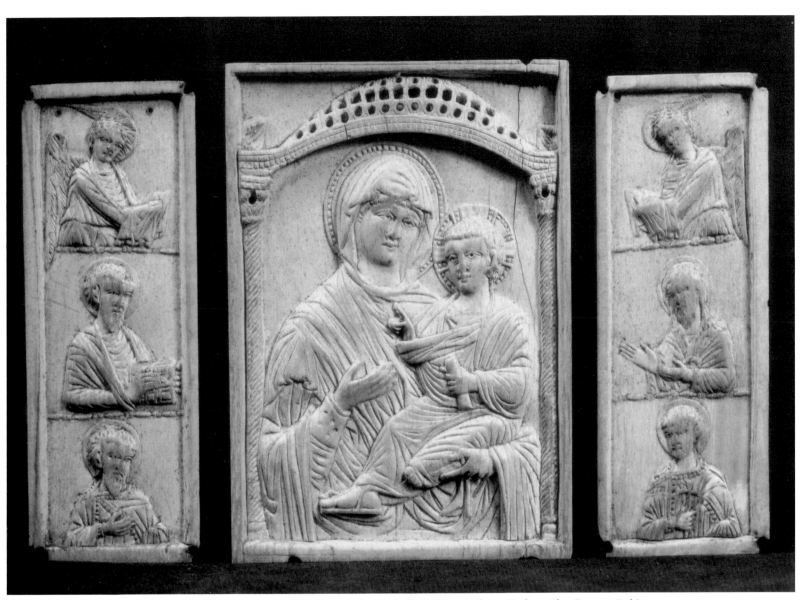

2 Triptych, ivory, Byzantine, late tenth century (Fürstlich Oettingen-Wallerstein'sche Kunstsammlung, Harburg über Donauwörth)

21 The Baptism of Christ

Southern Italian (Campania), *c.* 1100
Ivory

Dimensions
Height: 15.9 cm; width: 13.3 cm

Provenance
Thomas Fischer Collection, Lucerne, 1953[1]
E. and M. Kofler-Truniger Collection, Lucerne
Bought 26 April 1971
K91A

Exhibitions
Ravenna, Chiostri francescani, *Avori dell'alto medioevo*, 1956, no. 114
Cologne, Schnütgen Museum, *Grosse Kunst des Mittelalters aus Privatbesitz*, 1960, no. 10
Zurich, Kunsthaus, *Sammlung E. und M. Kofler-Truniger, Luzern*, 1964, no. 678

Christ is shown at the centre of the composition, short-haired and unbearded, submerged up to His shoulders in the River Jordan; above are the hand of God the Father emerging from the arc of Heaven and the Dove of the Holy Ghost carrying a wreath or crown in its beak. To the left are three figures: the first, John the Baptist, steps forward to touch Christ's head with his right hand while gesturing heavenwards with his left. Behind him are the apostles Peter and Andrew (cf. John, I, 29–34). To the right of Christ are two angels carrying His garments: they float behind what appears to be a parapet decorated with a diamond pattern.

The plaque is in good condition. There are some minor breaks on the top and bottom borders and there is surface cracking throughout. The large circular hole in the top centre was presumably made after the plaque had been divorced from its original setting and probably facilitated hanging. The back is plain.

The present plaque was first published in 1953 by Julius Baum, who noted certain Byzantine characteristics which he related to the art of Montecassino between 1000 and 1100, and he rightly associated it with the so-called Salerno Ivories, most of which are to be seen in the Museo del Duomo at Salerno.[2] The latest study of these ivories, by Robert Bergman, has convincingly dated them to just before 1084 and has postulated Amalfi rather than Salerno as their place of origin.[3] The Thyssen-Bornemisza plaque is clearly not from the ensemble found in Salerno, as there is already a Baptism scene in that group and its style is slightly coarser. Bergman has assigned it to a later group, of *c.* 1100, which he considers to be derived from the Salerno Ivories in style and iconography but with additional influences. This group, first assembled in part by Adolph Goldschmidt in his monumental *corpus* of early medieval ivory carvings, is made up of 14 plaques all showing scenes from the New Testament, but they do not all come from the same object as there are slight differences in style between some of the pieces and the Crucifixion is represented three times.[4]

Notes
1 J. Baum: 'Avori sconosciuti in Svizzera', *Arte del primo millenio*, ed. E. Arslan (Turin, 1953), 139–40
2 *Ibid.*, 140
3 R. P. Bergman: *The Salerno Ivories: Ars Sacra from Medieval Amalfi* (Cambridge, MA, 1980), 76–91. Whether Amalfi was their place of origin is not certain; see my review of the above in the *Burlington Magazine*, CXXIV (1982), 299–300
4 Bergman, *op. cit.*, 120–21 and 139–40; A. Goldschmidt: *Die Elfenbeinskulpturen aus der romanischen Zeit*, IV (Berlin, 1926), nos. 129–37, 142–3. Goldschmidt did not know of the existence of the Baptism plaque

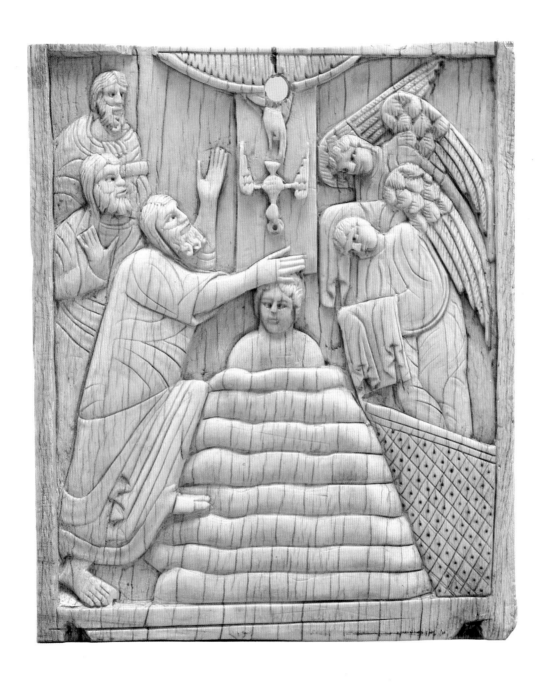

Referring to an inventory of 1575 held in the Archivio Diocesiano at Salerno, Arturo Carucci connected some of this group with a *cona* (probably best interpreted as a triptych) decorated with the arms of the Piscicelli family: '*Item una cona dove ci sono intagliate le figure del testamento novo etiam de avolio [sic] ad serratura bellissima con l'arme de piscicello*'.[5] He went on to date the Baptism plaque to the end of the twelfth or the beginning of the thirteenth century, which for stylistic reasons must be too late.[6] Unfortunately, the 1575 inventory note is of no use for the group's original setting, even if we accept the reference as pertaining to it, as the *cona* mentioned therein can only have been made in the fifteenth century.[7]

Of the 14 plaques in the post-Salerno Ivories group the Thyssen-Bornemisza Baptism is closest in style to six others: a Flight into Egypt in the Museo Civico at Bologna, the Adoration of the Magi in the J. F. Willumsens Museum in Frederikssund, Denmark, the Presentation in the Temple in the Victoria and Albert Museum, London (fig. 1), the Healing of the Blind, Dropsical and Lame in the Museum of Fine Arts in Boston (fig. 2), and two plaques in the Staatliche Museen Preussischer Kulturbesitz, Berlin-Dahlem, the Arrest of Christ (fragmentary) and the Crucifixion (fig. 3).[8] As with the reconstruction of the Salerno Ivories, there are several possibilities for the original context of the later group: an *antependium*, a dossal, an episcopal throne, or even the decoration of a door. Unfortunately, in this case any reconstruction would be no more than hypothesis, without any supporting evidence.

The iconography of the Baptism plaque is similar to the same scene in the Salerno series, although in the latter Christ is shown naked in front of the river and is bearded, and the two apostles behind John the Baptist are omitted. These figures do appear, however, in earlier Byzantine representations of the Baptism, from the sixth century or seventh onwards (see, for instance, the painted wooden reliquary box from the *Sancta Sanctorum*, Rome, now in the Museo Sacro Cristiano of the Vatican).[9] It seems likely that both the Salerno and Thyssen-Bornemisza *Baptisms* derived from such a representation as on the Vatican box, although there are sufficient differences to conclude that they were not copying the same model.

Notes
5 A. Carucci: *Gli avori salernitani del secolo XII* (Salerno, 2/1972), 9
6 *Ibid.*, 196
7 Bergman, *op. cit.*, 121
8 *Ibid.*, figs. 166–8, 170–72
9 G. Schiller: *Iconography of Christian Art*, I (London, 1971), 127–36, esp. 134–5 and fig. 357

Additional bibliography
Schnitzler *et al.* (1964), 14, no. S15
P. Lasko: 'A Notable Private Collection', *Apollo*, LXXIX (1964), 464–73, fig. 6
Schnitzler *et al.* (1965), 14, no. S15

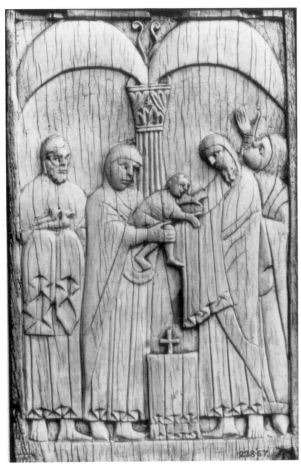

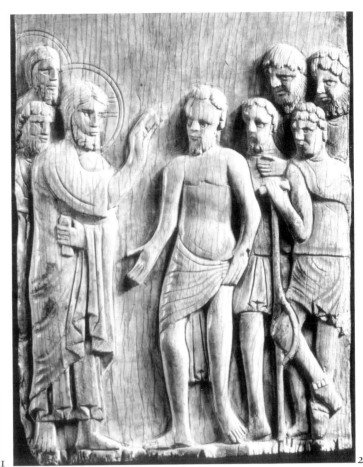

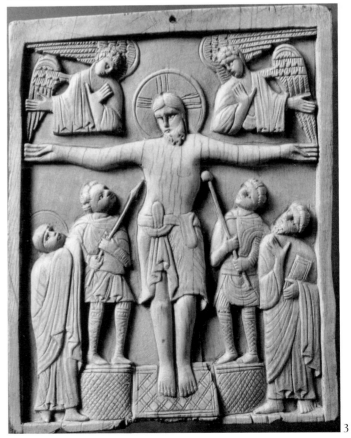

1 The Presentation in the Temple, ivory plaque, Southern Italian (Campania), *c.* 1100 (Victoria and Albert Museum, London)

2 The Healing of the Blind, Dropsical and Lame, ivory plaque, Southern Italian (Campania), *c.* 1100 (Museum of Fine Arts, Boston)

3 The Crucifixion, ivory plaque, Southern Italian (Campania), *c.* 1100 (Staatliche Museen Preussischer Kulturbesitz, Berlin-Dahlem)

22 Virgin and Child

French (Paris), *c.* 1320–30
Ivory

Dimensions
Height: 23.3 cm

Provenance
M. Larcade Collection, Paris
E. and M. Kofler-Truniger Collection, Lucerne
Bought 26 April 1971
K91B

Exhibition
Cologne, Schnütgen Museum, *Grosse Kunst des Mittelalters aus Privatbesitz*, 1960, no. 20

The Virgin sits on a bench, holding the Christ-Child with her left hand: He stands on her knees and holds her mantle-cord with His right hand. The Virgin wears a belted gown which is covered by a long mantle; on her head is a short veil surmounted by a small crown. The Virgin's right arm and the head of the Child are missing. There is a circular hole in the top of the Virgin's head (either to hold a halo added later or to facilitate turning while carving) and on the underside of the base there is a circular dowel-hole and cross-hatching for fixing the group to a separate base. Extensive amounts of probably original paint remain: the underside of the mantle of the Virgin was dark blue and around the edges of the garments were gold and blue patterns. The Virgin's veil was green (with red inside), the same colour as the ground below the Virgin's feet, and the bench appears to have been mainly red. The Virgin's hair was gilded.

The present *Virgin and Child* fits into a small group of ivory seated Virgin and Child groups, the other pieces being in Baltimore (Walters Art Gallery), London (Victoria and Albert Museum and the British Museum) and Villeneuve-lès-Avignon (figs. 1–4). This ensemble was first gathered together by Richard Randall and has more recently been discussed by Charles Little and Neil Stratford:[1] the dating for these pieces has settled at between 1320 and 1330 and it seems most likely that they were the work of Parisian ateliers. A local tradition linking the Villeneuve-lès-Avignon *Virgin and Child* with Cardinal de Via (*d* 1335) would, if it were true, reinforce the above dating arrived at on stylistic grounds. The Thyssen-Bornemisza *Virgin and Child* is the smallest of the group, but it bears close comparison on a number of points. The polychromy, especially the patterned borders to the garments in gold and blue, is similar to that employed on the British Museum and Villeneuve-lès-Avignon *Virgins*. Another feature found in both the present *Virgin and Child* and the Villeneuve-lès-Avignon example is the way in which the Christ-Child plays with the mantle-cord at the Virgin's neck. The long, thin proportions of the Christ-Child are very close in all the members of the group.

A characteristic which sets the present *Virgin and Child* slightly apart from the other members of the group is the shallowness of the figure, so that it almost resembles an *appliqué* carving. It shares this feature with another *Virgin and Child* of the same date, the superb example in the Treasury of the Basilica of S Francesco in Assisi (fig. 5):[2] in addition, both are roughly the same size, – the Assisi *Virgin* is 25.3 cm high – both are painted with deep blue paint on the undersides of the garments, and they have a similar decoration at the hem of the Virgin's mantle.

Notes
1 Richard H. Randall, Jr.: 'A Monumental Ivory', *Gatherings in honor of Dorothy E. Miner* (Baltimore, 1974), 283–300; Charles T. Little: 'Ivoires et art gothique', *Revue de l'Art*, XLVI (1979), 63–5; Fastes du Gothique, cat. no. 130
2 Most recently published in Fastes du Gothique, cat. no. 139 (ill. in colour on p. 25)

Additional bibliography
Kunstschätze in der Schweiz (Zurich, 1964), pl. 20
Schnitzler *et al.* (1964), 17, no. S33
P. Lasko: 'A Notable Private Collection', *Apollo*, LXXIX (1964), 464–73, fig. 16
Schnitzler *et al.* (1965), 17, no. S33

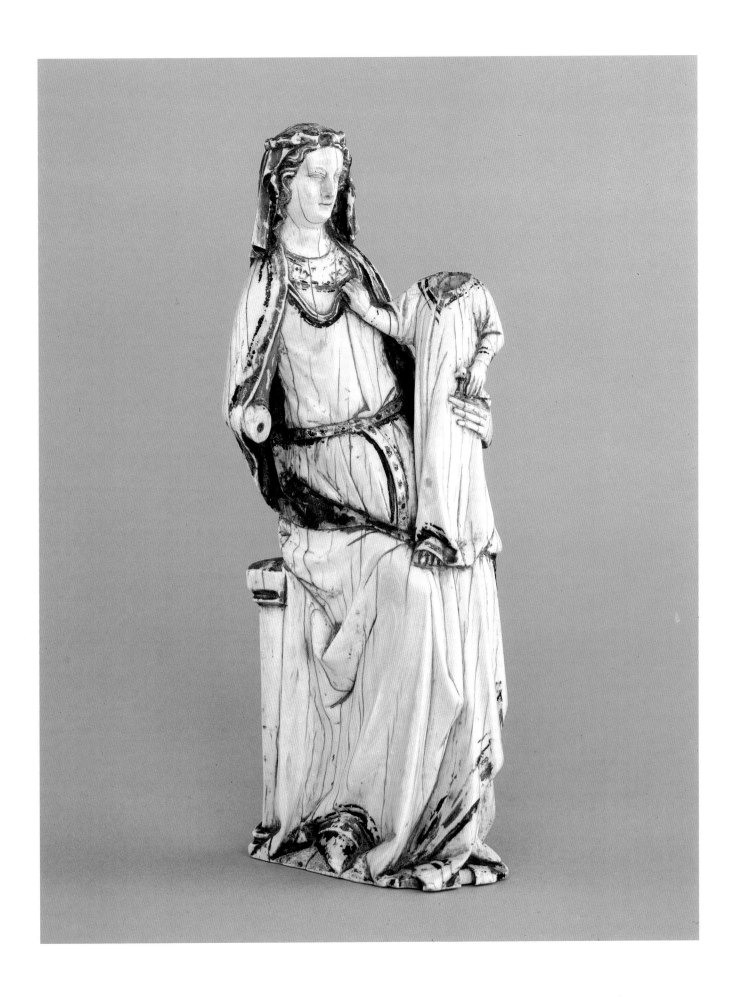

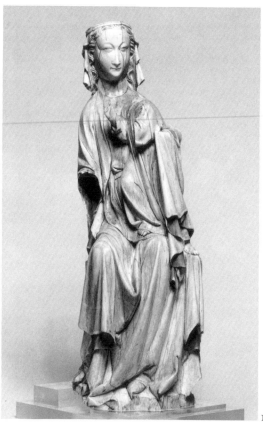

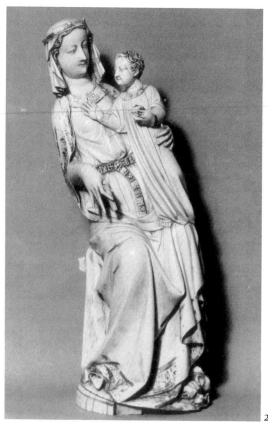

1 Virgin and Child, ivory, French
(Paris), 1320–30
(Walters Art Gallery, Baltimore)

2 Virgin and Child, ivory, French
(Paris), 1320–30
(British Museum, London)

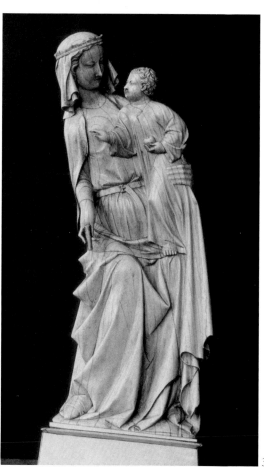

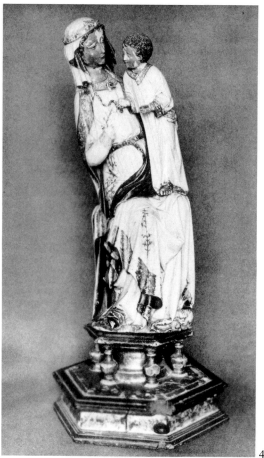

3 Virgin and Child, ivory, French
(Paris), 1320–30
(Victoria and Albert Museum, London)

4 Virgin and Child, ivory, French
(Paris), 1320–30
(Trésor de la Collégiale,
Villeneuve-lès-Avignon)

5 Virgin and Child, ivory, French
(Paris), 1320–30
(Treasury of S Francesco, Assisi)

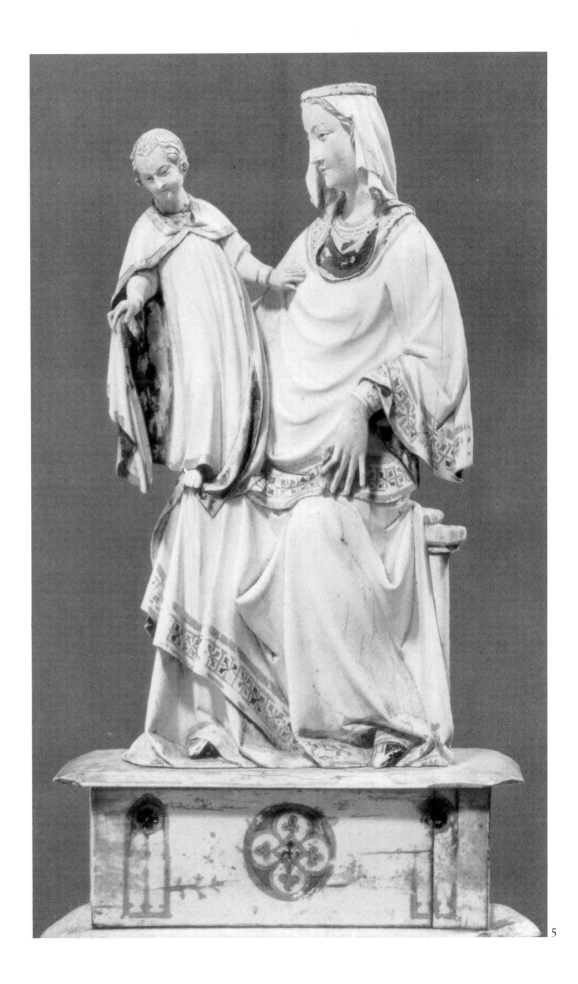

5

23 Triptych with the Passion of Christ

French (Paris), *c.* 1330
Ivory

Dimensions
Height: 24.6 cm; width: 20 cm

Provenance
Spitzer Collection, Paris (sold Paris, 25 April 1893, lot no. 122, pl. IV)
Professor W. Weisbach Collection, Berlin, until after 1924
E. and M. Kofler-Truniger Collection, Lucerne
Bought 26 April 1971
K91C

Exhibitions
Berlin, *Austellung von Kunstwerken des Mittelalters und der Renaissance aus Berliner Privatbesitz*, 1899, no. 5, pl. XIV
 (catalogue by W. Vöge)
Cologne, Schnütgen Museum, *Grosse Kunst des Mittelalters aus Privatbesitz*, 1960, no. 24

The triptych shows scenes from the Passion of Christ and should be read from left to right, starting at the bottom left corner: Judas takes the 30 pieces of silver, the Betrayal, Judas hangs himself, Pontius Pilate washes his hands, the Flagellation, the Carrying of the Cross, the Crucifixion with the Virgin and Longinus (on the left) and St John and Stephaton (on the right), the Deposition, *Noli me tangere*, the Entombment, and the Harrowing of Hell. The triptych is in excellent condition. There are extensive remains of red and green paint, mostly in the inner spandrels of the arches; most of the haloes are still visible; and the shadowy silhouettes of painted trefoils still exist in the major spandrels and on Christ's tomb. The central panel has lost its pinnacles to the left and right and the central cresting is now missing. The hole at the top of the central panel was presumably used for hanging the triptych.[1] On the bottom of the central panel is cross-hatching and a dowel-hole for fixing to a separate base. The backs of the wings and central panel are plain.

In style, size and format the present triptych closely resembles two triptychs in the Louvre in Paris, formerly in the Arconati-Visconti Collection, both of which show Marian cycles with the Death of the Virgin in the centre (fig. 1).[2] All three pieces were assigned by Koechlin to the atelier of the 'Master of the Death of the Virgin', so called because many of the ivories in this group gave this particular scene prominence, for example the two splendid and iconographically close triptychs in Amiens and in the Martin le Roy Collection in Paris.[3] More recently, Danielle Gaborit-Chopin has refined the constituents of this group, placing the triptych of Saint-Sulpice-du-Tarn (Musée de Cluny, Paris) at the beginning of the fourteenth century and the Amiens and Paris ivories between 1320 and 1340.[4] The Passion iconography of the Thyssen-Bornemisza triptych clearly derives from similar scenes on the slightly earlier ivories of the so-called Soissons Group, mainly made up of diptychs showing the scenes of the Passion of Christ, the group taking its name from a diptych in the Victoria and Albert Museum said to have been formerly in the Cathedral of Saint-Jean-des-Vignes at Soissons, and probably to be dated to the end of the thirteenth century (fig. 2).[5]

Notes
1 Also seen in the two triptychs in the Louvre (see Note 2)
2 Koechlin, I, 141–6, nos. 218, 219; no. 218 is here illustrated (fig. 1). The second triptych is illustrated, and the present triptych discussed, in R. Koechlin: 'Les Retables français en ivoire du commencement du XIVe siècle', *Monuments et Mémoires. Fondation Eugène Piot*, XIII (1906), 67–76, figs. 3 and 4
3 Koechlin, nos. 210, 211, pls. LII, LIII; see also Fastes du Gothique, no. 143
4 D. Gaborit-Chopin: *Ivoires du Moyen Age* (Fribourg, 1978), 148–52
5 Inv. no. 211-1865. See M. H. Longhurst: *Catalogue of Carvings in Ivory, Victoria and Albert Museum*, II (London, 1929), 10–11, frontispiece; for an illustration in colour, see P. Williamson: *An Introduction to Medieval Ivory Carvings* (London, 1982), pl. 26

Additional bibliography
Koechlin, no. 220
L. Grodecki: *Ivoires français* (Paris, 1947), 96
Schnitzler *et al.* (1964), 23–4, no. s68
Schnitzler *et al.* (1965), 23, no. s68

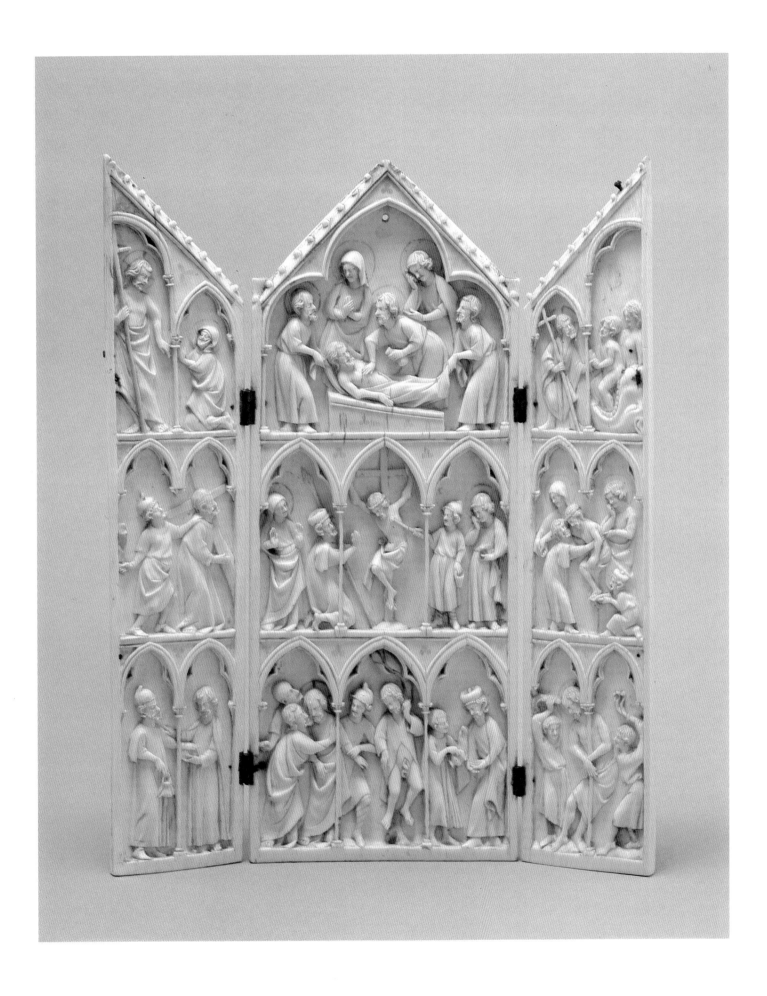

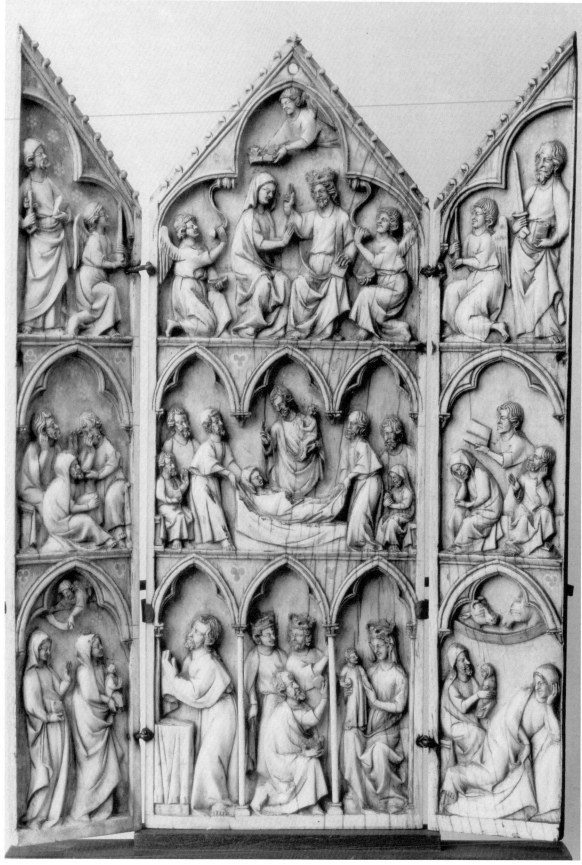

1 Triptych, ivory, French (Paris), *c.* 1330 (Musée du Louvre, Paris)

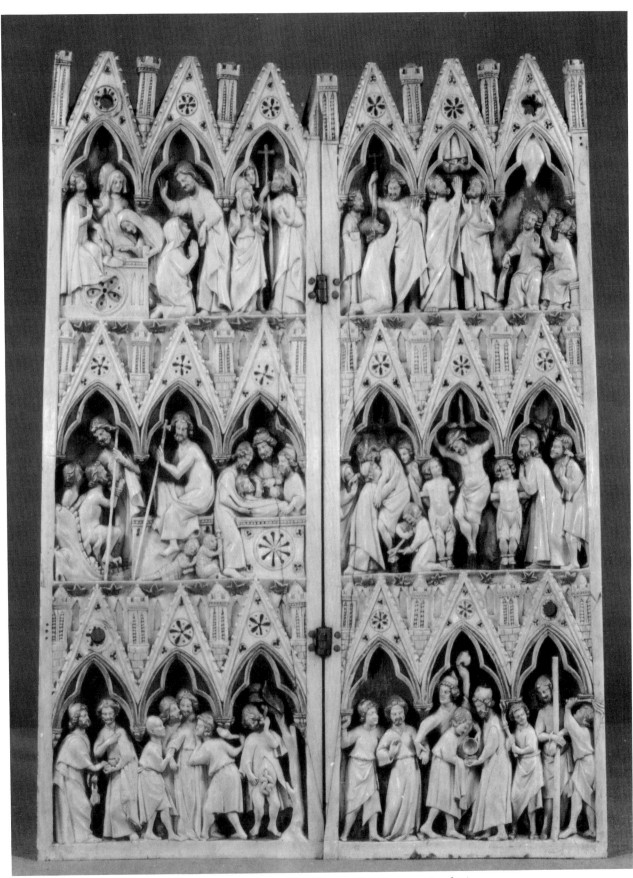

2 Diptych, ivory, French (Paris), late thirteenth century (Victoria and Albert Museum, London)

24 Diptych

French (Paris), mid-fourteenth century
Ivory

Dimensions
Height: 17.8 cm; width (each leaf): 9.6 cm

Provenance
J. E. Taylor Collection, London (sold Christie's, London, 1 July 1912, lot 80)
Dr Leopold Seligmann Collection, Cologne, until 1930[1]
E. and M. Kofler-Truniger Collection, Lucerne
Bought 20 May 1971
K91D

Notes
1 P. Clemen, O. von Falke and
 G. Swarzenski: *Die Sammlung
 Dr. Leopold Seligmann, Köln*
 (Berlin, 1930), no. 147
2 See, for instance, three ivory
 carvings in the Victoria and
 Albert Museum, nos. 290-1867,
 292-1867, and 161-1896
 (M. H. Longhurst: *Catalogue of
 Carvings in Ivory, Victoria and
 Albert Museum*, II (London,
 1929), 23, 26, 18–19)
3 Koechlin, II, no. 295. It is worth
 noting that another member of
 this group, not of such high
 quality as the present diptych,
 shares the same method of
 bevelling the outside edges of
 the leaves: it is the third ivory
 in the Victoria and Albert
 Museum mentioned above
 (Koechlin, II, no. 290, left)

Additional bibliography
E. Lüthgen: *Die abendländische
 Kunst des 15. Jahrhunderts*
 (Bonn and Leipzig, 1920),
 pl. 18
——: *Rheinische Kunst des
 Mittelalters aus Kölner
 Privatbesitz* (Bonn and Leipzig,
 1921), pl. 46
*Mittelalterliche Kunst aus Kölner
 Privatbesitz* (Cologne, 1927),
 no. 197
Schnitzler *et al.* (1964), 25,
 no. S74
Schnitzler *et al.* (1965), 24,
 no. S74

The diptych shows, on the left leaf, the Adoration of the Magi and the Death of the Virgin, and on the right the Crucifixion and the Coronation of the Virgin; each scene takes place within an architectural setting of three trilobed arches topped by finials. The diptych is in exceptionally good condition, although the hinges and clasp are later replacements; the two holes – one at the top right of the left leaf, the other at the top left of the right leaf – are clearly later additions, but their function is unclear. Both leaves have been bevelled on their left and right sides at the back, so that the back surface is almost curving. This feature is common to a number of Gothic ivory diptychs, but the difference in style between diptychs with this feature does not allow the assumption that this was the method employed by one particular workshop.[2]

Koechlin assigned this diptych to his group of 'diptyques à frises d'arcatures', and within this group it is certainly one of the finest pieces, carved in very high relief (some of the figures are almost carved in the round) and with great attention to detail.[3] The proportions of the figures are well understood and each face is individually treated. This is in marked contrast to the majority of the smaller ivory diptychs of this date, and indeed stylistically this diptych is closer to the earlier Passion diptychs of the atelier of the Soissons diptych and the slightly earlier triptych in the Thyssen-Bornemisza Collection (no. 23).

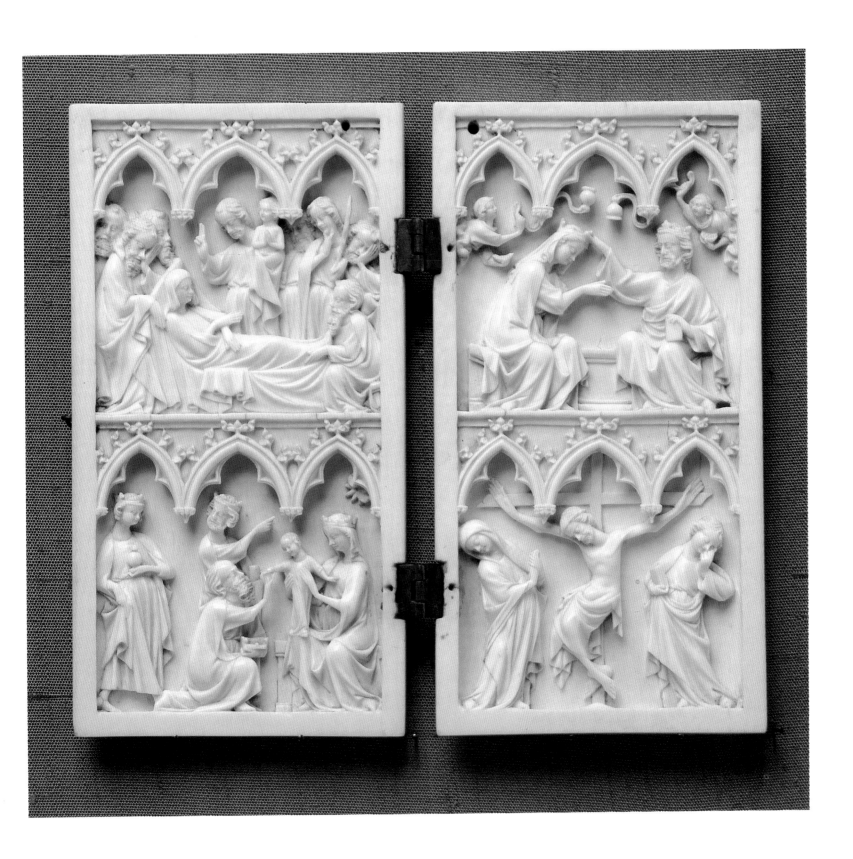

25 Diptych with the Crucifixion and the Coronation of the Virgin

French (Paris?), second half of the fourteenth century
Ivory

Dimensions
Height: 11.5 cm; width (both leaves): 14.5 cm

Provenance
Bought from H. Piel, Wassenaar, 12 October 1971[1]
K91F

On the left leaf Christ is shown crucified between the Virgin and St John, while above an angel holds the sun and moon;[2] on the right leaf the Virgin and Christ sit on a low bench, Christ blessing the Virgin with His right hand and holding a book in His left. Above, an angel places a crown (now missing) on the Virgin's head. The diptych is in good condition, although the left leaf has been cracked from top to bottom and repaired and the right leaf has a number of superficial shorter cracks. In the middle of the top edge of each leaf are two small holes, perhaps to fix a closing device. At the time of purchase in 1971, the diptych was mounted in a neo-Gothic wooden frame which has since been removed.

Diptychs of this type were made in large numbers in Paris and elsewhere in the fourteenth century as objects of private devotion. With a few notable exceptions the style of the diptychs is rather monotonous and stereotyped, and the iconographic arrangements are repeated from one diptych to another with very little variety. Judging by the surviving examples, the Crucifixion was most commonly shown alongside the Adoration of the Magi or the standing Virgin between angels, and it usually formed the right, not the left, side of the diptych.[3] The combination of the Crucifixion with the Coronation of the Virgin is an extremely rare iconography, there being no examples of this type in Raymond Koechlin's *corpus* of Gothic ivories.[4] The Coronation of the Virgin is shown, however, in very similar form in diptychs in Salzburg (showing the Coronation and the Death of the Virgin) and Lyon (the Coronation and the Last Judgement), the latter sharing with the present diptych a similar architectural, trilobed gable above the figures.[5] A slightly unusual feature of the Crucifixion panel is that it shows just one angel holding the sun and the moon, when there are more often two angels holding one symbol each.[6]

In format the tall rectangular leaves of the present diptych, with trilobed crowned gables flanked by a quatrefoil medallion on each side, are similar to those of many other diptychs of the fourteenth century. One of the finest of these, the so-called Mège Diptych in the Louvre in Paris, is probably to be dated *c.*1340–50.[7] The present diptych has none of the depth of carving of the Mège Diptych and should be placed in the second half of the fourteenth century.

Notes
1 Said to have been bought 50 years earlier from a family in Spain, who in turn had owned it for 200 years
2 For the symbolism of the sun and moon in the scene of the Crucifixion, see G. Schiller: *Iconography of Christian Art*, II (London, 1972), 92
3 For examples, see Koechlin, pls. LXXXIX-XC and pls. XCIV-XCVII
4 But these two scenes are sometimes combined on a single leaf: see no. 24, K91D (p.126)
5 Koechlin, nos. 519 and 524 (pls. XCII, XCIII)
6 Although rare, this feature is seen on three other ivory panels from diptychs showing the Crucifixion, one in Bologna (Koechlin, no. 539, pl. XCVI), one in Turin (L. Mallè: *Museo Civico di Torino, Smalti e avori del Museo di Arte antica* (Turin, 1969), pl. 128) and the other in the Victoria and Albert Museum in London (M. H. Longhurst: *Catalogue of Carvings in Ivory, Victoria and Albert Museum*, II (London, 1929), pl. XXIII, no. 234-1867)
7 Fastes du Gothique, no. 152

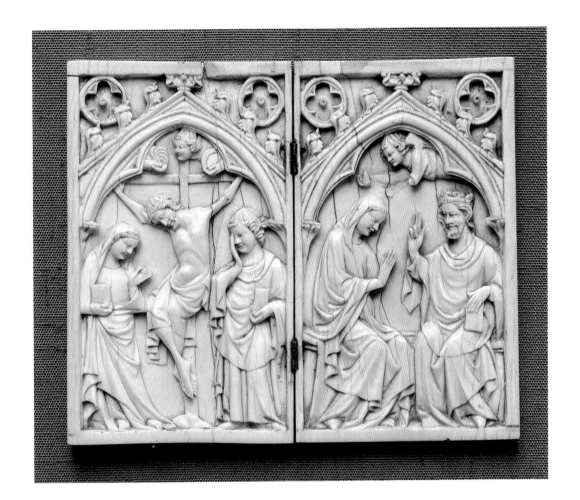

26 Diptych

German? (Cologne?), second half of the fourteenth century
Ivory

Dimensions
Height: 16.6 cm; width (each leaf): 12.2 cm

Provenance
Bought at Sotheby's, London, 9 April 1973, lot 17
K91G

The narrative order of the scenes runs from left to right, bottom tier first: the Annunciation, the Visitation, the Nativity and Annunciation to the Shepherds, the Adoration of the Magi, the Presentation in the Temple, the Flagellation, the Crucifixion, the Entombment and the Resurrection. The scenes take place under small trilobed arches topped by finials, six to each leaf on two tiers, and are divided by slender colonnettes. The brass hinges are later replacements.

This diptych clearly belongs to the group classified by Koechlin as 'diptyques à colonnettes', a sub-branch of his 'diptyques à frises d'arcatures', and so named because the scenes are divided by slim columns.[1] There are a number of other diptychs which share the almost square format for the leaves, the architectural setting, and also show scenes from the Infancy and Passion of Christ, the closest comparisons being with diptychs in Lyon, Brussels and New York (fig. 1).[2] These ivories can hardly be dated much before 1350 and were most probably carved in the second half of the fourteenth century, but their place of origin is more problematic. Although undoubtedly deriving from Passion diptychs produced in Paris in the first half of the fourteenth century, there are no features which conclusively link this group with that city. By the middle of the fourteenth century ivory carvers trained in Paris were at work in a number of other Northern European centres, where they had carried the style and iconography they had learnt in Paris. With this in mind, it is likely that the present diptych is the product of a German workshop, and the most likely city for the location of that workshop is Cologne. A small detail in the scene of the Resurrection confirms the dating of the diptych and may point towards a German origin: at the bottom right of the scene one of the two sleeping soldiers in front of the tomb rests on his shield. The shield is unusual in that it is in the form of a man's face – a *Gesichtsschild*, probably symbolising Hades, the conquering god of the underworld.

Notes
1 Koechlin, I, 183–92
2 *Ibid.*, nos. 361, 370, 372, pls. LXXXII–LXXXIII

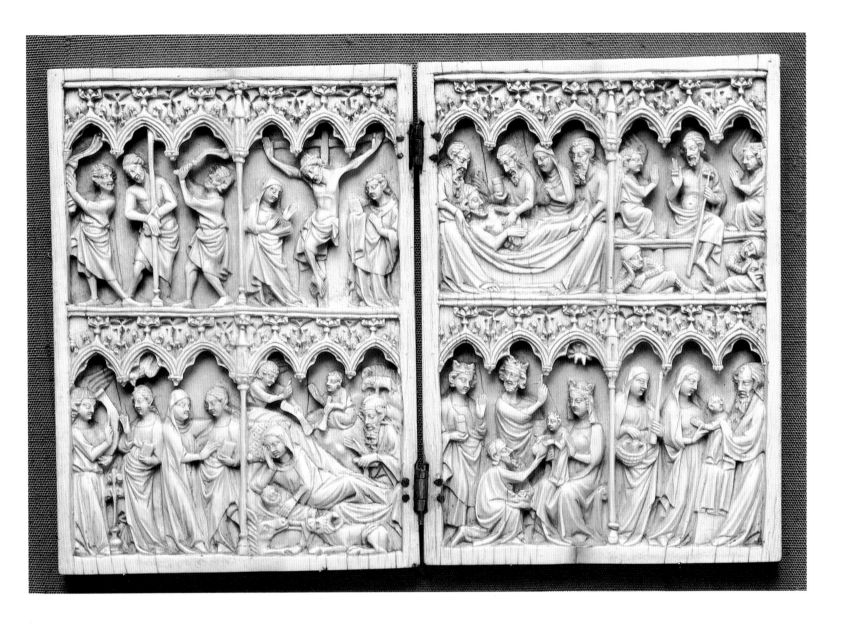

This feature is of the utmost rarity before the middle of the fourteenth century,[3] and with only a very few exceptions in other areas – the mitre of the workshop of the Parement de Narbonne in the Musée de Cluny in Paris is the best known – it is most commonly found in works of art of Bohemian or German origin.[4] The majority of examples may be dated to between the middle of the fourteenth century and the middle of the fifteenth, and they appear in both Resurrection and Crucifixion scenes, more commonly in the latter. Perhaps the most famous shield of this type is to be seen held by the captain of soldiers at the foot of the cross of the good thief in the so-called Rimini Altar, an alabaster ensemble probably produced in the Southern Netherlands in *c.* 1430 (now in the Liebieghaus, Frankfurt).[5]

Notes

3 The earliest example known to me is seen on f. 51v of Queen Mary's Psalter in the British Library, an English manuscript of the early fourteenth century (G. Warner: *Queen Mary's Psalter. Miniatures and Drawings by an English Artist of the 14th century reproduced from Royal Ms. 2B. VII in the British Museum* (London and Oxford, 1912), pl. 88)

4 For the mitre, see W. D. Wixom: *Treasures from Medieval France* (Cleveland, 1967), 222–3 [exhibition catalogue: Cleveland Museum of Art]; for a convenient discussion of the *Gesichtsschilden*, see A. Legner: 'Der Alabasteraltar aus Rimini', *Städel Jahrbuch*, II (1969), 113–21

5 *Ibid.*, pls. 46, 50

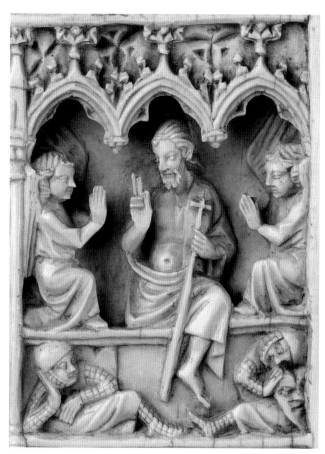

[26] *Diptych, detail*

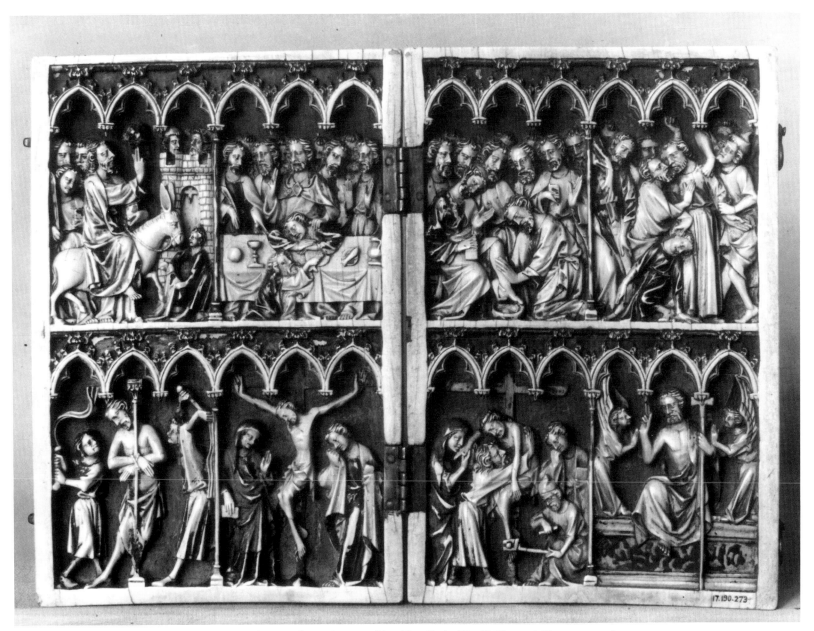

1 Diptych, ivory, German? (Cologne?), 1350–70 (Metropolitan Museum of Art, New York, Gift of J. Pierpont Morgan, 1917)

27 Seven roundels

Franco-Flemish, *c.* 1400
Polychromed ivory *plaques ajourées*, mounted on vellum

Dimensions
Each 2.3 cm diameter

Provenance
Swiss private collection[1]
Bought at Sotheby's, London, 15 December 1977, lot 28
K91 1

The seven roundels show four seated figures, St Peter, St Paul, St John the Baptist and St John the Evangelist, and three scenes, the Annunciation, Christ carrying the Cross and the Harrowing of Hell. All seven medallions are carved *à jour* and mounted on vellum, and retain their original polychromed decoration:[2] the colours used are crimson, azurite, green and a greyish pink, and there is extensive use of gilding, especially on the haloes.[3] They are in remarkably good condition, although parts of the borders are missing in places and the surface decoration has been rubbed.

Through the researches of Rasmussen and Müller and Steingräber it has been convincingly established that these roundels and a number of closely comparable polychromed ivory carvings are the products of a Franco-Flemish workshop of *c.* 1400.[4] They are intimately linked with the enamelled gold work produced for the Franco-Burgundian-Flemish Court and there is reason to believe that they were produced in close proximity to those works: Erwin Panofsky published a wax medallion in the same style as the ivories, formerly in Detroit, which probably served as a goldsmith's model, and many of the ivories were originally mounted on reliquaries.[5] Rasmussen assembled over 30 miniature coloured ivory carvings, mostly roundels, which he considered to have been produced in the early fifteenth century.[6] Although this group is not as homogeneous as it at first seems, there clearly being more than one workshop and variations in the quality of the carving, the difference in date between the pieces can hardly be greater than one or two generations.

The uses to which these ivories were put also varied. Some of the surviving pieces are still mounted in their original settings and serve as diptychs or pendants (fig. 1), but most have been divorced from the context for which they were made.[7] The present roundels are especially important because of their size: they are the smallest members by far of the group, and because they form a comparatively large ensemble they cannot originally have belonged to any form of jewellery. Fortunately there is extremely good evidence for their original setting which, although not specifically to do with the Thyssen-Bornemisza ivories, indicates their probable use. In the second quarter of the sixteenth century Cardinal Albrecht von Brandenburg (1490–1545) commissioned a set of watercolours illustrating the fabulous contents of his collection of reliquaries at Halle, the *Hallesche Heiltum*: these watercolours are now housed in the Stifts- und Schlossbibliothek at Aschaffenburg.[8] They are especially valuable for the light they shed on fifteenth- and sixteenth-century (and earlier) goldsmiths' work, as much of the contents of the *Hallesche Heiltum* was subsequently destroyed. On f. 328v is an illustration of a

Notes

1 J. Rasmussen: 'Untersuchungen zum Halleschen Heiltum des Kardinals Albrecht von Brandenburg (II)', *Münchner Jahrbuch der bildenden Kunst*, Dritte Folge, XXVIII (1977), 112–14, fig. 68; Rasmussen illustrated the very fragmentary remains of an eighth relief, the subject matter of which could not be ascertained, but only seven reliefs were sold at Sotheby's in 1977

2 The vellum background is almost certainly original as it is painted in the same crimson colour used on the garments of the soldier to the right of Christ in the Carrying of the Cross scene

3 The same colours are utilised on other closely-related ivories: cf. especially the roundel showing the Crucifixion, formerly in the Brummer Collection (now in the Schnütgen Museum, Cologne; for a good colour photograph, see *The Ernest Brummer Collection*, I, *Medieval, Renaissance and Baroque Art*, Zurich (Gallerie Koller AG and Spink & Son), 16–19 October 1979, p. 100 [sale catalogue])

4 Rasmussen, *op. cit.*, 109–14; T. Müller and E. Steingräber: 'Die französische Goldemailplastik um 1400', *Münchner Jahrbuch der bildenden Kunst*, Dritte Folge, V (1954), 29–79, esp. 36

5 E. Panofsky: 'A Parisian Goldsmith's Model of the Early Fifteenth Century?', *Beiträge für Georg Swarzenski* (Berlin, 1951), 70–84

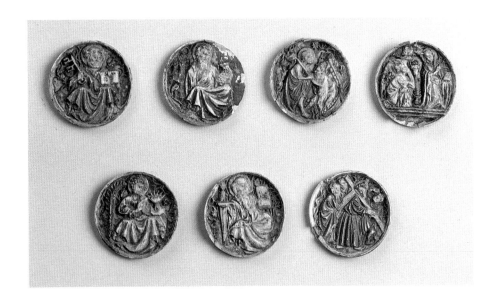

Enlargement

reliquary altar dedicated to St Nicholas and containing some of his relics (fig. 2). On the wings of the reliquary are twelve small roundels, six on each wing, and there are four larger medallions above and below the central space. It is immediately apparent how close the Thyssen-Bornemisza roundels showing the four seated saints are to the roundels on the left wing of the reliquary, which show SS Paul, Peter, John the Evangelist, John the Baptist, Anthony (?) and Andrew; however, it is clear that they are not the same pieces, as there are distinct differences in the iconography and there is no reason to suppose that the artist responsible for copying the reliquaries for the Cardinal was anything other than accurate: indeed, the watercolours throughout the volume are markedly precise. Although it would seem that the reliquary illustrated in the watercolour is of the later fifteenth or early sixteenth century one might realistically suppose that small ivories of this type were always meant to be set into this sort of context.

If it is certain that such ivories were made for setting into reliquaries and other sacred vessels, it is far from clear how the workshops functioned. It may well be that the ivory carvers produced the roundels completely unaware of the carvings' eventual destination and that the assemblage was decided upon by the goldsmith (who kept the ivory carvings in stock in his workshop) after discussion with the commissioning patron. If this is the case, any attempt at a meaningful reconstruction of the original size of the ensemble is not possible. It hardly needs to be pointed out that the series of scenes – the Annunciation, the Carrying of the Cross and the Harrowing of Hell – is incomplete and should be increased by at least the addition of the Nativity, the Flagellation, the Crucifixion, the Deposition, the Entombment and the Ascension; but how these roundels would have related to one another is unclear, especially in view of the bewildering variety of forms utilised on the reliquaries of the *Hallesche Heiltum* alone. Because of the valuable evidence contained in the Aschaffenburg codex it is likely that the roundels did form part of a reliquary rather than the foot of a chalice, as Rasmussen has suggested; the number of pieces and the fragility of the *à jour* relief preclude the latter use.[9]

Notes

6 Rasmussen, *op. cit.*, 129–30, n. 409 [with references to locations and older literature]
7 There is a diptych in the Wallace Collection, London, and pendants in the Metropolitan Museum of Art in New York and the Victoria and Albert Museum, London (Rasmussen, *op. cit.*). The setting of the Wallace Collection diptych may be later than the ivories it encloses but there can be no doubt that the carvings were originally presented in the same manner
8 MS. Aschaffenb. 14; see P. M. Halm and R. Berliner: *Das Hallesche Heiltum* (Berlin, 1931)
9 There is another reliquary illustrated in the Aschaffenburg codex which also houses ivory roundels of a similar type (see Halm and Berliner, *op. cit.*, pl. 142b, and Rasmussen, *op. cit.*, fig. 64)

1 Pendant, polychromed ivory set in metal mount, Franco-Flemish, *c.* 1400 (Victoria and Albert Museum, London)

2 Reliquary altar set with polychromed ivory roundels, formerly in the Hallesche Heiltum, Halle (f. 328*v*, MS. Aschaffenb. 14, Stifts- und Schlossbibliothek, Aschaffenburg)

28 Marriage casket

Northern Italian (workshop of the Embriachi), *c.* 1415–25
Carved bone panels, horn veneer and *alla certosina* marquetry on a wood core

Dimensions
Height: 13.5 cm; width: 17.2 cm; depth: 11 cm

Provenance
Provenance unknown
Date of acquisition not known (now at Daylesford House)
K91N

The casket consists of a wood core over which are placed carved bone panels showing confronted couples on the front, back and sides and female figures bearing shields and standards at the four corners. On the lid at the front two naked genii fly towards one another holding a scroll, and on the back two flying clothed angels face one another holding a heart; at each end of the lid is a shield: one shows an eagle displayed *or on a field gules*, the other *per bend, in chief argent,* a lion *passant bendwise or, in base barry of 4 argent and gules.* There are extensive remains of gilding, red, blue and green paint on the figures and background: the hair is gilded, the lips red and the eyes blue. The base and the top of the box proper are veneered with horn strips, the edge of the lid is made up of alternating bone and wood mouldings, and the rest of the lid (excluding the carved bone panels) is comprised of bone strips stained green and *alla certosina* marquetry. The metal handle is original.[1] Underneath, the casket has been marbled with paint, and there is a label with the number F.2404 written on it. It is in good condition, with a few minor losses of veneer – a piece of moulding is missing at the back – but the foot at the front right-hand side has been broken. The hinges are replacements and the two plain bone panels at the front would seem to be replacements for carved panels, removed when the lock and key hole were put in.

This casket is instantly recognisable as a product of the so-called Embriachi workshops, founded by the Florentine Baldassare degli Embriachi at the end of the fourteenth century. These workshops, in Venice and Northeast Italy, were only active for a short time and seemed to have stopped producing by the middle of the fifteenth century.[2] The output of the workshops was huge, the most popular products being small triptychs and caskets of different types. It seems likely that the workshops functioned like a production line, carving large numbers of bone panels which would be assembled on caskets and triptychs at a later stage: there were perhaps different men employed as carvers and casket and triptych makers, and this would help to explain the slightly different sizes of the panels on the present casket (both in height and width). The quality of the carving is rarely better than mediocre with the best sculptures seen, not surprisingly, on the more important commissions, such as the very large altarpiece produced for the Certosa of Pavia in the first decade of the fifteenth century.[3]

From its iconography the present casket is clearly a marriage casket, given as a wedding present; there are numerous caskets of this type in various collections, of different shapes and

Notes
1 For identical handles on other Embriachi caskets, see two very similar caskets in Padua (A. Moschetti: *Il Museo Civico di Padova* (Padua, 1938), 245, fig. 131) and London (Victoria and Albert Museum, fig. 1)
2 The most comprehensive account of the Embriachi workshop is still to be found in J. von Schlosser: 'Die Werkstatt der Embriachi in Venedig', *Jahrbuch der Kunsthistorischen Sammlungen des allerhöchsten Kaiserhauses,* xx (1899), 220–82
3 Sadly, the panels from this major work of the Embriachi were stolen from the Certosa of Pavia in 1984 (although a small number of the panels have since been recovered). The best photographs of the altarpiece (many in colour) are in G. A. Dell'Acqua: *Embriachi: Il trittico di Pavia* (Milan, 1982)

[28] *Front of marriage casket*

[28] *Details of lid*

1 Casket, bone panels, horn veneer and *alla certosina* marquetry on a wood core, Embriachi workshop, North Italian, *c.* 1415–25 (Victoria and Albert Museum, London)

Notes
4 M. H. Longhurst: *Catalogue of Carvings in Ivory, Victoria and Albert Museum*, II (London, 1929), 66 (no. 198-1894); von Schlosser, *op. cit.*, pl. XXXV, 2; Moschetti, *loc. cit.*; P. Giusti and P. Leone de Castris: *Medioevo e produzione artistica di serie: smalti di Limoges e avori gotici in Campania* (Naples, 1981), cat. no. II, 18 [exhibition catalogue: Museo Duca di Martina]
5 The standard works on Venetian and Italian heraldry, P. Coronelli: *Blasone Veneto* (Venice, 1702) and G. B. di Crollalanza: *Dizionario Storico-Blazonica* (Bologna, 1886), do not include the coats-of-arms found on the present casket. The eagle is, of course, found on many coats-of-arms, such as those of the Venetian family of Baldovino and the Austrian family of Raven, but it is not depicted here in any way which would set it apart and allow it to be identified conclusively. The nearest coat-of-arms to that shown on the other end of the casket is one for the family of Kerner of Württemberg. There is also the possibility that the shields were carved some time after the casket was made and that therefore they would not be of any use in identifying the original owners. I am most grateful to Michael Holmes for discussing the heraldic aspects of the casket with me and for suggesting the families cited above

sizes, and closely comparable examples may be seen in London (fig. 1), Vienna, Padua and Naples.[4] All show the confronted couples dressed in long robes, with the standard-bearing figures at the corners and with flying genii holding scrolls or hearts on the lid. The Thyssen-Bornemisza casket has the rare feature of carved coats-of-arms on the lid; the vast majority of the surviving marriage caskets have blank shields, some of which were perhaps originally painted, but there can be no doubt that it was the intention that these shields should be filled with the coats-of-arms of the families being joined by marriage. Unfortunately, the coats-of-arms on the present box have not so far been identified and thus do not shed more light on the casket's provenance.[5] A date towards the end of the first quarter of the fifteenth century seems most likely.

Enamels

29 Candlestick

Northern German?, *c.* 1180–1200
Copper and *champlevé* enamel

Dimensions
Height: 43.9 cm; diameter of base: 15.9 cm

Provenance
Antwerp private collection[1]
Bought from Kunstzalen A. Vecht, Amsterdam, 1954[2]
K88A

The candlestick and base are composed of six separate pieces: the base on three clawed feet, two cylindrical shafts separated by a knop of rock crystal, and a drip pan topped by a separately-cast pricket. The base is decorated with six petal-shaped lobes, each containing engraved, gilded and reserved drawing on a ground of dark blue and light blue enamel. Between the lobes and around the edge of the base is cross-hatched, incised decoration with six *fleur-de-lys* filling the spaces between the curve of the lobes and the edge. The central rivet holding each foot (there are three rivets to each foot) goes through the *fleur-de-lys*. There is a plain border with, on the outer edge, square beading. The lobes contain the following subjects: (a) a human-headed griffin, (b) foliate ornament, (c) a lion, (d) foliate ornament, (e) a griffin(?) with a human-headed tail and (f) foliate ornament.[3]

The lower section of the shaft is composed of two spirals of slightly different hanging devices in light blue on a background of dark blue enamel, divided by a beaded cable. The upper section comprises one spiral of hanging devices, the same as below, and a spiral containing crosses of light green enamel within diamond-shaped gilding. The dark blue enamel background is common to both spirals, and the running cable is the same as on the lower shaft. The drip-pan is of plain copper with a running engraved line inside the edge, forming six *fleur-de-lys*.[4] The outer edge has the same beaded decoration as the base.

The condition of the candlestick is reasonably good, but the enamel on the base has fallen out in places – or has been gouged out – on all the lobes, and on four of these there are holes where the copper background was too deeply excavated. One foot has been broken off and repaired and there is reason to suppose that at least the central rivets are restorations, as they interfere with the *fleur-de-lys* designs on the base. The candlestick was restored prior to acquisition, in Amsterdam: the inner shaft holding the different components of the candlesticks together has written on it in white paint: ST . . . VERNIEUW. . . . 2/9/1953 (V)OOR NICO WITTEMAN AMSTERDAM.

Enamelled candlesticks were made in large numbers by the Limoges workshops in the twelfth and thirteenth centuries and many examples still survive. However, the form of the present candlestick and its decoration is quite different from those candlesticks, its closest parallels being with works of German manufacture. The base may be compared with the bases

Notes
1 Rohoncz (1958), 138
2 Ill. in *VIᵉ Oude Kunst- en Antiekbeurs*, Museum Prinsenhof, Delft, 25 August– 15 September 1954, p. 80: I am grateful to Jaap Nijstad for supplying me with a photocopy of the relevant page of the Delft catalogue
3 These were wrongly described as evangelist symbols in Rohoncz (1958), *loc. cit.*
4 The *fleur-de-lys* is commonly used as a decorative device on a variety of Limoges products: see, for instance, the undersides of two gemellions in the Victoria and Albert Museum (6959-1860 and M.83-1914)

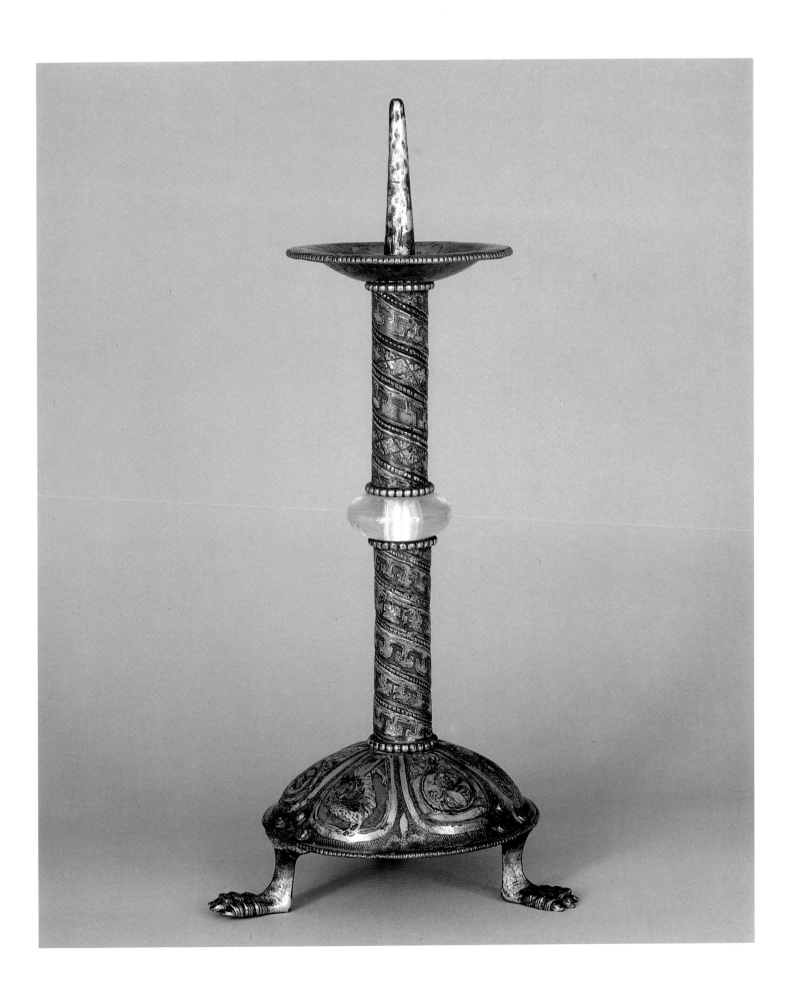

of a pair of candlesticks in the Metropolitan Museum of Art in New York (fig. 1), described by Marvin Ross as from Hildesheim and dated to the end of the twelfth century:[5] it is the same domed, circular shape, has the same type of square beading around the edge, and the style of the engraved drawing is also very close. The New York candlesticks also once possessed legs fixed to the edge of the base with round-headed rivets and it is perhaps significant that the New York candlesticks have, like the Thyssen-Bornemisza example, lost considerable amounts of enamel, possibly denoting that the workshop methods were faulty. The *champlevé* enamelling is certainly coarse in both examples. Ross arrived at his localisation for the New York candlesticks by comparing them with a pair in Halberstadt with a similarly shaped base and rough enamelling.[6] The present candlestick is much taller than the rather squat examples in New York and Halberstadt; in its proportions and form it is close to a pair of candlesticks in Fritzlar, dated by von Falke and Meyer to the middle of the twelfth century.[7] These are not enamelled (save for the central knop on the shorter of the two), but their tall and slender proportions and the running spirals around the shafts suggest a common pedigree: the shorter of the two Fritzlar candlesticks even shares with the Thyssen candlestick the petalled crosses in the running spiral on its upper shaft.

These similarities, both of a general and more specific nature, point towards an origin for the present candlestick in North Germany and a date around the end of the twelfth century.

Notes

5 M. C. Ross: 'German enamelled candlesticks of the late XII century', *Pantheon*, XI (1933), 162. A small group of Limoges candlesticks, all dating from the end of the twelfth century, do have bases of a domed sphere with three feet but the decoration is quite different (cf. M.-M. Gauthier and G. François: *Medieval Enamels: Masterpieces from the Keir Collection* (London, 1981), cat. no. 23, fig. 4)

6 J. Braun: *Das christliche Altargerät* (Munich, 1932), fig. 388

7 O. von Falke and E. Meyer: *Romanische Leuchter und Gefässe, Giessgefässe der Gotik* (Berlin, 1935), no. 104, pl. 47; see also J. Braun, *op. cit.*, pls. 98–102, for convenient illustrations of a range of candlestick types

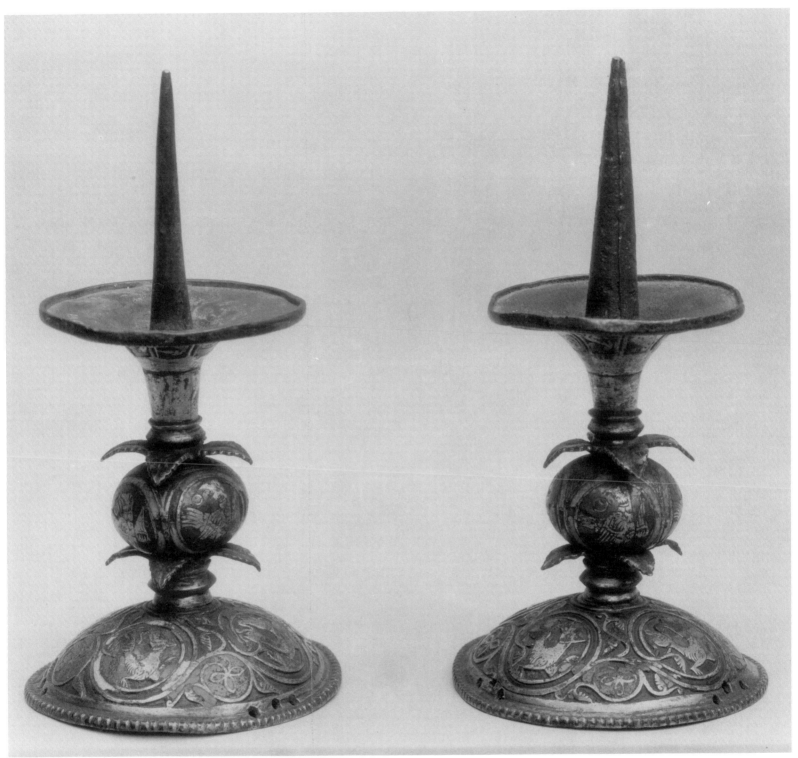

1 Pair of candlesticks, *champlevé* enamel on copper, North German (Hildesheim?), late twelfth century
(Metropolitan Museum of Art, New York, Gift of J. Pierpont Morgan, 1917)

30 Eucharistic dove

French (Limoges), *c.* 1210
Copper and *champlevé* enamel

Dimensions
Height: 21.5 cm; length: 26 cm

Provenance
Bourgeois Collection, Cologne, in 1846[1]
Soltykoff Collection, Paris (sold Hôtel Drouot, Paris, 8 April 1861, lot 74)
Basilewsky Collection, Paris, until 1884[2]
Hermitage Museum, Leningrad
Bought by Baron Heinrich Thyssen-Bornemisza (1875–1947) before 1938
K88

Apart from its wings and upper tail feather, the dove is of plain gilt copper, rubbed on the chest and the back: the incised drawing of the feathers covers its entire body and the upper parts of its legs. The dove's right eye is now missing; the left is made of black glass. On its back a hinged cover conceals the circular compartment for the Host. The cover originally would have had a turning knob to secure it, but this is now missing. The wings, made separately from the body and fixed with two pins, are of identical design. The enamelling is divided into four principal zones; the first zone, nearest to the chest, imitates the incised design of the feathers on the dove's body. The colour combinations of the feathers are the same as elsewhere on the work, alternating between white, light blue, dark blue and red, and yellow, light green, dark green and red enamel. Running around the edge of the wing is a turquoise and dark blue motif. Dividing this foremost section from the other three zones – which are all of the same design – is a band containing five glass paste gems of blue, orange, blue, yellow and blue (the three middle gems missing on the right wing). Between each gem is an incised design of a diamond flanked by four smaller diamonds. The major part of the wings is covered by the three sections of longer wing feathers, the first and third sections being white, light blue and dark blue, and the second (middle) section yellow, light green and dark green. The upper part of the tail feather is of the same colours and design as the first wing zone, nearest the dove's chest.

Notes
1 M.-M. Gauthier: 'Colombe limousine prise aux rêts d'un ''antiquaire'' bénédictin à Saint-Germain-des-Près, vers 1726', *Intuition und Kunstwissenschaft: Festschrift für Hanns Swarzenski* (Berlin, 1973), 186, n. 12
2 A. Darcel and A. Basilewsky: *Catalogue raisonné de la collection Basilewsky, précéde d'un essai sur les arts industriels du 1er au XVIe siècle* (Paris, 1874), cat. no. 223; see also C. de Linas: 'Les émaux limousins de la collection Basilewsky à Saint-Pétersbourg', *Bulletin de la Société Scientifique, Historique et Archéologique de la Corrèze*, VIII (1886), 13–14, n. 233

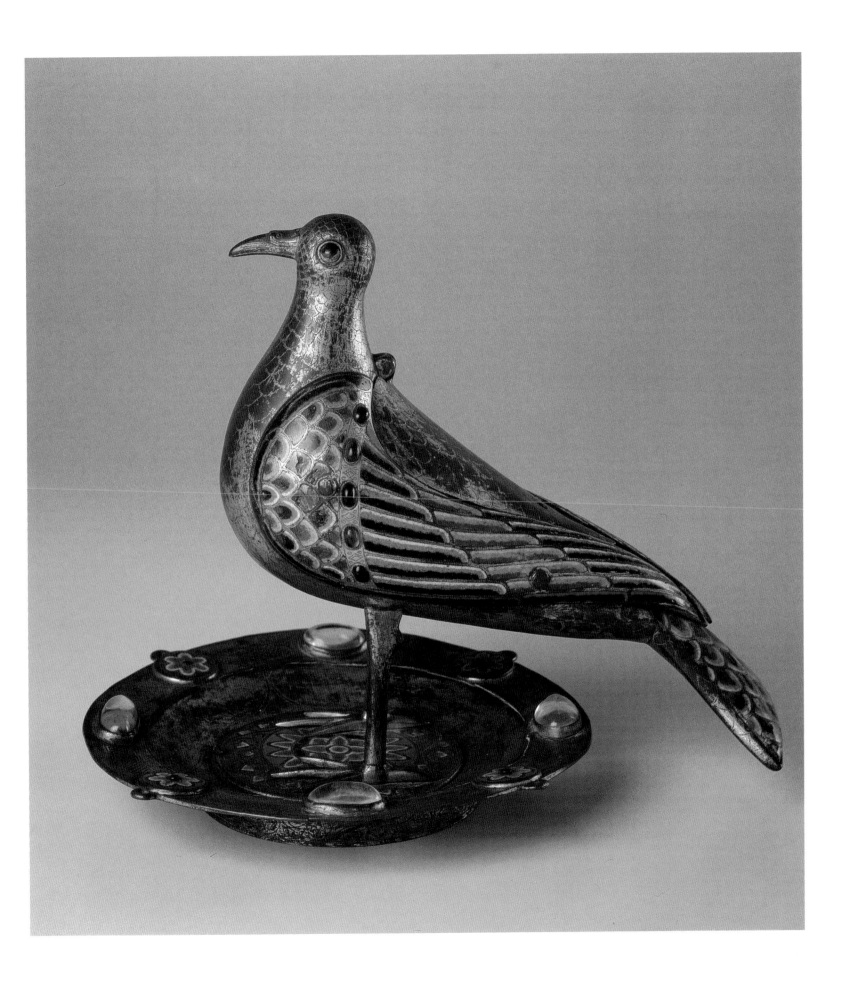

The dove stands on a circular enamelled panel within a circular dish. The panel has three circular zones, the innermost containing a four-lobed star device of yellow, green and red enamel with a centre of white, light blue and red. The star is set over a square of white, light blue and red enamel with a dark blue surrounding ground. The second, middle, zone is decorated with yellow and green lobes with a red centre of exactly the same type as in the innermost star device and, like the innermost design, the pattern is drawn on a reserved copper gilt ground with a series of incised dots. The background is of turquoise enamel. The third, outermost, zone contains spiral foliate designs with terminals of white, light blue and red, and yellow, green and red enamel, the whole design placed against a dark blue ground. The rest of the dish is gilt copper, rubbed in places, but the rim is set with four enamel roundels and four rock-crystal stones, the latter visible from both sides of the rim. The roundels contain flower-like devices of six petals in white, light blue and red enamel set on a dark blue ground. Running around the centre of the rim is a ribbon of cross-hatching, and between the rim and the central, circular panel are incised loops terminating in eight *fleur-de-lys* motifs. On the rim, adjoining the enamel roundels, are four protruding loops from which the dish would have been attached to chains and suspended above the altar. Underneath, the dish is plain except for the raised circular base, which is incised on the outside with a design of spiral foliate patterns. The enamelling throughout is well preserved, although the enamel at the tip of the right wing has fallen out. There are also small circular gaps on both wings, left by air bubbles created in the firing.

In the Middle Ages eucharistic doves were employed to hold the unused consecrated Hosts above the altar: chains passed through the loops on the plates on which the doves stood and they were suspended above the altar until such time as they were needed. The symbolism of the dove as a holder of the consecrated Host lies in its representation of the Holy Spirit, believed to be present whenever the Host was converted into the Body of Christ.[3] Although eucharistic doves were in existence in the eleventh and twelfth centuries, the majority of extant examples were manufactured in the thirteenth century in Limoges in southwestern France. In 1973 Marie-Madeleine Gauthier recorded 42 enamelled doves of this type and produced a chronology for a number of the most important examples, ranging in date from 1200 to 1220, by comparing the incised designs on one of these doves with the dated enamel of the Mozac *châsse*.[4] The present dove is sufficiently close to the examples placed by Gauthier between 1200 and 1220 to be safely dated to the years around 1210. Its importance is increased by the fact that it still retains its original plate, one of the rare examples to do so.

Notes

3 For information on eucharistic doves generally, see most recently the admirable account in *Eucharistic Vessels of the Middle Ages* (Cambridge, MA, 1975), 86–90 [exhibition catalogue: Busch-Reisinger Museum]

4 Gauthier, *op. cit.*, 174–80

Additional bibliography

E. Rupin: *L'Oeuvre de Limoges* (Paris, 1890), 234
J. Braun: *Der christliche Altar* (Munich, 1924), II, 610
Feulner (1941), 44–5, pl. 33
Rohoncz (1949), no. 441
Rohoncz (1952), no. 441
Rohoncz (1958), 138

[30] *Eucharistic dove*

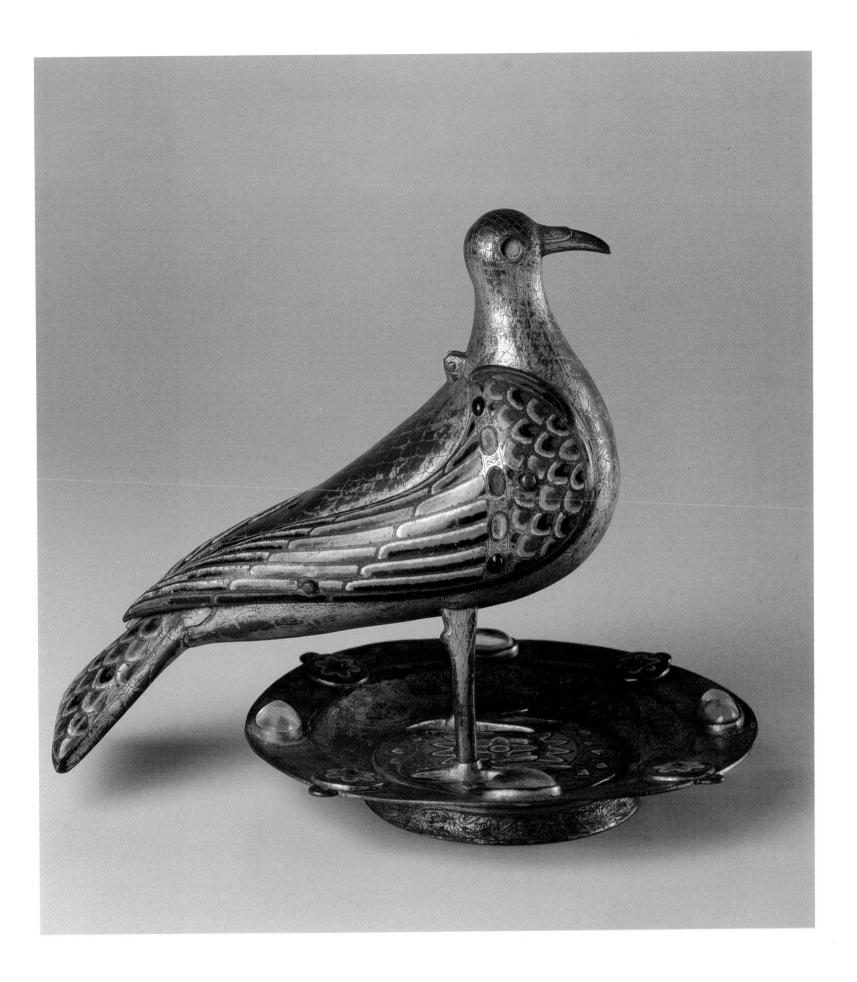

31 Reliquary-monstrance

French (Limoges), first half of the thirteenth century
Copper and *champlevé* enamel, rock crystal

Dimensions
Height: 28 cm; diameter of base: 9.2 cm

Provenance
Said to have come from a Dutch church[1]
Bought by Baron Heinrich Thyssen-Bornemisza (1875–1947) before 1930
K90

Exhibition
Munich, 1930, no. 39

The reliquary-monstrance is composed of six separate pieces: the base on three feet, two cylindrical shafts separated by a knop of rock crystal and topped by a hexagonal rock crystal, and an eight-lobed plaque with rock-crystal centre and seven rock-crystal finials.

The base is decorated with three large medallions within which are flower-like devices with eight petals: the petals are of yellow and green enamel; the centres are white, light blue and dark blue with a red highlight between each petal. Between each medallion is a reserved pattern of spreading foliate shoots formed at the centre with a figure-of-eight with two trilobed terminals of white, light blue, dark blue and red enamel. To each side of this device is a roundel within which is a four-petalled flower of yellow, green and red enamel, all set in a dark blue ground. The borders at the edge and centre of the base are of gilded and reserved star-shaped ornament on a turquoise enamel ground.

The two shaft cylinders, divided by a rock-crystal knop, are of engraved gilt copper. The front of the monstrance is decorated with a design of spreading foliate shoots with terminals in both white, light blue, dark blue and red, and yellow, green, blue and red. Four small roundels with quadrilobed designs of yellow, green, blue and red enamel flank the central rock-crystal 'window', which contains a partly-erased inscription written in ink on paper: *osi re(li)c(?)*. The relic (a small piece of bone?) is still inside. Around the rock crystal in the four principal semi-circular lobes are set four glass paste(?) gems. The back is decorated with an incised pattern of fleshy foliage around a central boss of lapis lazuli. There is a wood core, and the space between the front and back of the monstrance is covered with a strip of beaten copper impressed with quadrilobed flowers in a grid.

A monstrance is simply a vessel designed to exhibit a relic – as in this case – or to display the consecrated Host. However, monstrances and reliquaries of this particular shape are not com-

Notes
1 Feulner (1941), 45–6, pl. 34

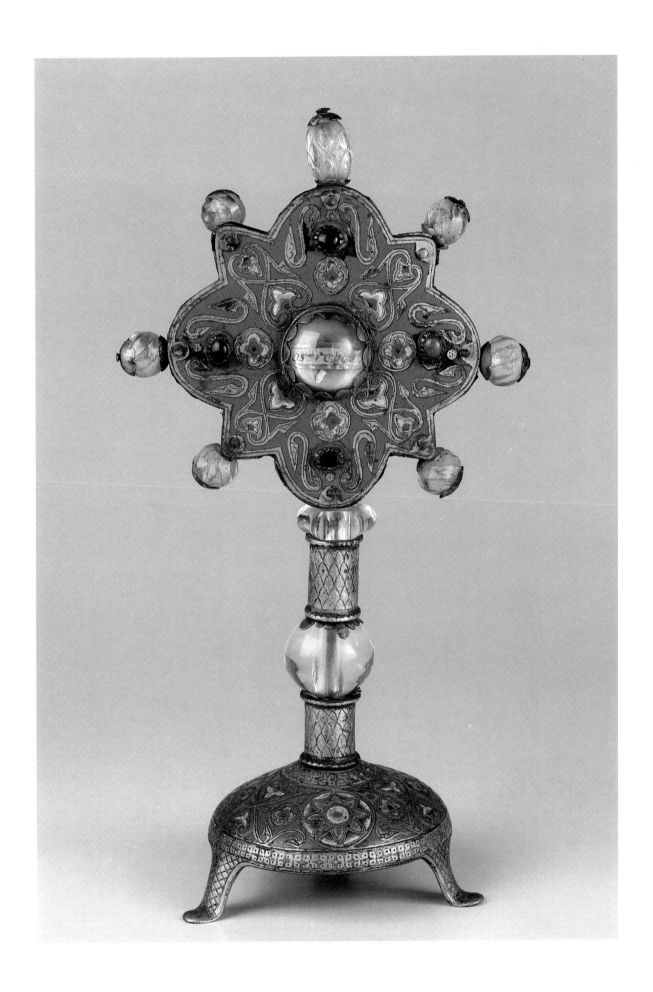

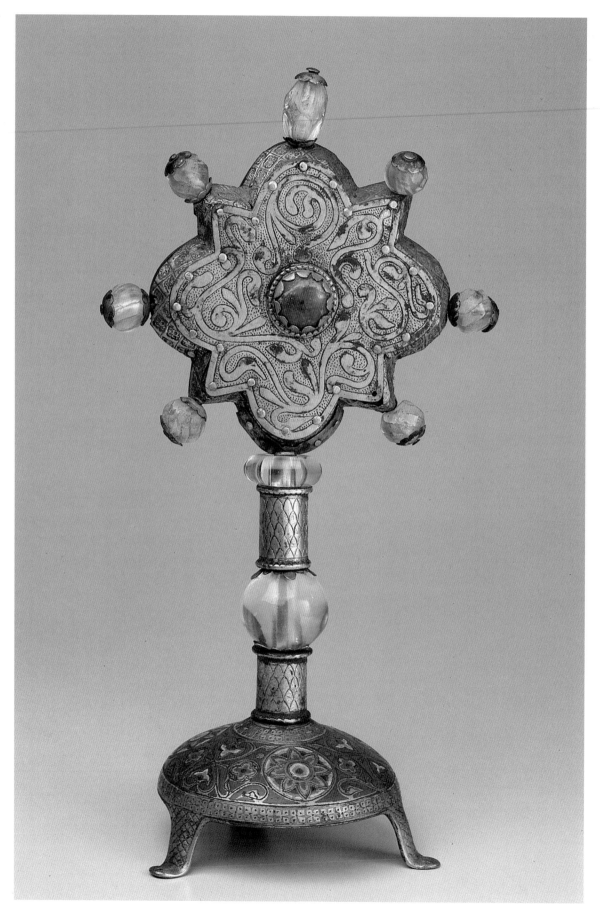

[31] *Reliquary-monstrance*
Back view

1 Reliquary of Henry II, *champlevé* enamel on copper with rock-crystal finials, Lower Saxony, *c.* 1175 (Musée du Louvre, Paris)

2 Reliquary monstrance, *champlevé* enamel on copper with rock-crystal finials; base, Limoges, early thirteenth century, upper section, Lower Saxony(?), late twelfth century (formerly Spitzer Collection, Paris)

Notes
2 M.-M. Gauthier: *Émaux du moyen âge occidental* (Fribourg, 1972), 359. On monstrances generally, see J. Braun: *Die Reliquiare des christlichen Kultes und ihre Entwicklung* (Freiburg im Breisgau, 1940), 295–300
3 *Collection Spitzer*, Paris, 17 April–16 June 1893, no. 243, pl. v [sale catalogue]

Additional bibliography
Rohoncz (1949), no. 443
Rohoncz (1952), no. 443
Rohoncz (1958), 138

mon: possibly the best-known is the so-called Reliquary of the Emperor Henry II, a product of Lower Saxony of *c.* 1175, now in the Musée du Louvre, Paris (fig. 1): this also has rock-crystal finials.[2] Another example, formerly in the Spitzer Collection in Paris, is closer in technique and style, but it seems likely that this piece was made up from two separate objects (fig. 2). The base is very close to that of the present monstrance, and clearly of Limoges workmanship, while the main part of the Spitzer reliquary is close in style and technique to the Reliquary of Henry II.[3] It is known that Spitzer 'restored' many objects in his collection, sometimes mixing elements of quite different works of art to make a 'complete' piece. Although the Thyssen-Bornemisza monstrance follows the form of the earlier Reliquary of Henry II, the enamelling technique is quite different and absolutely characteristic, both in colour and design, of Limoges work. It should therefore probably be dated in the first half of the thirteenth century.

32 Head of a crozier showing the Stoning of St Stephen

French (Limoges), *c.* 1220–30
Copper and *champlevé* enamel

Dimensions
Height (not including square shaft): 16 cm; transverse ⌀: 13.5 cm; vertical ⌀: 12.3 cm

Provenance
Emmanuel Chalandon Collection, Lyon, 1877
Georges Chalandon Collection, Paris, by 1905
Firmin Didot Sale, Paris, 1941, cat. no. 170
Brimo Laroussilhe, Paris
Ernest Brummer Collection, 1952–79
Bought at the Ernest Brummer Collection Sale, Zurich (Gallerie Koller), 16–19 October 1979, lot 232
K89A

Exhibitions
Paris, *Exposition Universelle*, 1900, cat. no. 2439
Paris, Hôtel de Sagan, *Croix Rouge, Exposition d'objets d'art du moyen âge et de la Renaissance, organisée par la marquise de Ganay, à l'ancien hôtel de Sagan*, 1913

The simple volute is made of two hollow moulds welded together; the outer profile has a crest of 38 integrally cast crockets. At the end of the volute a grained flower pistil between two divergent shoots is encased in the tubes of half palmettes and terminates in a grained flower bud between two leaves. There is reticulated, gilded and reserved ornament on a solid light blue ground, shaded in red and turquoise only at the petals at the end of the volute. The group of three small figures is made of cut moulds *repoussé*, engraved and gilded; they are attached at eight points to the inner profile of the volute. Blue beads act as eyes. There are losses to the enamel in patches around the volute, the most serious damage being at the bottom of the shaft on both sides.

The Stoning of St Stephen shows the saint kneeling in profile and facing outward from the crosier shaft. Each of the two executioners brandishes a stone in his right hand and re-supplies himself with stones from a pouch knotted from the folds of his tunic on both sides. The Hand of God dispenses rays on the head of the protomartyr.

As noted by Marie-Madeleine Gauthier in the catalogue of the Ernest Brummer Collection, only four of the 308 croziers so far known are decorated with a saint's image.[1] Gauthier also observed that the present crozier is particularly remarkable and rare, since it is the only example showing St Stephen. She postulated that it must have been ordered specially for a prelate whose bishop's or archbishop's seat was dedicated to St Stephen, and she pointed out that the cathedrals of Sens, Bourges, Nevers and Limoges were actually dedicated to that saint. In each place a number of thirteenth-century bishops received enamelled croziers made in Limoges. Although this is the only Limoges crozier to show the Stoning of St Stephen, the scene does appear on some Limoges *châsses* of about the same date;[2] like the crozier, they were probably specially commissioned.

Notes
1 *The Ernest Brummer Collection, I, Medieval, Renaissance and Baroque Art*, Zurich (Gallerie Koller AG and Spink & Son), 16–19 October 1979, cat. no. 232, p. 353 [sale catalogue]
2 E. Rupin: *L'Oeuvre de Limoges* (Paris, 1890), 381–4; see also M.-M. Gauthier and G. François: *Medieval Enamels: Masterpieces from the Keir Collection* (London, 1981), cat. no. 12

Additional bibliography
Père A. Martin: *Le bâton pastoral* (Paris, 1856), 233, fig. 109
Père C. Cahier: *Caractéristiques des Saints*, II (1867), fig. p. 535
J.-B. Giraud: *Recueil descriptif et raisonné des principaux objets ayant figuré à l'exposition rétrospective de Lyon en 1877* (Lyon, 1878), pl. XLIII
Rohault de Fleury: *La Messe*, VIII (1889), 104
G. Migeon: 'La collection de M. Georges Chalandon', *Les Arts* (1905), 28
C. Enlart: *Manuel d'archéologie* (Paris, 1916), III, 360
J. J. Marquet de Vasselot: *Les Crosses limousines du XIIIe siècle* (Paris, 1941), 31, 147, 300

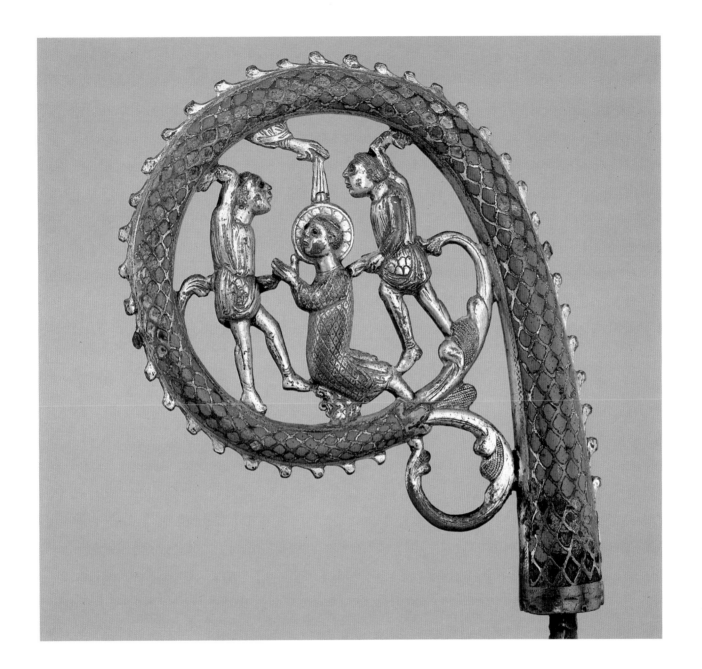

33 Head of a crozier showing St Michael and the Dragon

French (Limoges), second quarter of the thirteenth century
Copper and *champlevé* enamel

Dimensions
Height: 18.4 cm; transverse ∅: 12.9 cm; vertical ∅: 11.6 cm

Provenance
Bought from Z. M. Hackenbroch, Frankfurt, 30 August 1929
K89

Exhibition
Munich, 1930, no. 38, pl. 17

1 Crozier (volute and upper part of shaft), *champlevé* enamel on copper, French (Limoges), second quarter of the thirteenth century (Fitzwilliam Museum, Cambridge)

The simple volute is made of two hollow moulds welded together: the outer profile has a separately cast crest of 24 crockets. There is reticulated, gilded and reserved ornament on a solid dark blue ground. The figures of St Michael and the Dragon, and the dragon head terminating the volute, are cut moulds *repoussé*, engraved and gilded; they have jet beads for eyes (one eye of the dragon head on the volute missing). The Dragon has eight turquoise enamel beads running down both sides. The line of the Dragon's tail is continued and transformed into a flower shoot diverging into two separate terminals, one into a grained bud within leaves, the other into a long leaf, grained on the inside. It is in reasonable condition; the central figures are tarnished and there are losses of enamel around the volute. In one place, near the tail of the Dragon, there are four small holes, probably a casting flaw.

St Michael defeating the Devil in the form of a Dragon was the most popular scene with which the Limoges enamellers of the thirteenth century decorated the volutes of croziers: Marquet de Vasselot, in his *corpus* of Limoges croziers, included 46 examples of this scene in his catalogue.[1] Iconographically they vary very little and may be divided into two groups: the first group, of which the present crozier forms part, shows the Archangel advancing away from the shaft of the crozier towards the two-legged Dragon, usually plunging his spear into the Dragon's back. The second group shows an abbreviated version of the scene, with the Archangel stepping *towards* the shaft: the dragon's head at the end of the volute serves as the Devil.

In its original state the volute would probably have been connected to its enamelled shaft with an elaborate inhabited knop containing writhing, biting dragons, as may be seen by referring to a number of better-preserved croziers with the same iconography (fig. 1).[2]

Notes
1 J. J. Marquet de Vasselot: *Les Crosses limousines du XIIIe siècle* (Paris, 1941), 85–91, cat. nos. 122–67; see also *Medioevo e produzione artistica di serie: smalti di Limoges e avori gotici in Campania* (Naples, 1981), cat. no. 1, 5 (entry by P. Leone de Castris) [exhibition catalogue: Museo Duca di Martina]
2 Marquet de Vasselot, *op. cit.*, pls. XVIII–XX. These dragon-inhabited knops are not, however, solely utilised on croziers with St Michael iconography: they are common to many croziers with different scenes

Additional bibliography
Feulner (1941), 45
Rohoncz (1949), no. 442
Rohoncz (1952), no. 442
Rohoncz (1958), 138

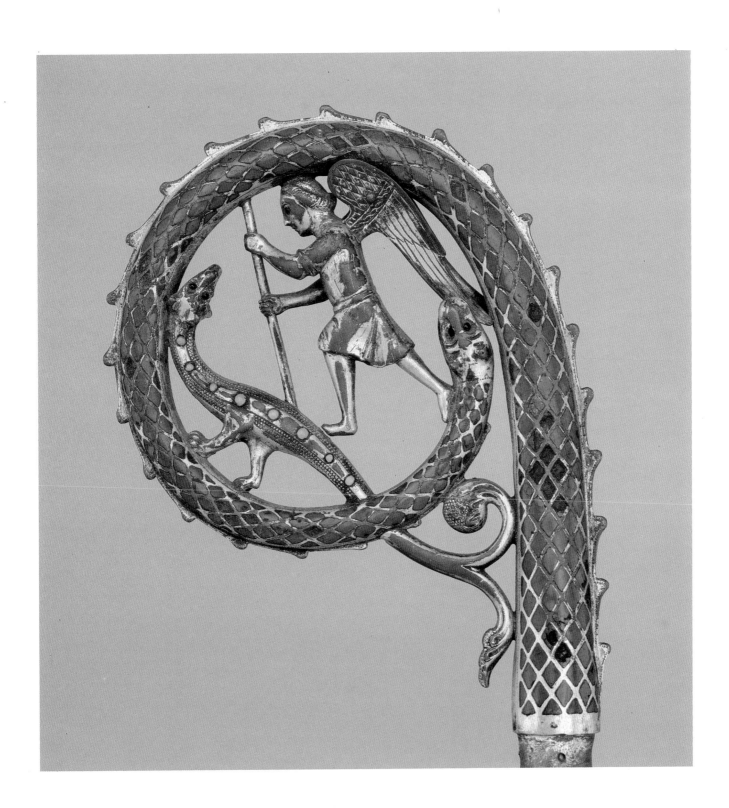

34 The Nativity of Christ

In the Byzantine or Georgian manner
Cloisonné enamel on gold

Dimensions
Height: 12.5 cm; width: 10.1 cm

Provenance
Botkin Collection, St Petersburg[1]
Paula de Königsberg Collection, Buenos Aires
Bought from Stuker, Berne, 22 May 1964, lot 150
K95A

Exhibitions
Montevideo, Salon Nacional de Bellas Artes, and Buenos Aires, Museo Nacional de Bellas Artes, 1945
Buenos Aires, *Exposición de Arte Gotico*, 1947, cat. no. 79

At the centre of the composition are the seated Virgin and the swaddled Christ-Child in a manger, with three sheep in front and the ox and ass behind. Joseph sits with a melancholy expression at the lower right. To the left is a group of six men, presumably shepherds, and behind the Virgin is another group of seven men, one of whom holds a crook, while the foremost presents a pot of gold. Above the six figures on the left a solitary figure approaches on horseback, presumably one of the magi. Above, two angels fly towards the star which projects its beam downwards towards the Christ-Child, filling the area above the manger with red stars and yellow spheres. The palette consists of white, light blue, dark blue, red, translucent green, black, yellow, pink and brown enamel. The plaque is in very good condition with only minor losses of enamel.

This plaque forms part of a group of eleven plaques formerly in the Botkin Collection which, barring the Annunciation, showed the Twelve Feasts of the Year.[2] When the Botkin Collection was dispersed shortly after its publication in 1911, this group was scattered into different collections: the Pentecost, the Raising of Lazarus and the Presentation in the Temple plaques are now in the State Museum of Fine Arts of Georgia in Tbilisi,[3] the Entry into Jerusalem is in the Blumka Collection in New York,[4] the Dormition of the Virgin was in the Robert von Hirsch Collection until its sale in London in 1978,[5] the Crucifixion and Ascension plaques are in the Metropolitan Museum of Art in New York,[6] and the Baptism and Transfiguration plaques are in the Detroit Institute of Arts.[7] The present whereabouts of the Harrowing of Hell plaque is unknown.

Chalva Amiranachvili attributed the three plaques in Tbilisi, and consequently the other eight plaques from the Botkin series, to a Georgian workshop at the end of the twelfth century: he felt this explained the curious architecture – which he considered to be Georgian – and other differences the plaques showed from metropolitan Byzantine enamels.[8] This thesis has been

Notes
1 *Collection M. P. Botkine* (St Petersburg, 1911), pl. 88
2 *Ibid.*, pls. 87–90
3 See, most conveniently, C. Amiranachvili: *Les Emaux de Géorgie* (Paris, 1962), 60–65, and most recently L. V. Khuskivadze: *Medieval cloisonné enamels at Georgian State Museum of Fine Arts* (Tbilisi, 1984), cat. nos. 145–7
4 *Medieval Art from Private Collections* (New York, 1968), no. 156 [exhibition catalogue: Metropolitan Museum of Art]
5 *The Robert von Hirsch Collection*, II, *Works of Art*, London (Sotheby's), 22 June 1978, lot 242 [sale catalogue]
6 The Ascension plaque is mentioned in *Medieval Art from Private Collections*, loc. cit. I would like to thank Margaret Frazer for pointing out that the Metropolitan Museum also owns the Crucifixion plaque and for discussing the group with me
7 A. C. Weibel: 'Byzantine Enamels', *Bulletin of the Detroit Museum of Arts*, IX (1928), 90–93
8 Amiranachvili, *op. cit.*, 60

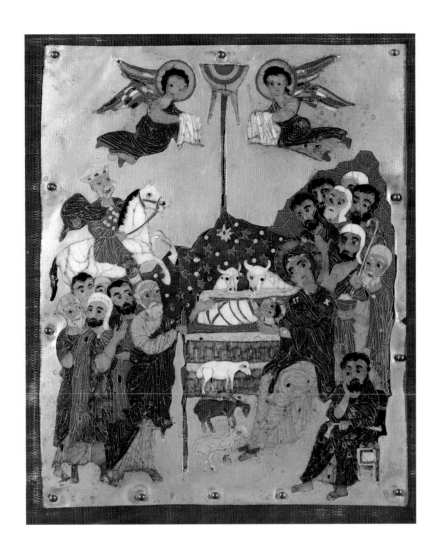

accepted by some scholars, but there are grounds for viewing the eleven plaques in a different light, as much later objects made in the Byzantine or Georgian style.[9]

There is now no doubt that a number of the 150 enamelled plaques once in the Botkin Collection are forgeries. Mainly for technical reasons, but sometimes on grounds of style or iconography, certain plaques have been considered suspicious and have been consigned to store in various museums.[10] One of the major factors contributing towards this degree of doubt is that many of the plaques, although of totally different type and often in different style, are very similar in technique, with the colour range of the enamels exactly matching. On grounds of technique the present plaque differs considerably from genuine Byzantine enamels. On the back there is no sign of the lines showing the placement of the *cloisons* on the other side, which are often clearly visible;[11] in addition, the plaque is constructed of one sheet of gold, rather than two, a characteristic alien to Byzantine enamels. Although the enamelling is of high quality, the drawing of the *cloisons* is highly erratic – note especially the Virgin's cloak, the cloak of the mounted magus, the draperies of the flying angels, and the clumsy drawing of the shepherd's staff. Iconographically, too, the present plaque leaves much to be desired: the three sheep float meaninglessly in front of the crib, the ass has horns, the large groups of figures on either side of the Virgin and Child – there are 13 figures in all – do not appear to have any parallels in Byzantine art, and there is confusion over exactly who is shown in those groups. Are these figures all shepherds? If they are, it is an extraordinary and unique representation, as normally only two or three shepherds are shown.[12] However, the foremost figure on the right holds a pot of gold and should therefore be interpreted as one of the magi. The other magus, on horseback, should also be seen as a misunderstanding of a Byzantine source because if shown in this way there are invariably all three of the magi approaching by horse.[13] There are also iconographic errors on a number of the other plaques in the series. Another feature which links the group together is the artist's fondness for decorative ornament as, for instance, on the chest of the magus on horseback and above the crib.

It may, therefore, be supposed that the plaques in this series were made probably only shortly before their purchase by Botkin. Their place of manufacture is unclear, but it seems that the craftsman or craftsmen responsible for making them were loosely basing their compositions on prototypes such as the enamels on the *Pala d'Oro* in Venice, which contains all the scenes shown on the Botkin plaques.[14]

Notes

9 His dating and localisation have been repeated in *Medieval Art from Private Collections, loc. cit.*, and by S. Bettini in *The Treasury of San Marco, Venice* (London, 1984), 56 [exhibition catalogue: British Museum]. Another plaque, showing the Dormition of the Virgin, apparently from the same workshop as the Botkin series, is in the Abegg-Stiftung in Riggisberg (M. Stettler and K. Otavsky: *Abegg-Stiftung Bern in Riggisberg*, I, *Kunsthandwerk-Plastik-Malerei* (Berne, 1971), pl. 15; provenance given as Botkin Collection, but this plaque is not shown in the 1911 catalogue): this plaque has been dated between the fifteenth and the seventeenth centuries and described as 'Byzantinischer Stil, vielleicht Georgien'

10 See the account in S. Boyd and G. Vikan: *Questions of Authenticity among the Arts of Byzantium* (Washington, DC, 1981), 29; also H. Swarzenski and N. Netzer: *Catalogue of Medieval Objects in the Museum of Fine Arts, Boston. Enamels & Glass* (Boston, MA, 1986), cat. no. A1

11 Boyd and Vikan, *op. cit.*, 28–9, fig. *a* on p. 28

12 See G. Millet: *Recherches sur l'Iconographie de l'Evangile aux XIVe, XVe et XVIe siècles d'après les monuments de Mistra, de la Macédoine et du Mont-Athos* (Paris, 1916), 93–135. There is the possibility that the grouping of the figures was derived from the same arrangement in the Dormition of the Virgin scene (see Note 5)

13 *Ibid.*, figs. 36–9, 86–7

14 H. R. Hahnloser *et al.*: *Il Tesoro di San Marco*, I, *La Pala d'Oro* (Florence, 1965), *passim*

Additional bibliography

L. V. Khuskivadze: *Gruzinskiye Emali* (Tbilisi, 1981), 135 and pl. XLIII (reported as lost)

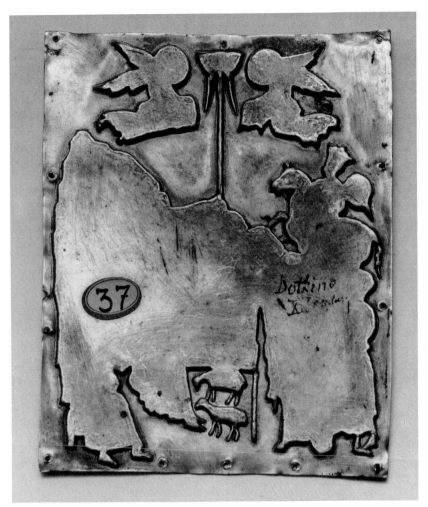

[34] *Nativity of Christ*
Back view

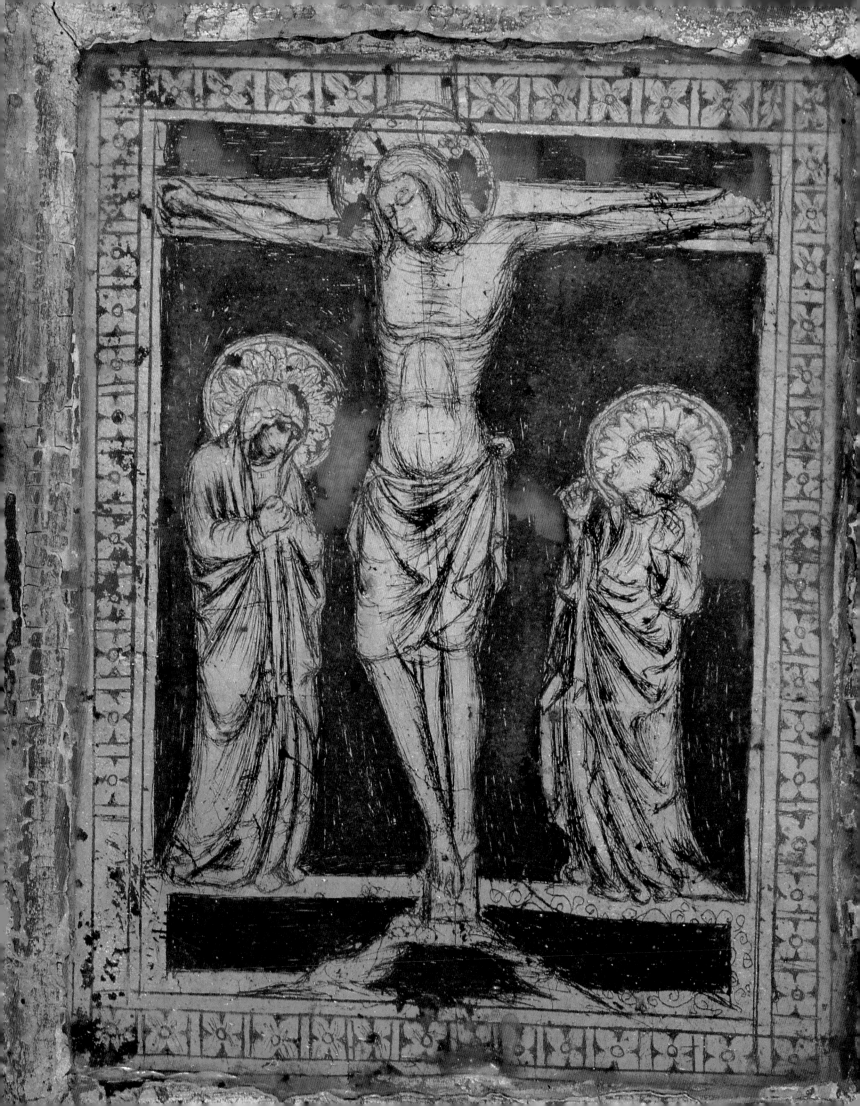

Other works of art

35 *Aquamanile* in the form of a standing lion

Northern German, *c.* 1300
Bronze

Dimensions
Height: 30.9 cm

Provenance
Camillo Castiglione Sale, Amsterdam, 17–20 November 1925, vol. II, lot VII
Goudstikker Sale, Amsterdam, October-November, 1927, Sculptures, lot 1
Bought Sotheby's, New York, 19 March 1971, lot 200
K106A

The bronze is in good condition: the lion stands with stiff front legs and an open mouth containing the spout for pouring; the handle is formed by the tail bent back and by a serpent with the head of a dragon which joins the lion's head. The tail has been broken off and repaired, but is original, the cover-flap once attached at the top of the lion's head is missing, and there is a small hole (a casting flaw) on the lion's right shoulder. There are still substantial traces of a dark-brown patina. Written in red paint underneath the back right paw is the number 914.[1]

Aquamanilia, water-vessels used for washing the hands either as part of the liturgy at the altar or at a secular table, were common in the Romanesque and Gothic periods and took a variety of forms: there are examples representing men on horseback, griffins, busts of men, birds and mythological groups. *Aquamanilia* in the form of lions were particularly popular, and Otto von Falke and Erich Meyer, in their *corpus* of Romanesque and Gothic candlesticks and cast vessels, list more than 200 pieces, ranging in date from the early twelfth century to the beginning of the sixteenth.[2] Von Falke and Meyer considered the present *aquamanile* to date from the first half of the fourteenth century and convincingly placed it in North Germany: they grouped it with a number of other lion *aquamanilia*, all sharing such features as the distinctive use of 'crenellations' on the curved tail, a plain 'bib' around the chin, and spoon-like ears.[3] Closest to the Thyssen-Bornemisza lion are a piece formerly in the Mortimer Schiff Collection in New York, now in the Burrell Collection, Glasgow (fig. 1), and another in Wartburg bei Eisenach.[4]

Notes
1 This is probably a Castiglione inventory number: the same red paint and similar writing may be seen on another object in the Thyssen-Bornemisza Collection which was also previously in the Castiglione Collection – no. 5, the Lion of St Mark in marble (K9)
2 O. von Falke and E. Meyer: *Romanische Leuchter und Gefässe, Giessgefässe der Gotik* (Berlin, 1935), 57–83 and cat. nos. 347–538. A useful discussion of lion *aquamanilia*, albeit earlier Romanesque examples, is by W. D. Wixom: 'A Lion Aquamanile', *The Bulletin of the Cleveland Museum of Art* (Oct 1974), 258–70
3 Von Falke and Meyer, *op. cit.*, 76, cat. no. 485, fig. 449
4 *Ibid.*, cat. nos. 480, 481; the Wartburg bei Eisenach *aquamanile* is not illustrated in von Falke and Meyer, but an illustration of it may be found in H. Reifferscheid: 'Über figürliche Giessgefässe des Mittelalters', *Mitteilungen aus dem Germanischen Nationalmuseum* (1912), fig. 16

Additional bibliography
L. Planiscig: *Collezione Camillo Castiglione, Catalogo dei bronzi* (Vienna, 1923), cat. no. 7

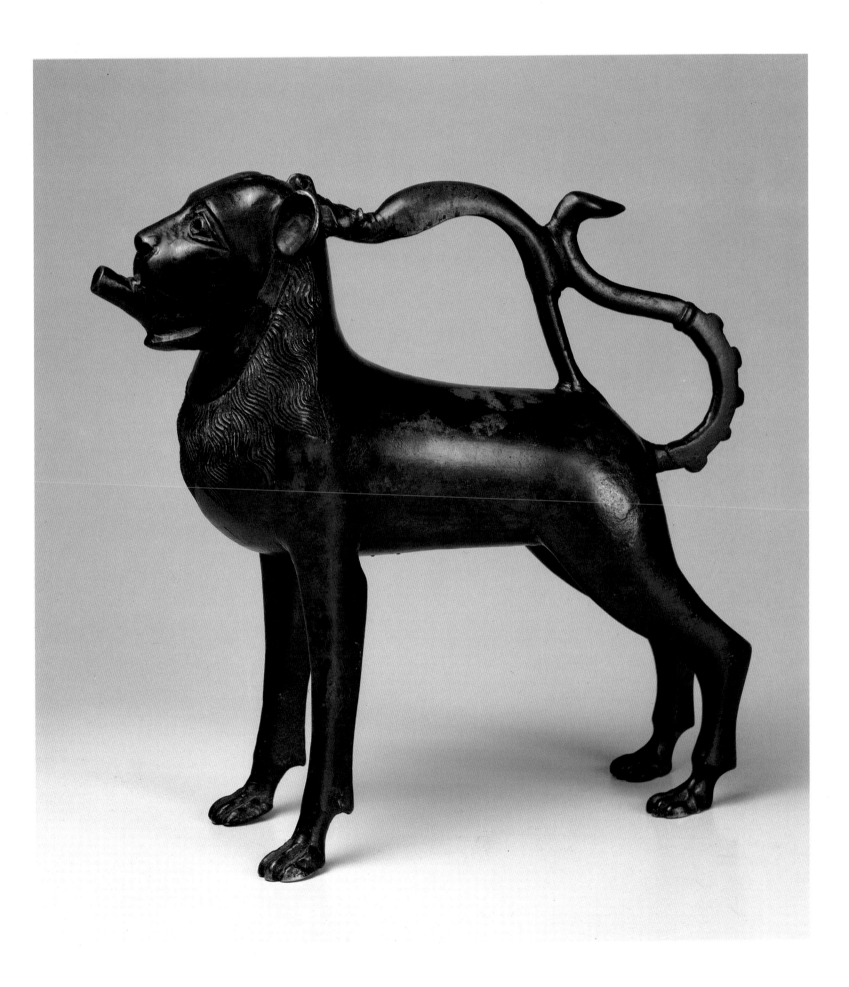

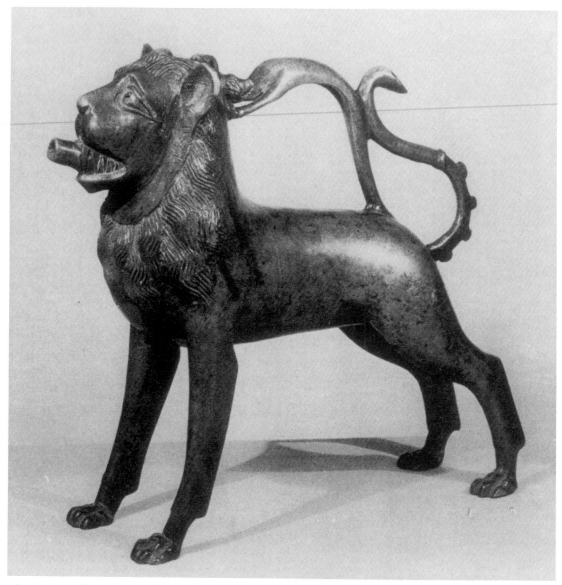

1 Lion *aquamanile*, bronze, North German, *c.* 1300 (Burrell Collection, Glasgow)

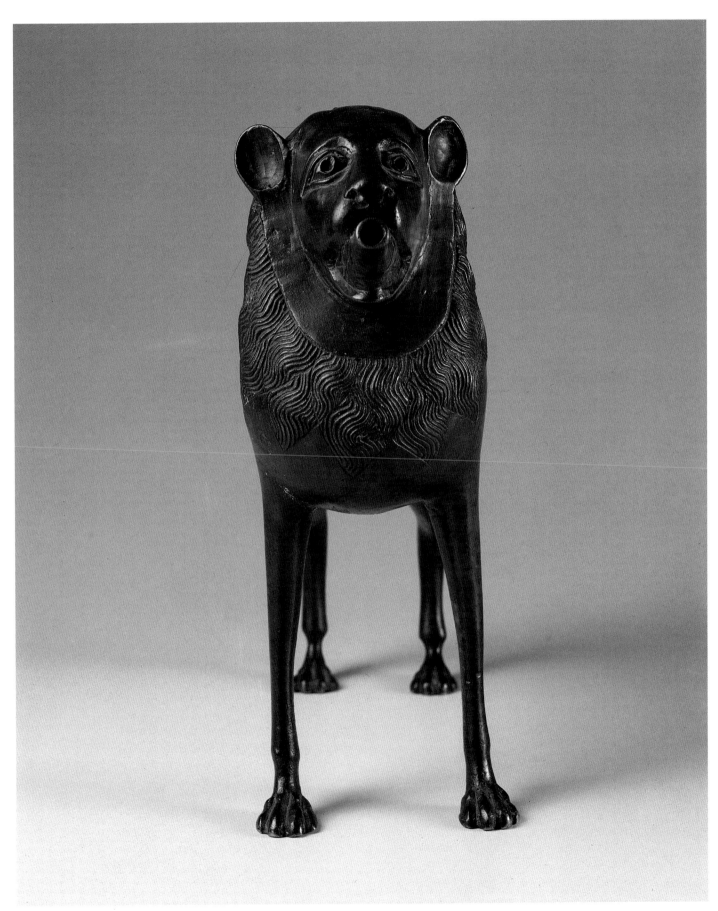

[35] *Aquamanile, front view*

36 Head reliquary

Italian, thirteenth-fourteenth century
Silver, with remains of gilding

Dimensions
Height: 26 cm

Provenance
Said to have come from a church in Naples[1]
Bought by Baron Heinrich Thyssen-Bornemisza (1875–1947) before 1938
K8

This head of an unidentified saint is in good condition generally, although it is cracked in two places on the neck and has two holes near the rim at the back, presumably used for fixing the head down or for attaching it to separately-made shoulders and upper chest, forming a reliquary bust. There are a number of small flaws around the head, where the silver has been beaten too thin. The cranium has been made separately and attached at several points inside. The beard and hair retain much of their orginal gilding, but the head is now dirty and much of the detail of the hair especially is obscured. The surface has been delicately punched with a chisel around the eyebrows, the edges of the eyes and the upper lip, to depict fine facial hair.

Head reliquaries of this type were commonplace in church treasuries throughout Europe from the eleventh century onwards. They were made from a variety of metals, most commonly silver or copper, more rarely gold, and they invariably enclosed a relic of a saint, sometimes the skull itself. Most were constructed with separately made craniums, so that the relic could be seen on certain occasions:[2] the joint would normally have been disguised by a crown or mitre. The vast majority formed part of a reliquary bust, which was invariably made up of two pieces, as the present example seems to have been, and many had a similar partial gilding, with the gold reserved for the beard or hair, or both;[3] from the fourteenth and fifteenth centuries especially many head reliquaries were naturalistically painted over a gesso ground.[4]

Although it has not proved possible to verify the provenance of the head, there is evidence that such reliquaries were made in Central and South Italy in the thirteenth and fourteenth centuries;[5] however, head reliquaries are notoriously difficult to date and localise accurately. It is quite conceivable that they were not made in the areas in which they are now found and even that the craftsmen responsible for their manufacture were peripatetic. Notwithstanding these difficulties, a thirteenth-century bust in the Treasury of the Cathedral at Veroli (southeast of Rome), reputedly containing parts of the heads of SS John and Paul, has several features in common with the present bust. The hair is similarly treated, deeply incised and curled in the same manner, the eyebrows are finely punched with parallel lines to indicate the hairs, and the pupils have been sunk.[6] Another bust, in the Cathedral at Vercelli and dated by Kovács to *c.* 1400, shares these features.[7]

While there is no reason to doubt the Neapolitan provenance for the present bust, and in the absence of further evidence to accept that it was probably made by either a Campanian or Central Italian workshop, the date is still an open question. It is unlikely to post-date the end of the fourteenth century, but for stylistic reasons cannot have been made before the middle of the thirteenth. A date somewhere between 1270 and 1350 is most likely.[8]

Notes
1 Feulner (1941), 11, pl. 1
2 See E. Kovács: *Kopfreliquiare des Mittelalters* (Budapest, 1964); F. Souchal: 'Les Bustes-reliquaires et la Sculpture', *Gazette des Beaux-Arts*, LXVII (1966), 205–16
3 See, for instance, one of the most famous head reliquaries, that of John the Baptist in Aachen-Burtscheid (colour ill. in *Die Parler und der schöne Stil 1350–1400*, Resultatband (Cologne, 1980), pls. 34–5)
4 See Kovács, *op. cit.*, pls. 37–9, and T. P. F. Hoving: 'The Face of St. Juliana: the transformation of a fourteenth century reliquary', *The Metropolitan Museum of Art Bulletin*, XXI (Jan 1963), 173–81
5 P. Piccirilli: 'L'oreficeria medievale a Venafro e Isernia', *Rassegna d'arte*, XV (1915), 43–8; R. Rückert: *Die Typen der metallenen Reliquienhäupter des Mittelalters: Beiträge zu den italienischen Beispielen* (diss., University of Frankfurt, 1956)
6 A. Paniccia and G. Trulli: *Il Duomo di Veroli e il suo Tesoro* (Abbazia di Casamari, n.d.), fig. 22
7 Kovács, *op. cit.*, pl. 31 and p. 70
8 A bust containing the relics of St Pantaleon now in the Historisches Museum, Basel, has a beard and hair treated very similarly to the Thyssen-Bornemisza head; this bust is likely to be dated *c.* 1270 as St Pantaleon's relics came to Basel in that year. Kovács describes the bust as a 'Basler Arbeit' (*op. cit.*, pl. 13 and p. 66)

Additional bibliography
Rohoncz (1949), no. 405
Rohoncz (1952), no. 405
Rohoncz (1958), 123

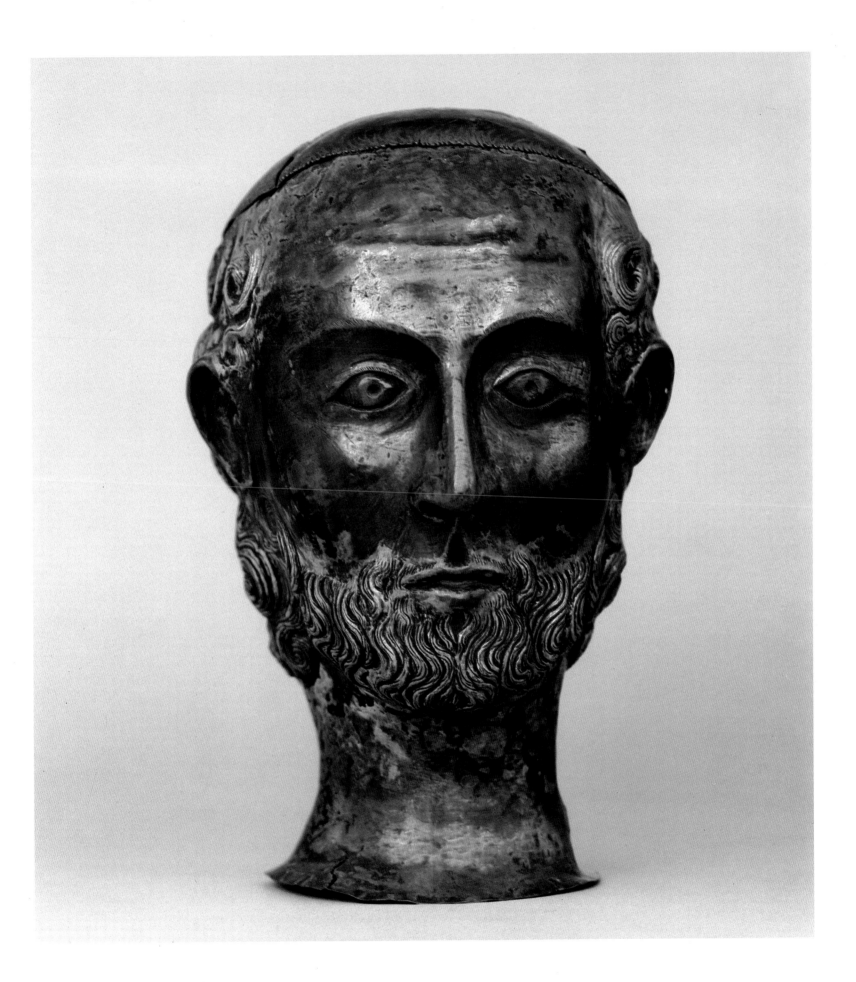

37 Right panel of a reliquary diptych

Northern Italian, second half of the fourteenth century
Painted wood with inset *verre églomisé*

Dimensions
Height: 22.1 cm; width: 15.6 cm; depth: 1.4 cm

Provenance
Collection of Dr Reber, Lausanne
Bought by Baron Heinrich Thyssen-Bornemisza (1875–1947) before 1930[1]
K91

Exhibition
Munich, 1930, no. 86

Because of the presence of two simple ring hinges on the left-hand side of the panel it may be surmised that it originally formed the right half of a diptych: several diptychs with *verre églomisé* inlays showing the Crucifixion on the right wing and the Nativity on the left (or *vice versa*) survive in other collections (fig. 1). Apart from the central glass plaque of the Crucifixion with the Virgin and St John there are four *verre églomisé* medallions at the corners, but because the figures portrayed lack accompanying inscriptions they cannot be identified with certainty. It is fair to assume that the female crowned head at the top left and the bust-length female at the bottom left are virgin martyrs, as such figures appear on other diptychs of this type.[2] The male head at the top right resembles many representations of St Paul, with his long black beard and high forehead, and if the figure of Christ did not already appear on the Cross in the central plaque it would not be unreasonable to identify the frontally-posed head in the bottom right as His image. The cavities between the medallions once contained relics and would have been covered with identifying parchment labels and glass (see figs. 1 and 2). As is the case with the other reliquary diptychs of this type, the relics in the cavities did not necessarily relate to the figures illustrated alongside them. The wood panel itself is gilded, with the red bole showing through in many places, and has raised, bevelled edges. The gilding has been punched with small circles throughout. On the back there are extensive remains of paint, now illegible. There is a double framing device (red and white) and the remains of a central roundel with a similar frame. It is not possible to ascertain the contents of the roundel: there appears to be a sleeve and the remains of a halo at the top. Above, on a blue ground, there are red swirls. Five labels are stuck on the back and there is an indistinct customs stamp (Douanes Françaises).[3]

The technique of reverse glass engraving or *verre églomisé*[4] in fourteenth- and fifteenth-century Italy is easily described and was explained at length by Cennino Cennini in his *Libro dell'Arte*, written at the end of the fourteenth century.[5] Gold leaf was pasted to the back of a transparent glass plaque, which was then incised with a needle, producing lines of clear glass. The back was then painted, in the present case with a dark green paint, to contrast with the remaining gold leaf and to highlight the drawing. The Crucifixion plaque in the Thyssen-Bornemisza panel was never completely finished (see the incomplete border decoration at the bottom left) and some of the background paint has fallen away in places, exposing the wood of the panel behind the glass plaque. An illustration of the difficulty in working in this particular technique, whereby any mark made on the gold leaf cannot be removed (thus necessitating particularly precise draughtsmanship), is the artist's mistake of overlapping Christ's halo onto the border: clearly the figure of Christ was drawn before the border was filled in.

The question of where and when the present panel was executed cannot be established with certainty. Georg Swarzenski, in his important study on the localisation of medieval *verre églomisé*, considered it to be a product of North Italy, but he did not go so far as to hazard a guess

Notes
1 Munich, 1930, no. 86; no further information given on provenance
2 See G. Swarzenski: 'The Localisation of Medieval Verre Eglomisé in the Walters Collection', *Journal of the Walters Art Gallery*, III (1940), 54–68, figs. 8 and 9
3 The labels read: (1) 13079 (?) palaca bruna (?); (2) 3787; (3) 5791; (4) I 1783 over K 91 (these are Thyssen numbers); (5) defaced
4 The term *verre églomisé* is derived from an eighteenth-century Parisian craftsman, Jean-Baptist Glomy, who popularised the technique at that time. It is thus not strictly correct to use the term in connection with Trecento and Quattrocento art, but this usage has gained widespread acceptance and it would seem pedantic not to use the term here
5 D. V. Thompson, trans.: *The Craftsman's Handbook* (New Haven, CT, 1933), 112–14

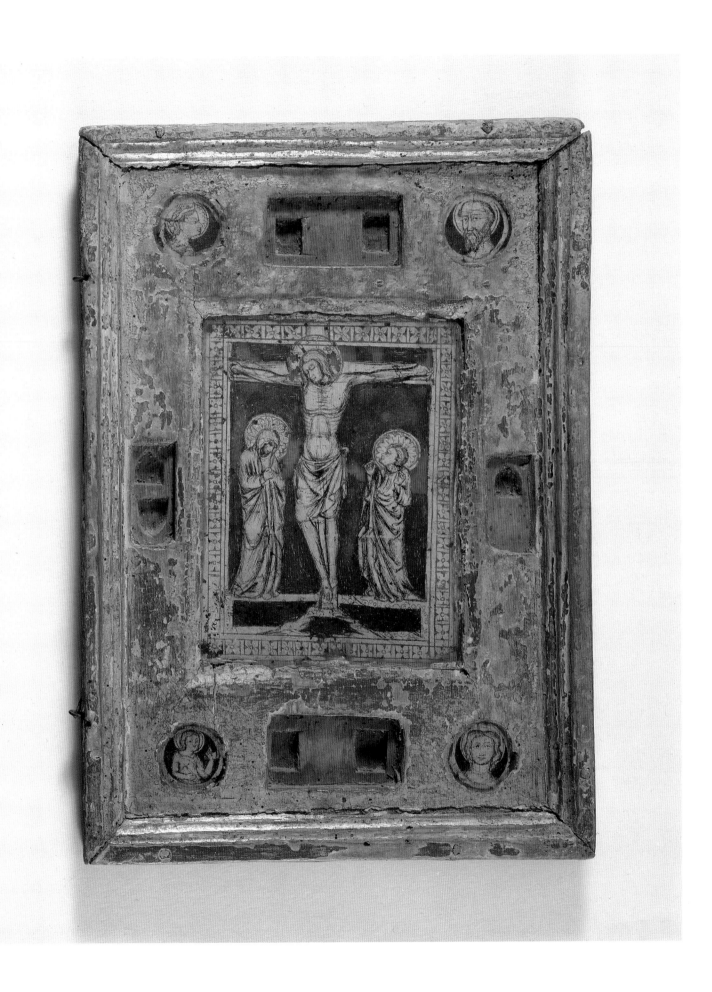

at its precise place of origin.[6] He compared it with a similar Crucifixion plaque at the centre of a reliquary tabernacle in the Walters Art Gallery in Baltimore (fig. 2), and with two other plaques in London and Turin; the Walters tabernacle he confidently assigned to Northeast Italy because the panel paintings on its front are clearly in the style of Tomaso da Modena, although it should be noted that he admitted that the *verre églomisé* plaque was not in the same style as the panel painting.

Verre églomisé seems to have been employed on tabernacles and diptychs throughout Central and Northern Italy in the Trecento, but the only works that can be localised precisely both come from Siena: a plaque on a double-sided processional panel, the painting on one side being signed by Francesco di Vannuccio and dated in the 1370s, and an *églomisé* plaque in the Fitzwilliam Museum, Cambridge, which originally fitted into a tabernacle now in Cleveland, and which may be dated to *c.* 1347.[7] Apart from the small group assigned by Swarzenski to the North, and another perhaps centred around Padua, the majority of pieces (mostly diptychs) almost certainly come from Umbria, the Abruzzi and the Marches, and many of the members of this group are still to be found in those regions.[8] They are generally not of very high quality and they often show representations of St Francis or Franciscan saints, which further reinforces their links with Umbria and the surrounding regions.

On balance, the Thyssen-Bornemisza panel does seem most happily placed near to the Walters Art Gallery Crucifixion plaque, although a number of small features, such as the scalloped haloes on the Virgin and St John, may be seen in the Umbrian examples.[9] A date in the second half of the fourteenth century, probably towards 1400, would appear to be the most likely time for the panel's execution.

Notes

6 Swarzenski, *op. cit.*, 60

7 D. Gordon: 'A Sienese verre églomisé and its setting', *Burlington Magazine*, CXXIII (1981), 149

8 Swarzenski, *op. cit.*, 63–4; for the Paduan group, see W. B. Honey: 'Gold-Engraving under Glass', *The Connoisseur*, XCII (1933), 372ff, and W. D. Wixom: 'Eleven Additions to the Medieval Collection, XI', *The Bulletin of the Cleveland Museum of Art* (Mar–Apr 1979), 139–43, 151; Gordon, *op. cit.*, 149

9 They may also be seen in the Cleveland plaque, attributed by Wixom to Padua (Wixom, *op. cit.*, fig. 100)

Additional bibliography
Feulner (1941), 46

[37] *Back view of panel*

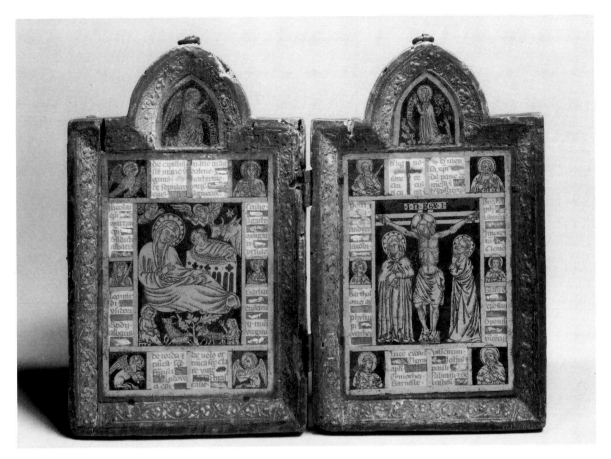

1 Diptych, *verre églomisé* on wood, Northeast Italian (the Marches?), late fourteenth century (Metropolitan Museum of Art, New York)

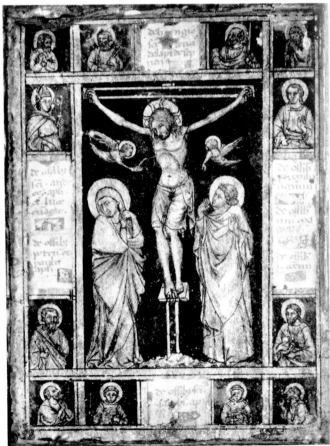

2 Reliquary tabernacle (detail), *verre églomisé* on wood, Northeast Italian?, second half of the fourteenth century (Walters Art Gallery, Baltimore)

Concordance

All objects with a number only (e.g. K7) were acquired before 1938 and were included in Feulner (1941). Those with a letter addition (e.g. K91F) were acquired after 1938, with the exception of K41A which was bought in 1937.

INVENTORY NUMBER	NEW CATALOGUE NUMBER
K7	14
K8	36
K9	5
K9 A	13
K12	11
K12 C	10
K41	3
K41 A	1
K42	9
K42 A	18
K43	2
K44	6
K45	15
K46	16
K47	12
K48	7
K57	17
K58	19
K88	30
K88 A	29
K89	33
K89 A	32
K90	31
K91	37
K91 A	21
K91 B	22
K91 C	23
K91 D	24
K91 F	25
K91 G	26
K91 I	27
K91 K	8
K91 L	20
K91 N	28
K95 A	34
K106 A	35
K72 I	4

Photographic acknowledgements

ANGHIARI
 Museo di Palazzo Taglieschi

ASCHAFFENBURG
 Stifts- und Schlossbibliothek

BALTIMORE
 Walters Art Gallery

BAMBERG
 Historisches Museum

BERLIN
 Staatliche Museen Preussischer Kulturbesitz,
 Skulpturenabteilung

BOSTON
 Museum of Fine Arts

BRUSSELS
 Musées royaux d'Art et d'Histoire

CAMBRIDGE
 Fitzwilliam Museum

COLOGNE
 Schnütgen Museum

DETROIT
 Detroit Institute of Arts

FLORENCE
 Museo Nazionale del Bargello

FRIBOURG
 Leo Hilber

GLASGOW
 Burrell Collection

HARBURG ÜBER DONAUWORTH
 Fürstlich Oettingen-Wallerstein'sche Kunstsammlung

LONDON
 British Museum
 Stanley Eost and Peter MacDonald
 Lambeth Palace Library
 Victoria and Albert Museum

MILAN
 Castello Sforzesco, Civiche Raccolte d'Arte ed Incisioni

NEW YORK
 Metropolitan Museum of Art

PARIS
 Musée du Louvre

PERUGIA
 Galleria Nazionale dell'Umbria

TURIN
 Museo Civico

Index of collectors, collections and dealers